A Creative Future

A Creative Future

Future

The way forward for the arts, crafts and media in England

Co-ordinated by the Arts Council of Great Britain on behalf of the English arts funding system

LONDON: HMSO

© The Arts Council of Great Britain 1993
Applications for reproduction should be made to HMSO
First published 1993

ISBN 0 11 701515 6

British Library Cataloguing in Publication Data
A CIP catalogue for this book
is available from the British Library

Cover Image:
Thérèse Oulton, *Counterfoil*, 1987. Oil on canvas.
Arts Council Collection, South Bank Centre, London.
Photograph: John Webb.
Bought from Marlborough Fine Art with financial assistance from English Estates.

HMSO publications are available from:

HMSO Publications Centre
(Mail, fax and telephone orders only)
PO Box 276, London, SW8 5DT
Telephone orders 071-873 9090
General enquiries 071-873 0011
(queuing system in operation for both numbers)
Fax orders 071-873 8200

HMSO Bookshops
49 High Holborn, London, WC1V 6HB
(counter service only)
071-873 0011 Fax 071-873 8200
258 Broad Street, Birmingham, B1 2HE
021-643 3740 Fax 021-643 6510
Southey House, 33 Wine Street, Bristol, BS1 2BQ
0272 264306 Fax 0272 294515
9–21 Princess Street, Manchester, M60 8AS
061-834 7201 Fax 061-833 0634
16 Arthur Street, Belfast, BT1 4GD
0232 238451 Fax 0232 235401
71 Lothian Road, Edinburgh, EH3 9AZ
031-228 4181 Fax 031-229 2734

HMSO's Accredited Agents
(see Yellow Pages)

and through good booksellers

Printed in the United Kingdom for HMSO
Dd 294230 C50 1/93

CONTENTS

CONTENTS

INTRODUCTION

This book is dedicated to the idea that everyone should have an effective opportunity to enjoy and practise the arts; and that active reading, looking, listening, making and discussing the arts enrich the individual and the community — that the arts are central to society. It is the culmination of a fascinating and unique consultation exercise, the largest ever undertaken on the arts in England.

In late 1988, the ex-head of the Office of Arts and Libraries, Richard Wilding, was commissioned by Richard Luce, then Minister for the Arts, to produce a report on the structures through which central government money is used to support the arts in England. He reported in October 1989. Five months later, Mr Luce announced a group of structural changes — notably the replacement of the then twelve Regional Arts Associations with ten Regional Arts Boards — which was intended to further the causes of decentralisation and accountability. In addition the Minister asked the Arts Council to co-ordinate a national strategy for the arts, crafts and media, in collaboration with the British Film Institute, the Crafts Council and the Regional Arts Associations/Boards.

In this book these organisations are called, for brevity, the funding bodies or funding system. In practice they do a great deal more than fund. The British Film Institute and Crafts Council spend only a minority of their resources on grants or subsidy, being, in the main, direct providers of services and activities; furthermore, all of these organisations have support and development of the arts, rather than funding alone, among their most important aims.

There were several reasons why the funding bodies did not want this to be an internal exercise. First, they are far from being the only important spenders of public money on the arts: local government taken as a whole spends more. Consequently, the local authority associations — the Association of County Councils, the Association of District Councils and the Association of Metropolitan Authorities — were represented on the group monitoring the process, along with the Museums and Galleries Commission and Committee of Area Museum Councils. The full membership of the group is listed in Appendix A. Second, if the funding bodies seek to adopt policies which are to have a significant impact on the cultural scene, they have a duty to consult fully those who will be affected. Third, new ideas emerge when people get together to talk about common needs and opportunities. Finally, an open process is the best means to establish the partnerships so crucial in this area.

A major survey of public attitudes to the arts was carried out in the summer of 1991, and 44 discussion papers were published that autumn. They were considered at more than sixty strategy seminars, attended by more than three

thousand people, held throughout England between October 1991 and January 1992. There were also many regional and local strategy discussions convened by arts organisations, Regional Arts Boards and local authorities. And the discussion papers generated many hundreds of written responses.

The result was *Towards a National Arts and Media Strategy*, published in May 1992. It too was a document produced for consultation and improvement. Appendix B lists all those who responded to it in writing. This book is the outcome. In it, the authors, Howard Webber of the Arts Council and Tim Challans of East Midlands Arts, record the main lines of discussion which arose in consultation. Specific policy points for the funding system are to be found in the section entitled 'A Creative Future', between Chapters 2 and 3: see pages 25–40 below. The book relates to England alone; separate exercises were undertaken in Scotland and Wales.

Its writing has been an act of selection and organisation, rather than of creation. The process of gathering views and information revealed a range of aspirations and concerns very differently expressed but with a common core. Virtually everything of substance in what follows derives from things said or written during the consultation process. However, the discussion documents commissioned at the start of the process contain between them nearly 400,000 words. Millions more were spoken and written during consultation. This book seeks to synthesise and express the essence of these views. The beginning of a process as much as an end, the issues discussed here are not to be resolved in a single exercise. In some areas, the book is precise and specific. In others, it sketches in possible future developments – both because the future is uncertain and because the developments may depend on new links and partnerships yet to be forged.

Chapters 1 and 2 provide context and background. They are followed by a statement of principles, aims and policies for the arts and media funding system, submitted to the Secretary of State for National Heritage in October 1992. This statement has been endorsed by the Arts Council of Great Britain, British Film Institute and Crafts Council, and welcomed by the Scottish Arts Council and the Welsh Arts Council alongside their separate processes; it was produced in consultation with the Regional Arts Boards.

The statement is an agreed policy framework rather than a strategy in the technical sense. It answers the questions 'Where to?' and 'Why?'; not, other than in general terms, 'How?'. That question is to be answered by the individual corporate plans of the organisations concerned. The statement focuses on the funding system rather than on the arts as a whole; the issues it raises are discussed in broader terms in the chapters which follow it. These later chapters are addressed to others – artists, arts organisations, local authorities, the commercial and private sectors, planners, broadcasters – as much as to the funding system.

The book as a whole deals with the content and policies of arts support, rather

than with its form — such as the structure of the funding system itself. It discusses the standards by which the funding bodies will wish to be judged. If they meet these standards, the system's recent restructuring will have been justified; if not, it will need further structural change.

The outcome of this remarkable process is designed to be a means of advocacy for the arts, crafts and media, a practical working document and a shared vision of the future. It will be central to the work of the Arts Council, British Film Institute, Crafts Council and Regional Arts Boards; but it is for all who care about the arts and want them to flourish.

CHAPTER 1 · THE ARTS AND SOCIETY

Art and artists

It is notoriously difficult to say what art is or what it is for. One possible definition runs: art is a form of symbolic communication by which an artist represents and arranges objects, signs, sounds or events in a manner likely to imply meanings or arouse emotions. But that definition does not conjure up a sense of what art *does*.

Once the term implied a skilful activity carried out according to firmly prescribed rules; in modern times it has come more often to be applied to a non-pragmatic product which is free from constraints as to its utility, but whose creator possesses extraordinary qualities. These notions are often mixed up, but great differences exist between cultures as to who is thought to be and who is thought not to be an artist. In Chinese art great emphasis is placed upon continuity of knowledge and skill over centuries, upon the achievement of perfect realisations of the conventional; in modern Western art originality tends to be treated as a prerequisite of artistic identity.

The palaeolithic cave painter probably thought that his or her images of bison would help the hunters. Today those images are experienced as the purest examples of non-utilitarian art. There survives in our day a romantic view of the artist as a being necessarily in constant conflict with a constraining society. There is a converse view that emphasises the communal and highly dependent position of the artist as the co-ordinator of a diversity of roles and skills: the artist employs inherited conventions and practices, uses materials created by others, receives money which has been accumulated at the discretion of others, relies on others to make performance and exhibition spaces available and carry out the tasks of distribution. Then there are critics to deepen knowledge of the work, and historians, curators and teachers who help establish the framework of beliefs in which a work is experienced by audiences. Moreover the audience's response, the relationship between audience and artist, is part of the act of creation, as well as part of the process of reception. At one end of the spectrum of definition the artist is a divinely inspired genius and at the other end a cog in a complex social process. The poet can seem to be working entirely alone. The film and television director carries out a function within an industrial process in which many forms of art and many artists are at work.

A painter in fifteenth century Florence knew that every Biblical reference painted into a canvas, every gesture, every arrangement of figures would be recognised by the viewer; a painting could be an infinitely subtle weaving of symbols into an extended and sophisticated allegory, the meaning of which could

be read by almost any contemporary. The painter could rely upon the viewer's recognising, by the facial expression or the position of the hand of the Virgin, which of the five stages of the Annunciation was being represented, which human virtues were intended by every flower he had painted in the Garden of Eden. There are parallels in the culture of today: every television viewer understands the conventions implied by sudden cuts between scenes, interprets the looks, phrases and gestures of narrative television, grasps the difference between acted and documentary footage, between the rhetoric of the advertisement and the rhetoric of the interviewed politician, while instinctively noting the references between media and the jokes made by one comedian about another. Audiences are trained into their function, however unconsciously.

In any art gallery you can see the art of one age being appreciated by audiences of another age who probably lack the knowledge which gave the pictures their original meaning. At one level this does not matter. Art is something one learns from, rather than something one learns about. But as audiences acquire more of the knowledge built into art, their pleasure in it greatly increases. There is no art which does not teach and no art from which we cannot learn.

Many processes are entailed in the creation and delivery of any work of art, and it is impossible to agree exactly which processes, and which forms, are artistic and which not. The Greeks recognised nine muses presiding over various arts and sciences: music, poetry, dance and tragedy were the arts. Painting, sculpture and architecture subsequently joined the party of the 'fine arts', and this term finally came to be coded in Diderot's 'Encyclopédie' in the eighteenth century. Photography, cinema and video are examples of much later entrants, seeking to escape permanent relegation to the more modern category of 'popular' arts and wishing to join the more exalted ranks. The 'fine arts' tradition is still very strong especially in formal education but many feel that the time has come not just to admit one or two more to the pantheon but to pull down its dainty barriers altogether and evolve a different and more social notion of the arts. We have retired the muses and instead we enjoy a democracy of the arts.

'Who is doing most to shape British culture in the late 1980s?', asked two recent writers on the subject, 'Next Shops, Virgin, W.H. Smith's, News International, Benetton, Channel Four, Saatchi & Saatchi, the Notting Hill Carnival and Virago, or the Wigmore Hall, Arts Council, National Theatre, Tate Gallery and Royal Opera House? Most people know the answer and live it every day in the clothes they wear, the newspapers they read, the music they listen to and the television they watch.' People have acquired sufficient social confidence – plus a wide range of consumer-driven tastes – to reject confining inherited notions of the arts. They realise that art is also part of what they do and what they buy. The arts have been brought back in from that cultural reservation at the periphery of society where they were banished; they are no longer treated as the leisure pursuits of a refined minority. Their link to the central economic and industrial

processes is now widely acknowledged by artists, audiences and political leaders alike.

The idea that art has a social, an improving, role is an ancient one. Many traditions in architecture, for example, recognise the divine interconnections between buildings and the cosmos. Indian temples are built according to beliefs about the forms prevailing in Heaven. Renaissance churches are microcosmic representations of the mathematical perfection of divine Creation. Vitruvius noted the parallels between human shapes and geometric design. Buildings were messages in stone, intended to help reproduce in society the morality of a divine order. In industrial society the arts have remained fundamentally educative, helping to shape values, change them, reproduce them. The arts help to create new taboos and break others. This is not the first period in history during which the arts have become subject to 'political correctness'. Creative works, said Leslie Stephen in the 1870s, are both the producer and the product of society. Today they are expected to advance a series of causes which are social rather than aesthetic in inspiration. There is a danger of social purpose swamping aesthetic purpose; but the greater danger is to undervalue art merely because it seeks to further a social cause. Some of the greatest nineteenth century writers – Thackeray, Dickens, George Eliot, Tolstoy – represented contemporary mores, and in some cases sought social change, in their novels. The art of every generation bears the marks of attempts to impose (or to reform) contemporary values, ideas and behaviour. If there is one fault often shared by the people who gather around art it is censoriousness in good causes.

There are certain aspects of the arts which are more long term, perhaps eternal. They develop the senses and the emotions; they promote the growth of imagination and the creative use of materials. 'If I had to live my life over again', wrote Charles Darwin in his autobiography, 'I would have made a rule to read some poetry and to listen to some music at least once every week. For perhaps the parts of my brain now atrophied would thus have been kept active through use. The loss of these tastes is a loss of happiness and may possibly be injurious to the intellect and more probably to the moral character by enfeebling the emotional parts of our nature.' The arts develop the personality, of both individuals and groups.

The arts are also inescapably part of a material world with materialist values, and one of the most powerful (and just) defences of the arts is to argue the economic case for them. An opera house creates hundreds of jobs, brings in tourists and large sums of VAT. An internationally recognised orchestra raises the pride of a city. A best-selling author helps the balance of payments. A successful rock group can be as beneficial to exports as a new model of car or a pharmaceutical product. Cultural industries can be crucial in promoting regional regeneration, in restoring the life of cities, in creating skilled jobs in areas of unemployment and environmental decline.

It is necessary to remember and acknowledge that the arts are useful. It is just as necessary that every individual should be allowed to invent his or her own uses for them.

Definitions of the arts

Any attempt to define the arts – or arts and media – may diminish them. The only justification for using a definition is that of convenience; in this case, to indicate in a few lines the subject matter of this book and the area of interest of the arts and media funding system. The following definition, from Public Law 209 of the 89th United States Congress, has been found useful for this purpose:

> The term 'the arts' includes, but is not limited to, music (instrumental and vocal), dance, drama, folk art, creative writing, architecture and allied fields, painting, sculpture, photography, graphic and craft arts, industrial design, costume and fashion design, motion pictures, television, radio, tape and sound recording, the arts related to the presentation, performance, execution, and exhibition of such major art forms, and the study and application of the arts to the human environment.

This definition, used in setting up the American National Foundation for the Arts and Humanities, was also endorsed by the Education, Science and Arts Committee of the House of Commons in its 1982 report on funding the arts. And in essence it was the definition set out in the constitution of the Council of Regional Arts Associations in 1988. From here on, the arts will be defined in this wide sense except where the context suggests something more specific.

In a sense, the definition is an admission of the impossibility of defining the arts: it is basically a list, but one which does not even pretend to be comprehensive. Nonetheless, it has a number of virtues. It acknowledges that what can properly be regarded as the arts will change over time. It does not refer specifically to video or to art forms created using new technology, but it does include the crafts and the arts of the moving image; so the phrase 'arts, crafts and media' can be avoided unless a distinction is being drawn between these forms. And it extends beyond those art forms at present receiving significant public funding. **The endorsement of this liberal definition signals the adoption by the arts funding system of a broader cultural role than in the past – and one not necessarily limited to areas in which it has a major financial stake.**

Public funding of the arts

Why should it be the business of government to pay for the arts?

There are different answers, depending on the kind of society in which the question is put and on its values and aspirations. Some are 'weak' arguments in the sense that they support some intervention and some subsidy in some circumstances: there is a collective benefit to be gained from the arts, and government can help achieve it. Others are 'strong' arguments in the sense of amounting to a case for the centrality and necessity of government support: its absence is damaging to society as a whole. Fifty years ago, in the days of Keynes and the early Arts Council, the weak case was true and sufficient for the nature of the support expected. Today society has changed, and the role of the arts has changed with it. The case is now based upon the strong argument.

John D. Rockefeller III's views are illustrative of what is now an almost universally accepted position. 'Just as society has accepted responsibility for health, welfare and education, it must support the arts. Today creative development is as important to man's well-being and happiness as his need for physical health was fifty years ago.' That is the basis of the strong argument, but it is strengthened by the economic arguments, which come in three main forms.

The first is the argument of collective benefit: we are all improved by a society well endowed with artistic skills and talents, we want future generations to enjoy our heritage, but the cost must be met in the present. The second is that of equality of access: a pure free market would distort effective public access geographically as well as socially. And the third is the argument of preference distortion individuals simply do not have the information about the arts to enable them to make effective consumer choices. These arguments, however powerful they are, all presuppose that there exists a social priority attached to the arts. As economic arguments they are not complete in themselves. People enjoy unequal access to everything which is scarce or expensive, for example to good restaurants, but few would suggest that these should be subsidised. Many people do not have sufficient knowledge to evaluate the pleasures of wrestling, but that is not necessarily an argument for subsidy.

The arguments which underpin the economic ones derive from the essential characteristics of the arts — as support for emotional and spiritual health, as protection for the individual's and the group's sense of identity, as enhancement of the moral environment. They are placed at the door of government because society has abandoned other ways of supporting the inner life of its members and because it has lost or dethroned the institutions which once provided the physical (and doctrinal) support for the arts. These never did exist in the 'private sector'. The arts at times have enjoyed the support of rich private patrons, but generally have depended upon great institutions — churches, guilds, hospitals, monasteries, colleges, railway companies — for which painting, music and sculpture fulfilled a

clear purpose.

There are dangers in all government support: that it might directly or subtly interfere with the freedom of the artist, and that it tends to expect proofs of cost-effectiveness that might undermine artistic purpose and freedom. There are unmatchable advantages, however: that it is offered in the context of an openly debated public policy, and that it provides the only basis for opening the experience of the arts as of right to every member of society.

The arts need to be funded from public sources because they are vital, and because funding enables people to enjoy more of the range of the arts in more ways (providing that the money is well used). Public funding helps to ensure that personal inclination and not personal income is the touchstone of access; it enables the best work to be more widely available; and it assists the arts themselves to keep developing.

Today there is a mixed economy of the arts. Commercially produced plays tour to subsidised venues; plays from subsidised companies tour to commercial venues. Much of the drama in London's commercial West End originated in the publicly funded sector. Most of the performers, directors and technicians were trained or partly trained in subsidised theatre. The BBC is an arm of the public sector by which a large part of British musical and dramatic talent is discovered, recruited and trained; and which uses musical and dramatic talent discovered, recruited and trained elsewhere. The profitable parts of the arts industries would wither without the constant infusion of ideas, innovation and inspiration from the publicly funded sector.

The mixing of the arts economy goes deeper. The commercial recording of classical orchestral music and operas depends upon the existence of the subsidised orchestras and opera houses. Commercial publishers sell a high proportion of new hardback fiction to public libraries. The arts economy is both subsidised and commercial; it is a mistake to imagine that there exist two separate worlds.

Encouraging the arts to find every penny they can for themselves does not contradict the policy of public support for them. It is a policy of thrift and good management. The capacity of one art form to earn much or all of its own income in the market place does not constitute a case against subsidy where that is beneficial or necessary to a perceived artistic objective.

Conclusion

The arts are about developing the senses and the emotions, about promoting the growth of the imagination and the creative use of media and materials. The arts help individuals, communities and society as a whole to be more creative – in ways that go well beyond the arts themselves. The development of cultural identity is a basic human need, alongside those for

shelter, food and social relations. Art is central to this, whether one is involved as creator, participant or audience. Those who are denied arts opportunities are indeed deprived.

A Creative Future is a recipe not for creating art, but for helping to spread enjoyment and experience of the arts. Neither state subsidy nor private patronage nor the consumer market can guarantee the flourishing of any particular branch of the arts, for that depends upon a fusion of individual and societal circumstances; no single human agency can wittingly contrive them. However, a society which provides support for the arts from every sector of its economy tells the world that it welcomes and respects what the arts do. It will still need from time to time to look at the distribution of the financial and physical resources of the arts; it will need plans and policies and strategies.

CHAPTER 2 · PUBLIC FUNDING IN PRACTICE

Chapter 1 was a brief discussion of the arts in society and of the arguments for funding them from public sources. This chapter provides the practical context for the rest of the book – from a description of the funding system and its aims, through some examples of its spending patterns over the years, an illustration of the economics of typical funded arts organisations and some key points about the scale of arts activity in England, to a note on the social and population trends most relevant to the arts and arts funding. The purpose is to raise the questions that the rest of the book, looking to the future, seeks to answer.

The amount of public funding

Each organisation in the funding system has broadly the same objectives – to develop the practice and understanding of the arts, crafts and media and to widen opportunities to enjoy them and participate in their practice.

The aims of the **British Film Institute**, founded in 1933, are to encourage the development of the art of film in Great Britain and Northern Ireland; to promote its use as a record of contemporary life and manners; to foster study and appreciation of film for television and television programmes generally; and to encourage the best use of television in Great Britain and Northern Ireland.

The Institute's total income in 1992–93 is estimated at about £24.5 million, of which government grant is less than two-thirds. It is primarily a direct provider of services – for instance, the National Film Archive, the National Film Theatre, the Museum of the Moving Image and a range of production, exhibition, distribution and education services. Its funding role accounts for less than 15% of its total expenditure; and more than half of this funding is channelled through the Regional Arts Boards.

The **Crafts Council** was established as an independent body in 1979. The two major strands of its work are to enable as broad a section of the public as possible to see, experience, understand and enjoy the crafts; and to ensure that craftspeople receive suitable training, that standards of work rise and that businesses flourish.

The Craft Council's total expenditure is about £4 million, of which about three-quarters comes from government grant. Much of the Council's activity is as a provider of services; it spends about £1 million in grants, £700,000 of which is channelled through the Regional Arts Boards and the Welsh Arts Council.

The three objectives of the **Arts Council of Great Britain**, which was founded in 1946, are to develop and improve the knowledge, understanding and

practice of the arts; to increase and improve the accessibility of the arts to the public throughout Great Britain; and to advise and co-operate with departments of government, local authorities and other bodies. These objectives are also applicable to the **Scottish and Welsh Arts Councils**. The **Regional Arts Boards** in England are similarly constituted, seeking above all to promote high standards and to enhance access to the arts in society. The resources of the three Arts Councils and ten Regional Arts Boards are provided by central government – about £220 million in 1992/93. Around £44 million of this went to the Regional Arts Boards, and local government also contributed directly, in total, about £3.5 million to the RABs. Funds are divided between England, Scotland and Wales roughly in proportion to the population of the three countries.

The Arts Councils and Regional Arts Boards offer regular funding to about 600 arts organisations, and also offer several thousand project grants to organisations and individual artists each year. The largest grants are to the five 'National Companies' in England (the Royal Opera House, English National Opera, Royal National Theatre, Royal Shakespeare Company and South Bank Centre), which together in 1992/93 receive £62 million (around 30% of the Council's grant from government). The other largest subsidies are concentrated in opera and dance – to Welsh National Opera (£5.6 million), Scottish Opera (£3.7 million), Opera North (£3.7 million) and English National Ballet (£3.5 million). These figures are considered further below.

The grant from **central government** through the Department of National Heritage (formerly the Office of Arts and Libraries) to the funding system is far from the total of central government support for the arts and culture. In 1990/91, for instance, it totalled less than £176 million of a total of £494 million spent by the Office of Arts and Libraries. Of the rest, nearly £110 million went to the British Library, and more than £170 million to museums and galleries.

In the same year the Scottish and Welsh departments spent more than £45 million on museums, galleries, the arts and libraries; around £20 million was spent by the Department of Employment or its agencies on special employment measures to arts and cultural projects (1990 figures); £9.1 million from the Department of Education and Science was spent on university museums and galleries; the Department of Trade and Industry grant to British Screen Finance was £2 million; and the Ministry of Defence spent £55 million on military bands (1990 figures). These figures are not comprehensive, but it is likely that in 1990/91 central government expenditure on the arts, museums, galleries and libraries approached £700 million, and that its grant to the funding system formed little more than one quarter of this.

It is still more difficult to be precise about **local government** expenditure in this area, but figures collated from government expenditure plans suggest that local authorities in Great Britain spent in 1989/90 £291 million (including capital spending) on what were classified as museums, galleries and the arts.

Expenditure on public libraries is often excluded from discussion of public funding of the arts. Local authorities spent £580 million on public library services in Great Britain in 1989/90. A large part of this cannot be considered expenditure on literature or the arts in any form, but that is no reason to exclude *all* public library expenditure from the heading of 'arts and related activities'. Even if only one third of the revenue expenditure on public libraries goes towards literature and the arts, this comes to just over £190 million – making a total of over £480 million arts-related spending by local government in 1989/90.

Thus central and local government support for the arts, museums, galleries and libraries exceeded £1 billion annually by the beginning of the 1990s. And this is without taking account of the BBC's huge spending on drama, music and the other arts; or arts expenditure through the education system – from nursery schools to further, higher and adult education; or arts expenditure by the NHS.

Spending patterns and current strategies

Over the years, the constituent parts of the arts and media funding system have produced a variety of policy documents, corporate plans and mission statements, ranging from multi-volume extravaganzas to the four words 'access', 'excellence', 'resources', 'advocacy'. But it is arguable that the *real* strategy of the system is more accurately reflected in how it has chosen to spend the money available to it. In particular, the consistency of its spending patterns over, say, the past twenty years may provide some indication of how easy or difficult it might be to change these patterns in the future. For this purpose, two controversial issues have been chosen as illustrations: the allocation of grant between London and the rest of England, and the treatment of the largest funded arts organisations. For simplicity – and also because the Arts Council is by far the highest spending of the funding bodies – the following examples relate to the Arts Council's spending patterns in England (including that part of its grant passed on to the RABs and their predecessors).

Many papers, speeches and research documents have been produced on the issue of the arts in **London in relation to the rest of England**. One can argue that London should be artistically at least as well provided as other major capital cities; or that people throughout the country have the right to an equitable share of public spending on the arts, whether they live near a major population centre or in a sparsely populated rural area. Both policies can be justified, but it is unlikely that both can be pursued adequately at the same time. The table below shows total Arts Council expenditure for England (ie. excluding grant going to the Scottish and Welsh Arts Councils, but including that passed to the RAAs/RABs) for selected years from 1972/73:

£ Million	1972/73	1980/81	1990/91	1992/93
Total	10.3	54.7	141.2	178.2
Grants to RAAs/RABs	0.78 (8%)	7.7 (14%)	33.4 (24%)	44.0 (25%)

This is a 1600% rise in money terms in the total sum. When inflation is taken into account, it has increased by 170% in real terms. The grant to the RAAs/RABs has obviously grown much faster than this.

This is the picture of total Arts Council and RAA/RAB spending in London and the rest of England:

£ Million	1972/73	1980/81	1990/91
London	5.1 (49%)	27.5 (50%)	71.1 (50%)
Rest of England	5.2 (51%)	27.2 (50%)	71.1 (50%)

Thus over the last twenty years, one half of Arts Council and RAA money has been spent in London (though this includes spending on the 'National Companies' – see below). This proportion has remained almost exactly the same over the years. The implications of this are considered in Chapter 11.

Another common criticism is that relatively **few large grant recipients receive a disproportionate share of total resources**, leaving too little for young and emerging artists, producers and companies. The following table analyses the twenty largest grants in selected years, as a proportion of total Arts Council and RAA/RAB spending in England:

£ Million	1972/73	1980/81	1990/91	1992/93
Total	10.3	54.7	141.2	178.2
The twenty largest grants	5.4 (52%)	29.3 (54%)	73.4 (52%)	90.1 (51%)

This is striking: in each of these four years from the 1970s, '80s and '90s, the twenty largest grant recipients have between them received more than half of total Arts Council and RAA/RAB spending in England. This percentage has remained remarkably constant, though the list of companies has changed somewhat. Does this suggest that new development has been squeezed out of the system by a too rigid loyalty to large existing organisations? Chapters 3 to 5 consider this issue.

One element of the treatment of the big companies is the amount and proportion of grant going to the National Companies. This is the picture for the same years as above (the South Bank Centre became a funded National Company only in the mid-1980s):

£ Million	1972/73	1980/81	1990/91	1992/93
Royal Opera House	1.75	8.2	15.9	19
English National Opera	0.94	5.5	9.1	11.4
Royal National Theatre	0.4	5.2	9	11.1
Royal Shakespeare Company	0.43	2.5	6.8	8.8
Total	3.5 (34%)	21.4 (39%)	40.8 (29%)	50.2 (28%)

Thus the four National Companies together receive just less than 30% of total Arts Council and RAA/RAB spending in England, a proportion which has dropped significantly since 1980. Is this the right direction to be moving in? What is the proper relationship between National Companies and all others? These questions will also be considered in Chapters 3 to 5.

The economics of funded arts organisations

Arts organisations which receive regular financial support from the funding system are diverse and do not follow a single standard pattern of costs and income. The relationship between earned and grant income is very varied (some regional theatres, for instance, earn a far lower proportion of their own income than the one illustrated below). What follows are merely examples, but there are common features which can usefully be drawn out.

Many funded arts organisations depend on four main categories of income:

- earned income (including box office, fees for performances, sales of books/ magazines or artworks, profits from catering and commercial trading operations);

- contributed income (including sponsorship, membership schemes, fundraising);

- grants from local government; and

- grants from the arts and media funding system.

The profile of these sources of income will vary from art form to art form. Building-based producing theatres, for example, raise most of their earned income at the box office, while many art galleries do not charge for admission.

On the surface, funded arts organisations face a dilemma between maximising earned income by increasing prices, and improving accessibility by keeping prices low. In fact the issues are more complex; they are considered in Chapter 6.

Most funded organisations are registered charities, and operate on a break-even basis – that is, they plan to make neither profit nor loss. This has traditionally been the funding bodies' requirement. In some cases, this balance has proved difficult to strike and losses have been made, often with the result that future years' activities have had to be curtailed to recoup the loss. Many arts organisations are different in their financial structure from commercial companies, and indeed from many other charitable bodies, in that they have little or no capital finance; they operate almost exclusively on working capital. In theory, this makes it difficult for them to undertake capital investment, leaves little flexibility to cope with financial underperformance, and inhibits long term financial planning. In practice, however, many organisations have developed methods of retaining some element of capital finance through asset replacement and other specific reserves, through separate trusts, and by adopting accelerated depreciation and asset write-off policies.

Patterns of expenditure are as varied as those of income, except that labour costs are invariably crucial. As can be seen below, they form the majority of the costs of an orchestra and building-based producing theatre, and are by far the largest cost item even for less labour-intensive organisations, such as an art gallery. The other key cost variables are the volume of activity (e.g. how many touring weeks a company provides), and the quality of that activity. It is, however, notoriously difficult to correlate quality with expenditure, not least because of the risks inherent in the creative process.

The chart below illustrates the income and expenditure profile of a large independent gallery, with total income and expenditure of around £500,000. As often in the visual arts, this shows a lower proportion of earned income than is generally the case in the performing arts:

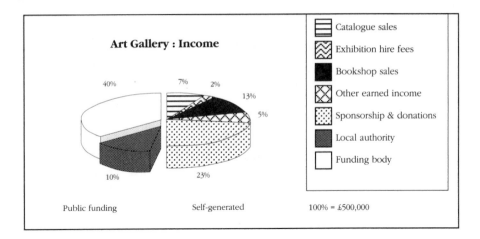

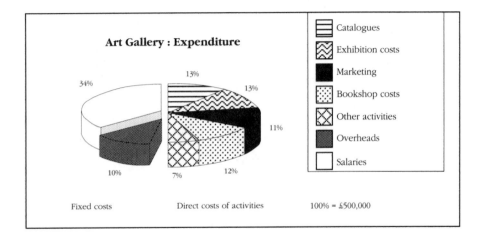

Key points:

- Lower proportion of earned income than performing arts
- Catalogue costs exceed income
- Bookshops make small profits
- 50% of total income is self-generated

This may be contrasted with the profile of an orchestra (with an annual income and expenditure of around £5 million) which is illustrated in the chart below. This shows a significantly higher proportion of direct salaries and artists' fees:

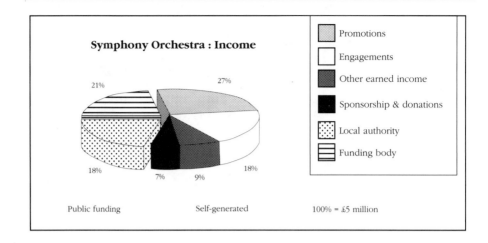

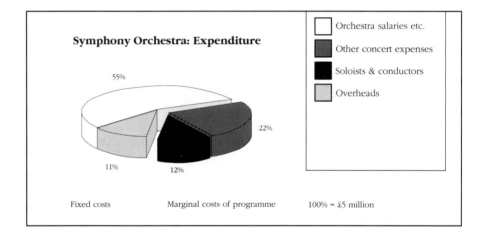

Key points:

- 61% of total income is self-generated
- Fixed costs represent 66% of total expenditure
- Of all arts organisations, orchestras spend the highest proportion of their expenditure on performers (67%)

The final table shows the profile for a regional producing theatre. Its annual income and expenditure are about £1.2 million and, like the orchestra, it receives approximately 40% of its income from local authorities and funding bodies:

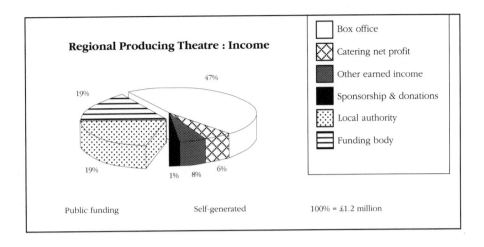

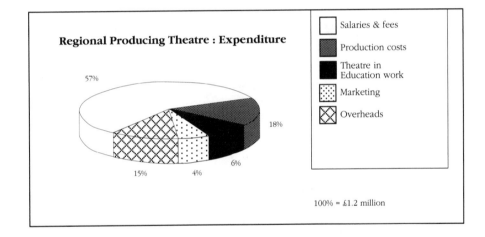

Key points:

- 62% of total income is self-generated
- Funding body financial support is matched pound for pound by local authority
- Theatres receive less income through sponsorship and donations than other arts organisations
- Overheads represent a relatively high proportion of total costs, reflecting the greater expense of operating a performing arts venue

The scale of arts activity

The Policy Studies Institute's (PSI) admirable publication, *Cultural Trends*, and the PSI report, *Amateur Arts in the UK* (published in 1991), provide a comprehensive picture of levels of arts activity in England, what is funded and who benefits. To highlight some points:

Theatrical performances
- There are around 18,000 drama performances each year in England which receive funding from the Arts Council or a Regional Arts Board. Six million seats are sold for these.

- There were around 63,000 performances, grant aided and otherwise, of drama, musicals, opera and dance in the UK in 1990/91. Slightly under 27 million seats were sold and total box office income was nearly £300 million.

- The average capacity filled was substantially higher in the West End (and South Bank) than outside London – 69% as against 58.5%.

Film, broadcasting and recording
- In 1988/89, BBC Television broadcast 476 hours of drama, on which it spent £97 million. (Altogether more than 5,000 hours of plays, series and TV films were broadcast on network television.) In terms of hours broadcast radio is an even more important source of new and classic drama.

- In 1988/89, BBC Television spent nearly £19 million on music and arts and BBC Radio spent nearly £31 million on what it called 'serious music', including £7 million on the BBC orchestras.

- The average number of hours of television people watched (including video playback) fell by 7% between 1985 and 1989, while the number of hours of television broadcast rose by nearly 30%.

- The sales of what are defined as 'classical albums' more than doubled between 1984 and 1990. Sales of all other recordings rose by little more than 10%.

Visual arts and literature
- Visits to UK museums and galleries total between 80 and 100 million each year.

- Public libraries issue an average of ten books per year for every man, woman

and child in the United Kingdom. 60% of issues are works of fiction for adults.

- 7,400 works of fiction were published in the UK in 1989; twice as many books are published in the UK each year as in the USA.

- In 1989 total sales of fiction in the UK amounted to £3 billion. The number of books sold rose by more than a third during the 1980s.

Participation in the arts
- More than three quarters of a million adults in the United Kingdom are regularly involved in formal amateur arts or crafts groups.

- Three million people regularly take part in one of the textile crafts, nearly 1.8 million in amateur music and drama and a similar number in painting and drawing.

- 16–19 year olds on average attend professional performing arts events, other than pop and rock concerts, less than any other age group. But this group has the highest involvement in the amateur arts.

- Annual spending on films, film processing and photography equipment in the UK is more than £1 billion.

- Compared with urban areas, rural areas tend to have fewer professional arts facilities but more formal amateur arts groups and a higher level of participation in them.

Attitudes to the arts
As part of the strategy process, a major survey was undertaken of arts and cultural activity in England. It was carried out by Research Surveys of Great Britain in June and early July 1991, by means of interviews with 8,000 adults. Among the main findings were these:

- 69% of the adults questioned support public funding of the arts and four-fifths of these, 55% of adults, support the funding of new and experimental work.

- Nearly 80% consider that arts and cultural activities help to bring people together in local communities, and more than 70% that arts and cultural activities help to enrich the quality of life.

- Only 4% of those interviewed *spontaneously* mentioned price as a reason for not attending arts and cultural events, but 40% said that the price had put them off going to at least one arts event. This view was strongest on the part of younger people.

- Only one-third thought that there were not enough arts or cultural events of interest in their area – but again, it was younger age groups which were most dissatisfied.

Social and population trends

The **overall population** of the United Kingdom is likely to increase by around 2.5 million, to 60 million, between 1990 and 2010 – rather more than in the previous twenty years. More significant, the **age structure** of the population will change markedly. In recent years, the number of teenagers has fallen sharply. Over the next twenty years, their number will level out, and it will be the 20–34 age group whose numbers will fall, from around 12 million in 1990 to fewer than 10 million by 2010. On the other hand, there will be a major increase in the population aged 45 to 64 – by 13% over the decade to 2001. Perhaps the most notable change in population structure is in the number of people aged over 80. In 1970, there were about 1.2 million. By 1990, this had risen by almost 75% to 2.1 million, and by 2010 there are likely to be 2.7 million people in this age group.

Given the projected sharp decline in the number of young adults in the United Kingdom, and the increase in the group aged 45 to 64, a shift in emphasis may be indicated in the nature and forms of support for artistic activity. By 2001, people in the 45–64 age group will be those who reached adulthood between the late 1950s and the late 1970s. Will they change the nature of this age group, or will reaching this age group change them? What should be the response of public funders of the arts to the more than doubling within a generation of the population aged 80 and over? All surveys suggest that infirmities due to age are a major factor preventing people from attending arts events outside the home. Given technological changes which will make potential arts provision in the home more satisfying, and the increase in the number of people with no alternative to such provision, public funders of the arts must consider giving higher priority to making the arts available at home and to working with social services and residential care authorities.

The Office of Population, Censuses and Surveys estimated that in the mid-1980s there were around 600,000 people in Britain of **Caribbean or African origin** and around 1.3 million people of **Indian, Pakistani or Bangladeshi origin**. The decline in immigration from these parts of the world means that an

increasing proportion of these groups was born in the United Kingdom (this is true of almost 50% of the 15–29 age group). What are their needs and aspirations?

Only around 60% of 16 year olds in the United Kingdom are in **full-time education**. This is far lower than in most European Community countries (in Italy, for example, the figure is 70%, in the Netherlands over 90%). If this percentage rises, there may be significant implications for the arts. Audiences for arts events are drawn disproportionately from those sections of the population which are or have been in full-time education. Will demand increase if the size of this group increases?

The **geographical distribution** of the population is a further important factor. The United Kingdom is among Europe's more densely populated areas. England itself is the most densely populated country in Western Europe. But the distribution of that population has changed in recent years by a shift out of large towns and cities to smaller towns and country areas. This too has implications for arts support. On the one hand, the size of local audiences for the largest arts organisations in the major centres of population is likely to remain static or even to fall to the year 2000, while the number of people removed from these centres of population will rise substantially. On the other hand, people may be more mobile, and newcomers to small towns and rural areas are likely to be diverse in their occupations, not to work locally and to have their roots elsewhere. Where will their allegiances lie? Will they be concerned primarily with the cultural life of their new homes, or will they wish to retain links with cities?

These issues, together with implications for the inner cities and public transport, are considered in Chapter 11, and underline the inter-relationship of the arts with social and population trends. If, for example, cheap, efficient and welcoming public transport is important for people wishing to visit arts venues, then the funding bodies have a duty to campaign for this. Equally, an arts venue's work in making itself accessible to people with physical disabilities will be severely compromised if for whatever reason the surroundings are not accessible. These matters are partly the responsibility of central government, but more so of local government. They are one reason among many why there must be effective partnership between the funding bodies and local authorities.

There is a further context in which the arts should be placed. The arts are a way that people use their leisure time, as participants and consumers, alongside sport, tourism and hobbies. These activities are 'competitors', but in a broader sense they are allies: together they are a vital part of what is meant by the quality of life. There should be greater co-operation between the bodies working in these various fields. The creation of the new Department of National Heritage, encompassing the arts, heritage, sport, tourism and broadcasting, is a welcome and exciting recognition of the shared interests of these fields.

Conclusion

The purpose of this chapter is to record relevant facts and raise some of the questions to be discussed and answered in later chapters. But it leads to some conclusions also, all of which suggest the need for a broad and flexible approach by the funding system:

(i) **The Arts Council, British Film Institute, Crafts Council and Regional Arts Boards are significant but relatively small players in a big game.** They are responsible for only a minority of central government spending on the arts, crafts and media; and for a relatively small minority of *total* government expenditure, central and local, in this area.

(ii) **The funding system's spending patterns have changed slowly, if at all, over the years.** Dramatic changes in the future, whether or not desirable, are unlikely; they will be easier to bring about in a situation of rising rather than static total expenditure.

(iii) **Funded arts organisations are anything but feather-bedded.** Their (usual) lack of capital reserves and their need to operate on a break-even basis makes them particularly vulnerable to outside economic circumstances.

(iv) **The arts, crafts and media are a major series of industries.** Even the 'pre-electronic arts' involve many millions of people doing, watching, listening and reading.

(v) **The funding system must respond to significant social and demographic changes – in particular the ageing population and the drift from the cities – if it is to provide a proper service to the public.**

The main lesson of the chapter is this: **the arts do not exist in isolation, and to be involved with the arts is to be involved with society.** The funding system must form partnerships with all those working in related areas: with those who spend public money on the arts, from local authorities to the BBC; with the commercial arts, media and cultural industries sectors; and with bodies responsible for public policy on sport, tourism and related areas.

A CREATIVE FUTURE

This part of the book reprints the submission presented to the Secretary of State for National Heritage in October 1992. It forms the strategic framework within which the funding bodies will produce their individual corporate plans. The following text omits some of the submission's introductory material, because its substance is to be found in Chapters 1 and 2. Apart from this and the addition of references to relevant later chapters, the text is unchanged.

The context

In the half century since the Second World War, the arts, crafts and media in Britain have been transformed. Theatre, opera and dance companies have been established throughout Great Britain. There is a rich orchestral life. Poets and novelists maintain the country's long literary tradition. Television and radio reach into almost every home, creating new art forms and transmitting existing forms. There is an extensive network for the distribution and exhibition, if not the production, of film. Britain remains one of the leading international centres for the crafts and visual arts. Hundreds of thousands of amateurs make music, present plays, write poetry, paint pictures and take photographs, so helping the arts to flourish in local communities and neighbourhoods.

As the working week shortens, as the population ages, people have more time than ever before to participate in the arts, whether as receivers or makers. Research shows that a majority of the population values the arts for the quality they add to life.

Many of our themes for the future arise from the strengths and weaknesses of the present:

> The funding system has long been committed to the support of new work and of education and outreach activity. Apart from the crafts, the emphasis has been on the provision of assistance to organisations rather than to individuals. But in the funding of institutions, we must keep clearly in view the product – the art itself – which will generally be the work of individuals. Their artistic and economic welfare must be our concern too.

> One example of the focus on institutions is the great post-war theatre

building programme, largely financed by local government. But many of these theatres are now in a poor state of repair. Outside London there are too few high-quality spaces for temporary art exhibitions or for dance. In some parts of the country, important gaps remain to be filled (for example, there is no purpose built concert hall in the North-East).

Although the Arts Council of Great Britain's predecessor, the Council for the Encouragement of Music and the Arts, saw the arts as an integrated whole, the public funding system has mainly focused on the professional rather than the amateur. There is a growing acknowledgement of the creative contribution from those whose artistic practice is voluntary and is not their main profession or vocation.

The major cities, particularly London, receive the majority of public funding. We must ensure that this artistic investment benefits the country as a whole — and that high quality touring work and the organic development of the arts are properly supported outside the big cities.

Great Britain is a diverse society. Funding tends to be directed towards the long-established and to those whose concerns reflect the dominant culture. But there is a great deal more on offer. Artists in the African, Caribbean and Asian communities are a major influence on the arts in Britain. Disability culture is a source of original and exciting work. The arts of the indigenous linguistic minorities in Scotland and Wales flourish.

Just as Great Britain is politically and economically part of wider international networks and interests, so its arts are an aspect of world culture. There is evidence of a growing enthusiasm among both public and promoters for a more comprehensive diet. Likewise, through the British Council much of the best of British arts is presented abroad — but more organisations and individuals could benefit from the experience than have the opportunity to do so at present.

In recent decades, local authorities have made a huge contribution to

the development of the arts. Without their work, the artistic life of the country would be decimated. But the record is still uneven. Moreover, there have been many recent changes to local government and to the education system, and more are in the pipeline. Many believe that support for the arts in both areas is at threat.

This country possesses artistic talent in abundance; money is in shorter supply. Much of this strategy can be achieved within existing resources, requiring no more than partnership between the many bodies which share a concern for the arts, or improvements in the funding system's own ways of working. Other aspects, inevitably, need more money. There are, finally, matters which must be dealt with at the political level – for example, the reviewing of certain aspects of the national curriculum in England and Wales and of local government finance. With the creation of the Department of National Heritage, the prospects are bright for such issues to be given the consideration they require and deserve.

We live in a society which is pre-eminent in many art-forms and well-endowed in virtually all of them. This must be sustained and enhanced. The arts fulfil needs which are personal as much as social, and success cannot be judged exclusively in utilitarian terms. All those who have been working over the course of many months on the strategy process have realised that Great Britain is poised for a leap forward in the arts, one which could transform the position of the arts in the minds of all the people in this country.

Principles and aims

The national debate of the past months has led to the identification of the ten following principles, which are consistent with the broad objectives of the arts and media funding bodies (see Chapter 2, pages 11–12) but develop and refine them. Each is accompanied by an aim which relates to it. We begin with the most general principles.

(1) **The arts, crafts and media are central to the lives of individuals and the well-being of communities. They offer inspiration, pleasure and comfort; and help people to criticise and celebrate society and understand their relationship to it.**

Our aim is to persuade both the general public and the government of this centrality and to ensure that audiences, artists, producers and participants are moved and challenged by the arts.

(2) Everyone should have the opportunity to enjoy the arts both as participant and as audience member.

Our aim is to make this opportunity effective, by increasing the availability of the arts, crafts and media, and by breaking down the barriers – social, physical, economic and others – to their active enjoyment.

(3) Education is at the heart of enjoying and understanding the arts and media. It is fundamental to a vital, varied culture.

Our aim is to ensure that education becomes more central to our work and that of arts and media practitioners; and that the arts and media become more central to the work of the education sector, formal and informal.

(4) Quality is the pre-eminent criterion for public funding of the arts. Quality is a broad term, encompassing such concepts as fitness for purpose. Work of high quality and originality may be produced in any form, at any scale and from any cultural aesthetic or community.

Our aim is to support high quality arts and media work in whatever form it is to be found and from whatever cultural aesthetic or community it springs, and to support particularly the creation, production, exhibition and publication of original work in all forms and media.

(5) Diversity and variety in the arts and media are valuable in themselves and as a reflection of contemporary life.

Our aim (as the complement to (4) above) is to support the widest possible range of arts and media, in order to promote choice, understanding and respect for all cultures.

(6) It is imperative that the arts of the past be renewed and kept alive.

Our aim is to ensure that artists, producers, curators and audiences, now and in the future, are able to benefit from the arts of the past, whether in

performance, audio and visual recording, publication, collections or archives.

(7) The arts and media should be viewed in an international as well as a local, regional and national context.

Our aim is to facilitate and support an international dimension to the work of artists and arts organisations in Great Britain, and to assist audiences and communities in Great Britain better to enjoy and understand artistic forms and activities from all over the world.

(8) Public funding of the arts and media, in people, buildings and equipment, is an investment. Its dividends are creativity, inspiration, civic pride and personal pleasure and confidence, as well as economic benefit.

Our aim is to act as effective advocates for increased funding of the arts and to promote the greatest benefit from such funding, through partnerships with the public and private sectors and other means.

(9) The arts should be generally available throughout the country.

Our aim is to encourage artistic development nationwide, continually to reassess the geographical and art form distribution of our resources and to alter the distribution nationally, regionally or locally in support of the principle.

(10) The arts and media funding system is accountable to the public through Parliament. It should seek to represent, be advised by and deserve the trust of the arts community.

Our aim is always to operate fair, simple and open procedures, with decisions taken at the most 'local' level appropriate; and to act as constructive and creative agencies in the support and development of the arts and media.

The funding system's pledges

This section is complementary to the principles and aims above and to the

policies below: our ability to make progress is dependent not merely on adequate resourcing but also on our ensuring effective, efficient and fair working methods. As with the rest of this paper, detailed targets and methods of review and assessment will be included in individual corporate plans.

These are our pledges to the public, the arts community and the government.

1 We shall become more effective advocates for the arts, crafts and media and their development, backing this up by co-ordinated research and effective dissemination of information.

2 We shall ensure that our application procedures are marked by simplicity, openness and fairness, with reasons provided for our decisions.

3 We shall ensure that there is a clear and consistent division of responsibility, function and duty between the national and regional elements of the system, with decisions taken at the most local practicable level (which will mean, where appropriate, delegation of decisions and funding from the national to the regional level and in some cases the 'franchising' of funding responsibility from the regional to the local level).

4 We shall maintain and improve our partnership with local authorities, which has been an essential feature of the post-war development of the arts.

5 We shall ensure that our decision-making is informed by a comprehensive range of sources of advice, including external advisers from a wide variety of backgrounds and cultural interests, self-assessment, funding body assessment and audience review. This range will enable us to realise the ideals of Principles 4 and 5; and it presupposes the retention of an 'arm's length' relationship between government and the funding system.

6 We shall work towards a relationship with funded arts and media organisations based on contracts negotiated and agreed with them in advance, which will define the purpose and conditions of funding and

the process of assessment. Where practicable, such funding contracts will be jointly negotiated with other funding agencies such as local authorities.

7 We shall work with arts and media practitioners to identify and provide, subject to financial and staffing constraints, support services in such areas as marketing, training, board development and management advice.

8 We shall place a high priority on effectiveness, efficiency and value for money, both for ourselves and for those we fund, in order to ensure that our investment and other activities achieve the greatest possible benefit.

9 We shall create or strengthen practical working partnerships with other bodies which have an interest in heritage and cultural issues. These partners or potential partners include museums support bodies; the commercial and industrial arts and media sectors; the formal and informal education sectors; the public library service; the private sector and the Association for Business Sponsorship of the Arts; tourism and economic development agencies; national organisations with a cultural role (such as English Heritage, the British Council and the broadcasting companies); and the Department of National Heritage and other government departments.

Policies

This section sets out key policies for the funding system, each of them deriving from one or more of the principles and aims above. Under each heading, the policies are put in a rough order of priority, and the most relevant principles and aims are listed. The headings themselves are also in order of priority, but in practice they are interdependent and of broadly equal status. It is necessary to renew the building stock in order to house a wide range of high quality arts activity; participation and diversity are the other side of the coin to 'the artistic imperative'; and, in different ways, education and money underpin all other areas of development.

The following programme is an integrated whole. All of it is necessary if we are to provide a comprehensive service to the public and to

the arts, crafts and media; though obviously it will be implemented in various ways, according to the art forms, regions and organisations concerned. Where examples are used in what follows, they are for illustration only: many others could have been chosen.

Some but not all of the programme will require a significant increase in resources. In current economic circumstances, this is unlikely in the short term. But our programme looks forward to the year 2000. It is right that, over this longer period, the funding system should be planning the use of increased resources.

In the meantime there are, inevitably, choices to be made. The detail of these choices is a matter for individual funding body corporate plans. We are, nonetheless, already taking action on some of the policies below. Others, particularly in the area of advocacy, can be implemented at little cost. Still others, which represent a change of direction or emphasis, are so important that we have determined to make a start on their implementation pending a real increase in grant-in-aid from the government. This need not require a significant re-allocation of funds away from current uses. In our funding role, we work *with* and *through* artists and arts organisations (though, as noted above, the BFI and Crafts Council are primarily direct providers rather than funders). This will continue to be the case. But our client list and our relationship with clients will evolve and develop. One of the most important developments will be contractual funding. This will enable us to ensure that, by mutual agreement, clients are funded specifically for work in some of the policy areas below.

The policies marked with an asterisk – which constitute the majority of those listed – are those on which we shall begin or continue action in the short or medium term. We can make no such commitment about those not marked with an asterisk, though individual funding bodies may well begin or continue action on some of these also. Resources permitting, we expect to be able to report progress in all these policy areas within three years.

1 The artistic imperative

These policies re-affirm our support for the 'originating artist' in all forms and media. We wish to encourage an increase in the amount of original work created and presented by artists and to improve the economic status and, indirectly, the public standing of the artist in society. (Chapters 3 to 5 discuss these issues more fully.)

* 1 Support for the creation of original, and where appropriate innovative, work by artists and groups of artists through means which match the needs of the art forms and artists concerned – such as funds for commissioning; for affordable rehearsal or studio space; for facilities for artists with disabilities; for setting-up crafts businesses; and for increased investment in film and video production. (Principle 4)

* 2 Support for the distribution, exhibition and presentation of original work in all media to existing and new audiences – for example, through funds for recording subsidies, for new means of presenting the visual arts and crafts, for assisting Black and other culturally diverse companies to run their own buildings and for permitting more dance and theatre companies to move to a fuller 'producing year'. (Principles 2 and 4)

* 3 Support for a network of arts and media organisations to preserve and renew the arts of the past, to encourage new work and new means of presentation, to serve the communities in which they are based and to act as a resource for artists and other arts organisations – for instance, through investment in programming and the promotion of conductor/choreographer/playwright (etc)-in-residence schemes. (Principles 2, 4 and 6)

* 4 Support for both initial training and re-training of arts practitioners in all forms, and others in the arts and media industries, through improved links with training providers (such as industry training organisations, TECs and LECs), training bursaries and so on; making available training to meet the needs of disabled artists; working to ensure that training is not dependent on economic status; and assisting artists to bridge the period between training and establishment in the professional world. (Principles 1 and 4)

* 5 Support for the use of new technologies in the arts, crafts and media. (Principles 4 and 5)

* 6 Support for art as an integral part of the environment – for instance, through funds for the development of public art,

lobbying for percent for art and promoting public debate on architecture and planning. (Principles 1, 2 and 8)

* 7 Support and advocacy for archives – for the preservation in appropriate institutions and collections of records of the arts and media, in sound, vision and print – for the benefit of posterity and the national heritage. (Principles 2 and 6)

II Participation and diversity

We intend to encourage an improvement of artistic standards in the amateur and community-based arts; and to increase the stability and influence of culturally diverse arts organisations.

Our programmes and practices should take into account the demographic changes occurring in Great Britain. Furthermore, opportunities to participate in the arts should be provided in ways which suit the individuals and communities to which they apply – rural or urban, young or old, male or female, deaf or hearing, Black or White: cultural diversity must become a practical reality, and one not restricted to the arts of particular communities or cultural aesthetics. (See further Chapters 7 and 8.)

* 1 Support for the full range of the arts – which includes amateur and community-based arts activity, as well as professional performance (these are merely terms of convenience, not watertight categories). We shall provide funds for advisory, training, membership and support organisations, and for professional input in participatory arts. Our aim will be to encourage new work, to increase local participation and diversity and to assist those who are seeking to raise standards. (Principle 2)

* 2 Support for the arts of the diverse cultures of Great Britain. Significant artistic movements are more likely to realise their potential if provided with structural support and funding (including funding for 'umbrella' support organisations) rather than with short-term project grants alone. Culturally diverse art has too seldom received such structural support. We shall alter this emphasis in the future. (Principles 4, 5 and 9)

 * 3 Support for the indigenous contemporary, folk and traditional arts
 of Scotland, Wales and England. (Principles 4, 5 and 6)

III Education
Our ambitions in the field of education and the arts go well beyond the
quantifiable. We propose initiatives which will enrich the lives of
children and others in the education system; and encourage a new
generation of active and adventurous readers, viewers, listeners and
participants – an important pre-condition of development of the arts and
of audiences.

Many arts organisations have pioneered inspiring educational prog-
rammes, which have helped thousands of people to understand and share
in the arts. These programmes must be maintained and enhanced. Many
of those in both the education and arts sectors fear that insufficient
funding and the recent reforms of the education system (including local
management of schools and opting out), whatever their other effects or
benefits, may put this work at risk. (See further Chapter 9.)

 * 1 Advocacy of the value of the arts, crafts and media in education
 (including special education) and advice on best practice to
 providers of education, including central government education
 departments, local education authorities, teacher education in-
 stitutions, providers of further, higher and adult education,
 school and college governing bodies and broadcasters. (Principles
 1, 2 and 3)

 * 2 Advocacy and lobbying particularly in two areas: the provision of
 mandatory grants at full cost for all arts courses in further and
 higher education; and inclusion of an arts subject, of the pupil's
 choice, as a mandatory part of the national curriculum for the
 14–16 age group in England and Wales. (Principles 1, 2 and 3)

 * 3 Forging links between pre-professional education and professional
 arts and media practice, with particular emphasis on the develop-
 ment of new creative talent. (Principles 3 and 4)

 4 Increasing the training and funding available for high quality
 education work by funded arts and media organisations, particu-
 larly for programmes that introduce artists and media practition-

ers into formal and informal education; and the careful evaluation of such programmes. (Principles 2, 3, 4 and 5)

5 Partnership with the public library, museum and gallery and broadcasting services, which are vital resources in arts and media education. (Principles 2, 3 and 6)

6 Advocacy to the public at large of the value of education as a means of increasing enjoyment and understanding of the arts. (Principles 1, 2 and 3)

IV Audience development

Our aim is to increase both the number and the social range of audiences. Effective access for disabled audience members is an important element of this. Further, we are as much concerned with the quality of experience as with numbers; the public has high expectations of the arts, and attention to its wishes will benefit the quality of art as well as the arts economy.

'Audience development' has at least three aspects: heightening the experience of viewing, reading, listening to the arts, crafts and media; increasing the numbers of people throughout society who have the opportunity to do so; and assisting the process of mutual understanding between maker or performer and receiver. (See further Chapters 6 and 13–15.)

* 1 Support for touring and distribution, including assistance to those who work in arts buildings (including arts centres, community facilities, and other performing arts venues, film theatres and cinemas, museums, galleries and libraries) to create a range of imaginative programmes; an increase in performing arts touring, particularly to reach new audiences; an increase in visual arts touring, arising particularly from improved links with museums, galleries, arts centres, collections and archives; initiatives in publishing; and 'electronic touring' – video, CD-I and so on. (Principles 2 and 4)

* 2 Support for marketing as a means of developing existing and new audiences for the arts. (Principle 2)

* 3 Reaffirming commitment to the principle of public service

broadcasting by both the BBC and the commercial companies, to provide an environment within which broadcasting as an art form can flourish and arts programming is supported. (Principles 1, 2 and 4)

4 Support for arts festivals presenting original work or reaching new audiences, and for local, regional, national and international artistic celebrations; where necessary through 'major events' funds to assist such initiatives as Arts 2000, the Cinema Centenary in 1996 and the possible Festival of Britain in 2001. (Principles 2, 4, 7 and 8)

5 Research to improve our understanding of audiences and partici- pants in the arts and their needs – including the barriers (psychological, educational, geographical, social, economic and physical) to full enjoyment of the arts. (Principle 2)

6 Support for outreach work by arts organisations to develop new audiences and participants, where necessary linked to programmes of research and evaluation. (Principle 2)

V Renewal of the building stock
By the end of this century, we hope that the stock of arts buildings will have been refurbished and where necessary new buildings constructed – so enabling people in every part of the country to enjoy the arts, crafts and media in settings which are welcoming, exciting and beautiful.

A large part of our building stock is in urgent need of refurbishment. The last boom in arts buildings – roughly, the fifteen years from 1955 – created its own problems in terms of running costs, maintenance and repair. Furthermore, certain art forms, such as dance, were left short of properly equipped spaces.

A key need is to ensure that arts buildings are accessible to disabled people. 'Accessible' must be seen as a broad term, covering physical access for both audiences and practitioners, signing, audio description and disability equality training.

Local authorities play the leading role in the provision of arts buildings, but the arts and media funding system has a broad strategic responsibility as well. The priorities which follow call for significant and bold investment by government. (See further Chapter 12.)

* 1 Drawing up a 'millennium map' based on a national audit of existing arts buildings (eg. theatres, concert halls, galleries, film theatres, arts centres and other multi-use buildings) and of the need for new buildings (such as a dance house and a deaf theatre). The question of access for disabled people will be addressed. (Principles 2 and 8)

* 2 Initiating a ten year programme, taking full account of value for money, and identifying resources from central and local government, charitable foundations and private sources, to meet the needs identified in the millennium map and validated by feasibility studies (see below, 3). This should include a more visionary look to the future – including the need for arts buildings equipped for work using new technology. It is hoped that the central government contribution to this may be met from the proceeds of the National Lottery. (Principles 2 and 8)

3 Establishing funds to go towards feasibility studies and for commissioning investment appraisals of arts and media building improvements – particularly to assist in establishing priority uses for National Lottery funds. (Principles 2 and 8)

4 Encouraging the flexible, imaginative and cost-effective use for the arts, crafts and media of multi-purpose and redundant buildings (such as schools, churches and mills) and of 'non-traditional' venues (such as sports arenas). (Principles 2, 5, 8 and 9)

5 Raising public awareness of the architecture of arts buildings, to underpin the above priorities: positively or negatively, the artistic quality of arts buildings affects the status and perception of the work that takes place in them. (Principles 2 and 8)

VI *Internationalism*

In collaboration with the British Council, Visiting Arts and other agencies, we wish to increase the quality and quantity of international arts activity enjoyed by the public and to broaden the understanding and appreciation of world cultures within this country.

We shall concentrate on supporting international contacts between creators, producers, promoters, venue managers and others, the exchange of information, co-productions and other forms of co-operation. Our

strategy does not address cultural diplomacy, which is the British Council's responsibility. This programme represents no radical break with the past, but hitherto our approach has been unsystematic. We shall develop clear, principled and consistent practice. (See further Chapter 16.)

* 1 Providing grants for artists, producers and promoters to train, work and undertake research outside Great Britain. (Principles 4 and 7)

* 2 Increasing funds for promoters, distributors and exhibitors to bring in the best work from all parts of the world, in all forms and media. (Principles 2, 4 and 7)

* 3 Seeking development of the European Commission's programmes in support of the audiovisual sector through enhanced funding of MEDIA, and UK entry to the Council of Europe production and distribution support scheme EURIMAGES. (Principles 7 and 8)

* 4 Providing up-to-date information on cultural trends, programmes and funds within and beyond the European Community, good practice, international cultural issues, and sales and marketing opportunities. (Principles 7, 8 and 10)

* 5 Backing international networks, as services provided *by*, not *for*, artists and arts organisations. Support of cultural diversity networks will be a high priority: the enhanced profile of disability arts, for instance, owes much to the growth of international networks of disabled artists. (Principles 5, 7 and 10)

 6 Facilitating cultural exchange and the development of British artists and arts organisations by relaxing restrictions on the use of domestic funding agencies' resources for work outside Great Britain. (Principles 4 and 7)

 7 Encouraging a cultural dimension to such areas of international exchange as town twinning. (Principles 1 and 8)

VII Money
A fully effective and efficient system of plural funding is required: the arts, crafts and media should receive a level of investment reflecting their

needs and their importance to society.

We need to help the market to function effectively and to intervene where it does not. This section of *A Creative Future* differs from most of the others, since a number of priorities are matters where the primary responsibility rests with government or other agencies. Our key role will be advocacy. (This is a subject which pervades the book; but Chapters 10, 17 and 18 are most relevant.)

* 1 Ensuring as far as possible that subsidy from funding bodies to artists and arts organisations is enhanced by their own earned income; helping them to earn more; and enabling them to use public funding in an effective, efficient, flexible and entrepreneurial way. (Principles 8 and 10)

* 2 Encouraging – in collaboration with the Association for Business Sponsorship of the Arts where appropriate – individual donations, sponsorship, corporate giving and investment in the arts and media through greater use of recently introduced tax incentives and concessions. (Principle 8)

* 3 Exploring more flexible and innovative ways of using some of the money within the public funding system, such as low-interest loans and art purchase schemes. (Principle 8)

* 4 Making the case for support of the arts to be a statutory responsibility of local authorities in England and Wales, eligible for revenue support grant from central government. The government has long endorsed arts provision by local authorities. The creation of a statutory responsibility would ensure that people are not denied arts opportunities merely because of where they live. (Principles 2 and 8)

* 5 Building on welcome new arrangements by seeking further fiscal and other incentives to stimulate investment in UK film production, distribution and exhibition. (Principle 8)

* 6 Making the case that a significant proportion of receipts from the National Lottery should go to the arts, crafts and media, particularly for capital investment; these funds to be distributed through the existing agencies, but not at the expense of their existing grants. (Principles 2, 8, and 10)

CHAPTER 3 · ARTISTS AND ARTS ORGANISATIONS

Artists are social beings: to divide the population into 'artists' and 'public' is to create a false division. But it is convenient for current purposes. This chapter and the next two consider the work and needs of artists. Chapters 6 and following consider the needs of audiences and participants.

The needs of artists

In an essay on his adaptation of Nicholas Nickleby, the playwright David Edgar wrote:

> I have discovered in recent years that there is nothing more snobbish and élitist than the view of even the most liberal thinkers as to the correct and proper hierarchy of arts. In the performance sector, the so called 'interpretive' arts — musicianship, acting — have struggled for years for their status as equal to and complementary with, rather than secondary and inferior to, the 'primary' arts of composition and playwrighting.

On the other hand, it is clear that the needs of artists vary partly according to the forms in which they work and partly according to whether they are 'primary' or 'interpretive' artists. The visual arts may be used as an example to focus discussion. One key theme of consultation on the visual arts was that support has been directed disproportionately to its presentation and to some extent, its distribution, rather than its production. (It is noteworthy that this has not been the case in the work of the Crafts Council.) The creation of painting and sculpture is, in general, a matter for individual artists rather than for arts organisations. But the agencies which spend public money on the arts, including local authorities, have tended increasingly to deal with arts institutions rather than with individual visual artists. If the arts funding system does not put the artist at the centre of its work then who will?

A formidable list of visual artists' needs can be built up, including the following:

(i) **Training**
 — technical and creative training which is easily available, affordable and of high quality;

– training in the financial, marketing and management skills necessary for someone likely to be self-employed.

(ii) **Financial assistance**
– financial assistance both during formal education and during the period when the artist is establishing her career and reputation;
– proper remuneration – a living wage – for work done.

(iii) **Information and networks**
– networks of information and support from colleagues;
– comprehensive registers of production facilities;
– easy availability of information over the whole field of the visual arts, including crafts, photography, design and architecture.

(iv) **Facilities and services**
– access to new technology;
– sufficient, suitable and secure studio space and facilities;
– concentrated and effective marketing of the art form – in the broad sense of education, promotion and publicity;
– a wide geographical spread of commercial/retail outlets;
– facilities to meet the needs of artists with disabilities.

(v) **Moral and practical support**
– adventurous acquisition and display policies by the major collections, including acquisition of work using new technology;
– assurance that censorship will be steadfastly resisted by those who present and distribute the work, and by those who fund them;
– active collecting and archiving policies – acknowledging the rights of future generations;
– informed, wide and deep critical debate, including high quality arts broadcasting and writing for magazines.

(vi) **'Empowerment'**
– assessment procedures for grant-aiding which include discussion with the artist and assessment by a peer group;
– prominent, rather than token, representation of the many cultures in Britain in the staffing and programmes of visual arts institutions, galleries, art schools and the funding system;
– a representative and unified voice for artists, to act as a lobby and think tank;
– a role for visual artists in the presentation and distribution of their work, including the growth of exhibition spaces programmed by artists themselves.

One feature of this list is that with relatively minor and fairly obvious changes, it would apply equally well to 'primary' artists in most forms and media, not merely in the visual arts. Artists are economic beings, and earn a living by selling goods and services; they are artistic beings and need a range of forms of artistic support. Obviously, the emphasis will vary from form to form, indeed from artist to artist. Some visual artists may have a particular need for access to new technology, others for retail outlets; poets for poetry magazines and publishers; choreographers for resources for notation; playwrights and composers for performance opportunities; and so on. But similar needs arise for most primary artists: training and financial help; mechanisms for getting their work to the public; support systems from their peers; assessment procedures in which they have a stake; provision of a range of services – technical, managerial, financial – by the funding bodies; and the establishment of a more constructive relationship, and one of greater equality, with those who present their work.

The needs of interpretive and 'producing' artists – actors, dancers, theatre directors – are not totally different from the above, but there are also, obviously, special requirements. Dancers' performing careers, for example, are likely to be relatively short. Their training must be broad based, include consideration of their prospects at the end of a performing career, and provide for them to develop skills in such areas as teaching and management. Dance can and should be seen as a career for life in a number of phases of which one will be performance, rather than as something short term, insecure and for young people. An organisation like the Dancers' Resettlement Fund and Trust serves a vital purpose in helping to make this a reality.

Status and pay of artists

There is no hierarchy of artists, whether they are 'primary' or 'interpretive' artists, or whether they work as teachers or animateurs. There are many ways of touching people's lives through art; none is inherently inferior or superior to any other.

A common theme of artists' contributions to strategy discussions was their wish to have a higher status than at present. There is little to be said about this issue in isolation. A wish for higher status is common among professionals – like teachers and nurses – who have undergone lengthy training, who are immensely skilled, but who find that their recognition by society, reflected in particular in terms of financial reward, does not match this. Artists fall into this category. The answer is likely to be that the recognition of the importance of artists will rise when the recognition of the importance of what they do and represent rises. If the status of the arts themselves is low, there is little that can be done about the status of the artist.

Pay and conditions in the arts, except for a very privileged few, are so

extremely — and notoriously — inadequate that there is little new to say about them. Throughout the country there are talented artists, with no other secure sources of income, subsidising their art. Some fine theatres, for instance, are unable to pay their actors anything but a small contribution towards expenses. The Gate Theatre in Notting Hill, celebrated for its innovative productions of neglected classics, is one such. Its former Artistic Director, Stephen Daldry, put the dilemma thus:

> The Gate is a minute theatre but a huge operation. At one point a couple of months ago we had 54 actors in three shows. To be able to fund the Gate and pay all those people a living wage would cost hundreds of thousands of pounds.

Development in the arts cannot be sustained if artists are unpaid — or even if they are paid only when their work reaches the public: development work is expensive. **Reductions in the amount of experiment and of new work in all forms are already apparent and are clear signs that Great Britain cannot without grave damage continue to get its arts on the cheap.**

All the available research points to the exceptionally high turnover of staff within arts organisations — far higher than can be accounted for simply by career progression. Indeed research suggests that low pay and poor conditions are responsible not only for high staff turnover but also for many people leaving the arts who would otherwise have stayed in it.

There are also more specific problems, for example for those artists who rely on disability benefits. They may feel that the personal risk of becoming a professional artist, with all the uncertainty that it implies, is too high because of the potential impact upon their right to some of these benefits. The issue is complex and needs dealing with case by case. The funding system should undertake research into this issue and work with the government departments concerned to resolve this uncertainty for disabled artists.

The funding system could use its limited resources to fund less work more adequately. An improvement in terms and conditions might be a consequence; another consequence might be an increase in unemployment for artists of all sorts and less arts activity available to the public. The alternative on existing resources is to continue to fund at, in general, subsistence level. This is not a reasonable choice. Britain's talented artists in all forms and media deserve and need a living wage. That is one of the main reasons why increased funding is necessary. But this is a nettle for the funding system to grasp also. In its response to the draft strategy, the actors' union Equity wrote: 'If the ACGB grant was doubled tomorrow, it would probably result in twice as many artists being poorly paid'. **The system should commit itself to using a substantial part of any increase in resources to improve the pay and conditions of those who work in the arts. This will**

contribute to the long-term artistic health of the nation, as well as to the economic welfare of artists.

There is a further means to alleviate the economic circumstances of at least some creative artists, though it is not within the remit of the funding system: reform of copyright procedures. One respondent to the strategy made a persuasive case relating to music, but it can be extended to other forms also. For music, copyright lasts for fifty years after a composer's death, and the money goes to the composer's heirs and beneficiaries. Almost all other European countries have copyright periods of between sixty and eighty years, and there are at present moves to make the period standard within the European Community. None of this, however, benefits other, living, composers. A simple change to the law could extend the copyright period to a hundred years, with the composer's heirs benefiting from the first fifty, as now, and 'living music' benefiting from the second fifty – for instance by using the resulting funds to establish commissioning, performing, publishing or recording programmes. For much art, the problem of recognition comes down to time, not money: artistic and subsequently financial recognition may arrive, but only several decades after an artist's death. It would be an admirable initiative to have the art of the past support that of the present and future in this way.

Artists and the funding bodies

One of the themes of the consultation process was that the funding bodies (with the exception of the Crafts Council) have too little contact with individual artists, as against arts organisations. **The funding bodies should develop policies to ensure a clear focus on artists themselves.** This should be a key element of their individual corporate plans.

The means will vary from form to form and region to region. Chapter 5 (pages 60–62) suggests some measures to encourage innovation and development at the smaller scale and focused on the individual artist – bursaries, placements, individual residencies. In addition the funding system should take action in such areas as these (which are examples, not a comprehensive list):

(i) Diversity is a key aim – it is valuable in itself as well as being the essential condition of sustained development and renewal in the arts. There should be a wide *variety* of opportunities for artists' work to be seen, exhibited, performed, sold or otherwise to reach the public.

(ii) Application procedures for funding should be clear, simple and flexible, and relate to the way in which artists work.

(iii) The funding system's unrivalled information resources should be collated, co-ordinated and disseminated effectively and for the benefit of artists, and new technology harnessed as a means to this end. This is essential if artists and small arts organisations are to play a fuller part in decision-making processes.

(iv) New technology also has the capacity to generate imaginative and relatively cheap promotional materials – with a level of polish that is essential if artists are to get their message across effectively. As resources allow, the funding bodies should establish new technology 'bursaries' to contribute to the cost of training and equipment.

(v) Where it is more cost-effective to do so, the funding system should not supply services to artists directly, but by making contracts with support and membership organisations such as the Independent Theatre Council, Theatrical Management Association, Dance UK, Community Dance and Mime Foundation and others.

(vi) The funding bodies' corporate plans and policies should be informed by full artist participation within the principles in this book.

Promoters and producers

Promoters – ranging from arts centre directors to independent producers working worldwide to discover the most exciting work – have, as far as funding is concerned, tended to be the most neglected element of the arts industry. But for their efforts, however, audiences and artists would have a vastly less interesting range of work to enjoy and learn from. **The funding system should develop substantially the support it provides to promoters.** Because this issue is so closely linked with that of touring, it is discussed in Chapter 14.

Arts organisations

Chapter 2 (page 14) showed that, every year within living memory, most of the grant from the government to the funding system has been devoted to relatively few, relatively large, arts organisations. Not necessarily the same organisations over a period of twenty years; but if priorities are reflected in spending patterns, then they have changed only slowly over the years.

These patterns have been partly the result of planning, and partly a response to the initiatives of others. The creation of opera and ballet companies of internation-

al standard at the Royal Opera House was an early aim of the Arts Council, one that, in its early years, required the majority of the Council's annual funding. The establishment of a network of regional producing theatres resulted from a mixture of artistic enterprise, municipal initiative and funding body encouragement. The growth to their current eminence of the Royal Shakespeare Company and the Royal National Theatre represents the backing of individual initiative by substantial funds.

But the word 'substantial' is relative. The largest arts organisations receive a high proportion of total available grant; but they exist on a level of public investment very low by international standards. They are, furthermore, significant businesses in their own right, with a turnover of millions of pounds, and employing hundreds of people. Yet they exist without the reserves which would be considered essential in the business world.

Britain has built up an array of arts institutions which, in terms of quality if not quantity, stands high in the world. The ability – and indeed the necessity – of major British arts institutions to make do on considerably lower sums of public money than their continental counterparts is a cause of amazement, congratulation and commiseration on the part of foreign observers.

The choices of the funding system are limited. It could end or substantially reduce funding to a number of these institutions – which in most cases would simply put them out of operation. Or it could decide that it has no business establishing priorities of its own, and leave things as they are. Or it could seek to work *with* and *through* the large scale arts organisations, ensuring that they are funded specifically for such policies as support for innovation, presentation of a varied programme, active education work and the provision of opportunities for young artists from a variety of backgrounds.

The conclusion of the consultation process is that the last of these is by far the best route to achieve necessary change. *The funding system must work **with** these large scale arts organisations, to encourage and enable them to respond to changing circumstances and needs. But they must be funded for their present and future, not for their past.*

This has a number of implications:

(i) **The funding bodies should move to a contractual relationship with arts organisations.** Theoretically, this is the case at present. In practice it rarely works like that. During the consultation process, many arts organisations wrote or said that they knew too rarely what was expected of them for the money they received. The term 'contract' implies genuine negotiation and agreement in advance, with each side knowing why public money is provided, what is expected for it and what will happen if contract terms are not met. Such contracts should be realistic: there will be an inevitable tendency to ask too much of arts organisations.

(ii) The large arts organisations – in particular the large arts buildings - should be encouraged to operate more flexibly than at present. For example, regional producing theatres should be open to work beyond their own art form; work from various sources; the transfer, where appropriate, of the best of their work to other stages; residencies by smaller touring companies, and so on.

(iii) It is an important task to achieve artistic 'crossover' between art forms, on the part of both artists and audiences. Arts centres are the most obvious but far from the only arts organisations with the capacity to mingle art forms, to create thematic links and to encourage new collaborations between artists from a wide variety of backgrounds and disciplines. Those arts organisations which are making progress in this respect deserve the fullest possible support - financial and otherwise – from their funders.

(iv) No organisation should expect to be funded in perpetuity. For what are at present regular revenue clients, funding should be offered in response to three or five year plans and renegotiated towards the end of the plan period.

(v) Linked with this, major arts organisations are too important to the communities they serve to be funded to operate at below their full potential. Commitment to a particular organisation should not necessarily mean commitment to its current artistic and management team.

(vi) Measures to foster innovation, education and equal opportunities, agreed with the companies concerned and tailored to their needs and situation, should be normal terms of the contract between funding bodies and arts organisations.

(vii) Funding must be adequate to enable all this to happen.

Most of these points are in the power of the funding system and the organisations concerned to negotiate and implement. As to the last, the sums involved will vary from organisation to organisation. In future, all appraisals of major arts organisations should consider not simply their current level and quality of operation but also – in collaboration with the company itself – a detailed and *costed* assessment of the sort of contract that would be appropriate.

In moving to such a system, it will generally be far more effective to use funding as a carrot than as a stick – to reward the most imaginative and forward looking plans. By no means all the terms of such contracts will require additional

money, but where developments are agreed which do require money, that money must be found. The funding bodies should work with local authorities in formulating some of the main contractual terms. Where it is possible and simpler for all parties, the funding bodies and local authorities should be joint parties to funding contracts with arts organisations. Chapter 10 considers in more detail the issue of co-operation between the funding bodies and local authorities.

There is a tendency for arts organisations to make conflicting, if understandable, claims on the funding system. On the one hand, they require security of funding, and argue that it is impossible for them to plan if they do not know well in advance how much money they are to receive. On the other hand, they require flexibility - the ability to respond quickly to new opportunities and situations as they arise. **The only way to square this circle is to retain, alongside revenue or contractual funding, the financial flexibility to help pay for such new developments at short notice.**

There is another brief point to be made, about the commercial arts sectors. If there is a single central theme to this book, it is that the work of the funding system must be focused on the issue of artistic quality above all, wherever that quality is to be found. **It is entirely right that the funding system should enter partnerships with the commercial sectors, where they serve the interests of the arts and the public.**

Conclusion

A move to a more contractual relationship with arts organisations should be widely welcomed – particularly by the organisations themselves. The key requirements of a funding contract are flexibility and an acknowledgement that arts organisations, as well as artists, have their individuality and their rights. Just as there is no single model of an arts organisation, so there can be no single model of the relationship between arts organisations and the funding system.

This chapter also signals another major shift – towards policies designed specifically to meet the needs of artists, to improve their pay and status and to empower both artists and promoters. The blend between direct provision of services, working with arts organisations and promoters and working directly with artists will vary between art forms and between funding bodies: this is one of the most important issues to be tackled in individual funding body plans.

CHAPTER 4 · VARIETY AND QUALITY IN THE ARTS

This chapter examines two issues crucial to the arts – variety and quality – which are more closely related in practice than in theory. They meet in discussions of the hierarchy, or supposed hierarchy, of art forms – which can be summarised in the question: Is a Keats poem better than a Bob Dylan song lyric?

A hierarchy of the arts?

To oversimplify, on the one side are those who argue that all opinions on quality in the arts and culture are subjective and thus that none has any greater validity than any other; at the extreme, that Shakespeare's work is neither better nor worse than, but merely different from, the contents of a telephone directory. On the other side, the argument tends to be not that a particular Keats poem is better or worse than a particular Dylan lyric (after all, so what?) but that there is something inherently superior in the *form* in which one of these artists worked.

Despite the gulf separating these positions, what they have in common is a refusal to make judgements of quality – since the latter group is judging on the basis of labels or categories rather than individual works of art. However one defines artistic quality, it is over-restrictive to suggest that it is found only in particular forms of art, or that there is something superior about a particular form (as if a symphony were by definition better than a folk song). Any supposed hierarchy is likely to be culturally determined. How are those schooled only in Western visual arts traditions to place, for instance, Russian Orthodox icon painting or Islamic weaving? Furthermore, some cultures do not make such a hard and fast division between 'high' and 'popular' forms; for example, certain Indian ragas appear in both folk and classical forms and Katkahl dance is both a classical and a popular art.

One of the key responsibilities of the funding system is to make judgements about the allocation of scarce resources. **The criterion of quality should be central to these judgements; but the concept is not associated solely with particular art forms, and the idea should be repudiated that some forms are of themselves superior or inferior to others.**

Variety and the role of the funding system

Variety was an issue which arose implicitly rather than explicitly during the strategy consultation process. When the range of art forms, ideologies and ways of delivering and participating in the arts that were raised during the process were surveyed, variety emerged as an overwhelmingly strong theme. One lesson to be learned from the process is that **the range of art forms with which the funding system should be concerned goes well beyond what it has been able or willing to support in the past.**

Architecture and design may be used as examples of this. The last twenty years have seen a phenomenal growth in public awareness of and interest in environmental issues. As part of this, architecture is now seen to have a major influence on the quality of life, rather than being a technical matter of little concern to the general public. Hence the establishment of the Arts Council Architecture Unit, which is intended particularly to stimulate public debate in this vital area, but which has also been widely welcomed within the architecture profession. The cultural dimension of architecture and its links with the rest of the visual arts have for too long been undervalued, and the funding system is well placed to reverse this trend in the 1990s.

Similarly with design. One of the strategy discussion papers, by Helen Rees, then Director of the Design Museum, made a strong case that design is a central but neglected cultural and aesthetic issue. In some cases, the industrial aspects of design outweigh its aesthetic aspects: linking design with the arts is likely to mean more to a designer of furnishing fabrics than to a designer of batteries. But it is important to make the case that there is a continuum here, not a sharp break between the work of craftspeople and that of industrial designers. It is part of the funding system's mission to demonstrate that the arts, crafts and media are central to people's lives. 'Reclaiming' design as part of the visual arts is one way to do so.

There are also forms which have been more widely accepted as coming under the banner of the arts, but which have been marginalised by the funding system: for instance, folk and traditional art, circus, carnival, puppetry, and, many would argue, photography and literature. As will be shown in the next chapter, development in the arts is hampered if support structures are based around rigid art form divisions. No-one can know when or how one form may fruitfully mingle with or influence another. Therefore, even if it were not necessary to take an interest in the whole range of the arts for their own sake – which it is – it would be worth doing so for their potential to influence those arts which have traditionally been supported. (It is also important for each of the funding bodies to keep in touch with developments in areas in which the others work: visual arts and crafts practices act and react on one another; emerging practices in film, video and television influence the performing arts, and so on.)

What sort of intervention by the funding system is appropriate in such areas?

There is no single answer to this. For major issues such as design and architecture, where its financial stake will be small, its responsibility will be largely to foster debate and raise awareness among the public as well as among the experts, as for instance the BFI did in its series of publications in 1990 about issues in broadcasting. The situation is different in relation to such forms as puppetry, illustration and carnival, where the funding system can provide at least three forms of assistance: funding opportunities which are flexible and not tied down to rigid art form divisions; explicit acknowledgement that they are indeed art forms; and organisational and financial help for practitioner networks, including, if appropriate, assistance if practitioners wish to set up national or regional membership organisations.

Quality

The issue of quality is so complex that the main contribution of this book may be no more than to state its complexity and to call for wider debate. Nonetheless, some attempt will be made to define the main areas of discussion.

This is Rupert Murdoch's view of 'quality television' (though it applies as much to the other arts):

> Much of what is claimed to be quality television here is no more than the parading of the prejudices and interests [of the broadcasters] and has had debilitating effects on British society, by producing a TV output which is so often obsessed with class, dominated by anti-commercial attitudes and with a tendency to hark back to the past.

It may well be an unwilling agreement with this view — in effect, guilt at traditional élitist notions of quality — that has prompted some to retreat from the issue. Nonetheless, such criticism should lead to attempts to improve and refine the concept, not to abandon it. As Geoff Mulgan argued in *The Question of Quality* (published by the BFI), again in the context of television:

> Criticism and judgement are part of the very process of making television. If critics and audiences do not repeatedly criticise programmes, developing a more sophisticated armoury with which to judge, then it is all too likely that standards will slip, that bad television will displace good.

The problem is that quality as a *concept* is relatively simple if one is adopting the élitist approach: it may take a lifetime to acquire the skills and experience to discriminate, but there is an objective scale of judgement which one can aspire to discover. On the other hand, the argument that there is more than one scale, and

indeed more than one type, of critical judgement can sound like an abdication – a refusal to judge. These are some of the facets of quality cited during consultation:

 (i) **Creator or producer quality.** The creator's gut feelings, and such standards as 'production values', are important here. Alongside quality as defined by expert advisers or critics, it is probably the most generally understood use of the term in the arts. It is intimately bound up with issues of artistic freedom, and is essentially subjective.

 (ii) **Expert assessor/critic quality.** This is similar to (i) but the assessment is now carried out by someone – however expert or well informed – who is outside the work in question; again subjective.

 (iii) **Consumer quality.** At its crudest, this is purely a numbers game: an exhibition receiving 5,000 visitors each day is better than one receiving 3,000; quality is a full theatre; the market decides. This sort of measure can be used, as Rupert Murdoch used it in the quotation above, as a stick with which to beat a presumed élite. But if 'consumer quality' is to be a useful concept, it must be at least as much about the nature of the artistic experience as about the numbers involved.

 (iv) **Enrichment of the community.** The public attitudes research demonstrated that the arts can be powerful agents for bringing people together in communities defined by geography, ethnicity, gender, religion, or simply shared interest. An artistic activity which has succeeded in conveying a shared vision – giving voice to what had previously been silent – might be said to have had its quality enhanced.

 (v) **Quality in variety.** This is a concept of quality based on the overall availability of the arts rather than on individual works of art. The argument runs that in a society of many different interests, cultures and experiences, an essential test of artistic quality is that the arts reflect that diversity.

 (vi) **Quality as 'fitness for purpose'.** The essence of this approach to quality is that it is not an abstract issue but one which arises from its context: in certain places, at certain times, opera is more appropriate than rock music; at others, vice versa. As to what constitutes great opera or great rock music, one of the earlier tests will have to apply!

Assessing quality – the role of the funding system

Funding decisions should be intimately bound up with issues of quality, so the above discussion is of more than academic importance. Thinking on the assessment of quality must be developed not by the funding system alone, but in partnership with others who work in and care about the arts. But a few general points can be made.

1 It is possible to draw up a list, though not a comprehensive one, of relevant factors. Such a list would include aesthetic ambition, artistic and social innovation and significance, and likely durability; each of which terms requires further analysis.

2 It is important to focus on the artistic process as well as on the artistic product. Factors more appropriate for objective analysis arise at that stage, though they will never be conclusive. For instance, it is *likely*, but far from certain, that there will be a link between the quality of a play's production and the length of its workshop and rehearsal period.

3 Self assessment should become an important part of the assessment process. This should be as rigorous as any other form of assessment – it is far more than an organisation saying 'We think that we did well (or badly)'. Its starting point must be an artistic mission statement – a statement in advance of overall aims and objectives, against which performance can be assessed. If an artist or organisation wishes to receive funding, then criteria and methods of assessment must be for *negotiation* between the organisation and the funder.

4 In order to discharge its responsibility to assess quality, the system needs to broaden the range of experience available to it from both advisers and staff. The role of advisers needs to become more coherent. The wider the range of the arts which are supported, the more diverse are the scales of judgement and notions of quality which must be applied, and the greater is the range of arts experience, expertise and knowledge necessary to help develop and assess the work.

5 Related to this, it is argued in Chapter 7 (page 73) that the best evaluation of the widest range of work may require paid assessors. Perhaps they should be paid as a matter of principle also: the creation of a contractual relationship with assessors could have beneficial consequences in terms of responsibility and accountability. On the other hand, in a situation of inadequate resources, it may be difficult to make the case that payment of assessors is the highest priority use of money; though if carefully targeted, such payment could, while

assisting informed assessment, also help buy time for artists to research and develop their own ideas.

6 The use of measures and indicators of performance must be clearly circums-cribed. They are substitutes for performance, not the thing itself. They cannot be 100 per cent reliable and thus 100 per cent reliance on them is inevitably a mistake. Those being assessed may work to score well on the assessment scales, rather than actually to focus on quality. (This is related to the sad phenomenon of arts organisations attempting to construct projects to meet inflexible funding criteria, rather than to fulfil their own aims.) Measures of performance are no more than 'material', to be used as critically as any other in judging how well an arts organisation is doing.

Conclusion

The funding system has an obligation to recognise and support new and evolving art forms. It has an equal obligation to act when art forms or ways of delivering the arts are losing their relevance. Flexibility of funding – widely regarded as desirable – cuts both ways. This is easy to accept in principle but tougher in practice; reducing or ending the support of institutions or whole areas of activity is inevitably painful. If such decisions are to 'stick', there are two prerequisites: an increase in the respect enjoyed by the funding system and in the range of advice available to it, and a contractual relationship between public funders (including local authorities) and those they fund, which was considered in Chapter 3.

Furthermore, the system must be prepared to act as an advocate even in those areas of the arts in which it is not a major financial player. Such activity should be by invitation only. It is surprising how often it is welcome. Thus those working in the public libraries, major publishers and bookstore chains are entitled to look to the funding system for support in the 'cause' of literature. The BFI and its partners should campaign for the revival of the British film industry for both artistic and industrial reasons. Arts broadcasters are entitled to whatever support and lobbying power, regional and national, the funding system has at its disposal.

Finally, acknowledging the value of variety in the arts and repudiating the idea of a hierarchy of art forms do not mean that all forms should attract subsidy. It does mean that subsidy must not be ruled out for any form simply because of its name. Originality, potential, quality, need and competing priorities are relevant factors; the art form label is not.

CHAPTER 5 · ARTISTIC ORIGINALITY AND DEVELOPMENT

Artistic originality

Artistic originality was one of the concepts most often discussed during the strategy consultation. It is a term commonly regarded as synonymous with 'innovation'. But the link between innovation and high quality may be unclear, and the term 'originality', which may be more satisfactory in this respect, is generally used in this chapter.

Originality relates not merely to new art, but to new ways of presenting, delivering and interpreting existing art, and new ways of expressing the relationship between art and the public. In this wide sense, it is something which all art forms can share. A novel and illuminating presentation of Renaissance art is original, as is a time- based piece of performance art using interactive computer technology. Indeed, the re-interpretation and renewal of the heritage is a form of originality in which the late twentieth century has been particularly rich. Thus the authentic instruments movement in classical music has had an influence on playing styles in symphony orchestras similar to that of fringe theatre on the major reps. Productions of the established operatic repertoire by many British opera companies may be as innovative and revelatory (or as misguided) as their productions of new opera. The publishing discoveries of Virago and other feminist publishers have enabled many of us to fill what were previously blank spaces on the map of women's literature - they have helped to change many people's idea of the history of literature. (A similar service could no doubt be performed by a Black publishing house for Black literature.) Originality in the arts is more a matter of approach, of state of mind, of new solutions to old problems, than of clean breaks with the past.

Artistic originality cannot be willed into existence, but there are conditions in which it is more likely to flourish than others. The results of consultation on this issue can be summarised as a series of propositions. With minor changes these propositions seem to hold good for many areas beyond the arts.

1. Originality of approach is most likely where artists have time and space in which to experiment. Obviously, poor working conditions can generate new ways of working. But given that originality cannot be entirely planned for, the process of creating an original work of art is unlikely to be smooth or efficient. The point is neatly made in the following quotation:

Development work is a messy, time- and energy-consuming business of trial, error and failure. . . . Success is not a certainty. And even when the result is successful, it is often a surprise, not what was actually being sought. . . . The exorbitant amounts of energy and time and the high rates of failure in the process of developing new work do not mean the development work is being done ineptly. The inefficiency is built into the aim itself; it is inescapable.

The subject of that quotation has nothing to do with the arts. It comes from Jane Jacobs' classic study *The Economy of Cities*, about why some cities develop, while others, however efficient, stagnate. Jacobs' brilliant analysis ties in closely with the views of artists. The search for artistic originality requires an acceptance of the possibility of failure. Artists often talk about their 'right to fail'. This is too negative, and almost suggests that failure is a virtue. Further, it can become debased into a right to be second rate or self-indulgent. More appropriate is the artist's right — perhaps even duty — to experiment, and the right to be provided with the facilities to do so.

2. **Originality is more likely to flourish where there are many individual artists and arts organisations rather than few: the more the better.** This means, inevitably, that there should be funding for many small and evolving, as well as large and developed, arts organisations. Individuals and large and small organisations all have their vital part to play. The arts in general, and artistic originality in particular, will thrive only if a wide range of artists and organisations is funded, not the artistic 'flagships' alone — however generously the latter are supported. The following quotation from Jane Jacobs suggests that this may be true more generally:

It is not the success of large economic organisations that makes possible vigorous adding of new work to older work. Rather, it depends upon large numbers and great diversity of economic organisations. . . .

One of the distinctive talents of a large arts organisation may be to provide a platform for the innovations of the small scale, develop and improve them and make them widely available. This thought lies behind a comment by the opera director David Freeman:

I certainly feel that Opera Factory is the only way I can experiment with opera. I can use these experiments at the Coliseum and at Covent Garden.

3. **Originality tends to arise from using materials or skills already being used, or in response to particular problems encountered in the course of existing work, or by bringing together two previously separate sets of skills, traditions or cultures.** This process is full of surprises and is impossible to

predict, let alone to plan. But little original work makes a clean break with the past.

It is inherently valuable to mingle different traditions, cultures and forms. Often, nothing of significance will result. But occasionally the consequence will be exciting and important – Peter Brook's version of *The Mahabharata*, or Jatinder Verma's production of Molière's *Tartuffe*. Such a mingling is more central to some communities than to others. For example, Black artists regularly seek to redefine and reinterpret their history by means of new techniques and approaches. The opportunity to bring together disparate forms and skills is one of the contributions that our major arts organisations – such as the regional producing theatres – can make to the continuing health of the arts generally.

4. **This unpredictability must be respected: trying to fit artistic origi-nality into pre-set categories is intrinsically misguided.** Much original work takes place intrinsically within particular forms or traditions. But the process may cut ruthlessly across categories, whether art form or geographical. Expecting the arts to stay within existing categories is an exercise in policing, not supporting.

5. **While original ways of presenting the arts may arise in response to public demand, most result from artists', producers' or promoters' logic rather than that of consumers.** The more daring the imaginative leap, the more likely it is to be creator – rather than audience-led. It may be many years before readers, viewers or audience – or indeed artists themselves – have a clear perspective on what has been developed. This has implications for the form of support for the arts. Some argue that it is less élitist, and more in tune with 'consumer sovereignty', to channel public support for the arts via the consumer (perhaps in the form of vouchers) rather than to the producer. But where funding is intended to further the cause of artistic originality it will usually be more effective to channel it to the artist, producer or promoter rather than to the consumer.

Propping up dying forms?

'From today, painting is dead.'
Paul Delaroche, 1839, on the invention of photography

There is another issue to touch on at this point. It is summarised by Geoff Mulgan and Ken Worpole in *Saturday Night or Sunday Morning*:

With the special exception of broadcasting, state policies have for too long been directed to only one small corner . . . the world of theatres, concert halls and galleries. It is as if every energy has been directed to placing a preservation

order on a Tudor cottage, while all around developers were building new motorways, skyscrapers and airports.

The argument is, therefore, that apart from the BFI and those parts of the funding system which deal with film, video and broadcasting, the rest of the system has devoted its energies to propping up a small, expensive and increasingly irrelevant part of the cultural fabric.

This is an interesting but questionable proposition. Granted, the funding system as a whole must keep centrally in mind the implications of broadcasting and all other relevant technologies both as artistic forms in themselves and as ways of transmitting the arts to more people. But the performing, visual and literary arts are still very much alive.

It was popularly supposed that the arrival of the cinema would spell the death of live theatre; that the introduction of television would, in turn, kill cinema; that mass production methods would put virtually all craftspeople out of business; that photography would make painting obsolete. In fact, none of this happened. Individual craftspeople did not seek to compete on price grounds with mass produced goods, but instead emphasised the uniqueness and individual creativity of their work. Theatre did not seek to compete with the strengths of cinema but emphasised its own 'liveness', the irreplaceable effect of human beings acting and reacting on each other. The 'electronic arts' did not supplant existing forms; instead, these forms adapted and renewed themselves to co-exist with the new. It is one of the purposes of public funding to help this process to happen. The success of the policy is plain from the figures in Chapter 2 (pages 20–22), demonstrating that many millions of people are involved as audience and participants in the non-electronic arts.

Artistic originality and the funding system

Quantity or quality?

The debate as to whether quantity or quality should be the key priority of the funding system is as old as the system itself. Chapters 4 and 6 look at different aspects of it. It is also relevant to artistic originality: funding too many companies at too low a level to enable them to mount a high quality programme of work is of little value. But with respect to artistic originality, the dichotomy is false. **Concentration of funding on a few 'centres of excellence' will lead to artistic stagnation; centres of excellence can stay excellent in the long term only if they are part of a broad and various range of arts provision.** Furthermore the wide range of cultural influences present in Great Britain is not at present, and perhaps cannot be, fully reflected in the 'centres of excellence'.

Developing or maintaining?

Many people have argued that support of contemporary and original work should

be the core responsibility of the arts and media funding system, and support of regular provision the core responsibility of local authorities. But the issue is not as simple as that.

What looks like an innovative project requiring a one-off grant has a tendency to turn into a client requiring long term revenue support. This is one of the most important issues for the funding system to resolve — how to avoid financial commitments which rise faster than the money available. As financial pressures increase, the tension between developing new projects and maintaining current ones becomes more pronounced.

The funding bodies' sincere and reasonable claim that they are development agencies may be viewed by some sceptics as an attempt to free themselves to take on innovative projects and to land local authorities with the responsibility for expensive and less interesting revenue and capital expenditure. This underestimates and oversimplifies the role of local authorities in the arts. Many have sophisticated developmental strategies of their own, very often in partnership with the funding bodies. If one considers, for example, the development of a Black arts infrastructure and its likely future, it is clear that in some cases it was the funding system that was most supportive, in others local authorities; and that a partnership, varying in its balance from place to place and without a rigid demarcation of roles, is the only way forward. **The neat scenario which would give local authorities the principal responsibility for maintenance while the funding system does the creative development is misleading. A sharing, not a shedding, of obligations must be the key.**

Support at the smaller scale
Individual artists and small arts organisations should have access to a wide range of opportunities to practise their art: this is one of the most fruitful means of encouraging artistic originality. In practice this could work, for example, by:

(i) increasing the use of writers' and artists' bursaries, on terms appropriate to the artists and their work;

(ii) developing new approaches to the support of craftspeople through links with industry or sales development;

(iii) increasing support for small scale film and video production, and by creating space within the moving image industries for individual creativity;

(iv) providing more funds for darkrooms, photography studios and technological resources for electronic imaging;

(v) extending placement schemes in the performing arts, such as residence programmes for playwrights, composers and choreographers to give young artists the opportunity to discover what will or will not work in performance; and placement in arts companies of young conductors and directors;

(vi) providing funds for second and subsequent performances of commissioned music;

(vii) encouraging the establishment of links between small scale touring companies and small scale venues (see further Chapter 14, on touring);

(viii) in other cases, encouraging the establishment of links between such small companies and larger ones — for instance, enabling small companies to collaborate with regional producing theatres in such areas as co-production and use of facilities;

(ix) providing long-term 'structural' support in cases where short-term project support might lead to damaging instability for a company or group of companies;

(x) providing funds for 'centres of innovation', along the lines of the Royal National Theatre Studio, where new work in all forms can be developed which in many cases will result in public performance, but where the emphasis will be on the process rather than on the outcome; and

(xi) providing 'economic empowerment' of creative artists — for instance, not only making playwrighting bursaries, but in some cases making available to the playwright a sum to go towards a play's production.

These would not be radically expensive measures to introduce or to strengthen. Compared with the necessary cost of supporting larger arts organisations, support at the level of the individual artist or small organisation is relatively cheap. In *Beggar's Opera*, for instance, Graham Devlin suggests that small and medium scale opera could be put on a much sounder footing for a sum representing just 2% of the grant going to the major companies; though this takes no account of the costs of support, monitoring and evaluation, which will be relatively high.

It will be noted also that several of these measures, all of them designed to assist individual artists and small organisations, involve their working in partnership with larger organisations. This is one of the reasons why contract funding, discussed in Chapter 3 (pages 47–49), is so vital. In many cases the aims of this book will be met not by wholesale reallocation of funds, but by the

improved targeting of funds to particular organisations in order that measures such as those listed above can be implemented.

Support and the larger scale

The large scale arts institutions in all art forms are crucial to the preservation and renewal of the 'classic' artistic traditions and heritage. If they had no other role, that alone would justify and require their continued support from public funds. But this does not mean that they are or can be static: re-interpreting the artistic heritage to succeeding generations requires a fresh and creative approach to the canon.

For instance, orchestral practice and orchestral organisation do not stand still. Some orchestras now incorporate chamber and contemporary music groups drawn from the orchestral membership; many train musicians in school and community education work; most commission, programme and market new music in active and exciting ways, helping to build active and critical 'participant audiences' now and for the future.

Similarly, the producing theatre must be a dynamic institution. Some have made noteworthy moves in the direction of opening themselves up to new art forms, by including seasons of dance, or by co-producing middle scale opera. Others through their youth theatre or community play work have developed adventurous new ways of breaking down the barriers between amateur and professional, or have opened their studio spaces or main stages to work co-produced with other companies. Such developments deserve encouragement and funding: only arts organisations which are themselves prepared to develop and change are likely to be effective agents for development and change in the arts.

Internal organisation

The funding bodies, too, must be prepared to develop and change – in particular in their approach to work that cuts across traditional art form boundaries. The remit of art form departments, where they exist, should be open, not closed. It does not matter whether puppetry and carnival come under the umbrella of drama, or which department deals with work which mingles dance, text and new music. It is vital that the internal organisation of and co-ordination between the funding bodies are such as to enable all artistic developments to be assessed on their merits: none must be excluded on the ground that it 'doesn't fit'.

Furthermore, there must be a strong combined arts function. Most of the RAAs/RABs have had this for a number of years. The Arts Council set up a combined arts unit in its 1991 re-organisation. There should be a wider range of programmes that encourage innovative collaborations between artists from different art forms, that support international collaboration, and allow applications by all sorts of movers and shakers in the arts — artists, companies, galleries, producers, publishers, promoters or any of these working in partnership.

Alongside this, advisory systems should reflect both the flexibility and the 'transparency' discussed in this chapter and funding procedures should empower artists and arts organisation rather than police them. Undoubtedly, more money is necessary, but just as important are changes of attitude and practice on the part of artists, arts organisations and the arts funding system.

A note on stability

It is important – in all the justified emphasis on artistic originality – that the claims of stability are not neglected. As was argued above, originality covers not merely new art, but new ways of bringing together art and public. All self-critical arts organisations, including those which work in traditional ways, think hard about themselves, the art they present and the communities in which and for which they work, and seek to develop accordingly. Development from a basis of stability deserves support; artistic stagnation does not.

Conclusion

The arts constantly renew themselves, and must do so if they are to thrive. The value of artistic originality was a central theme of the strategy consultation; originality not as a search for novelty for its own sake, and not relating to new art alone, but extending to new ways of presenting, distributing and interpreting existing art, and new ways of expressing the relationship between art and the public.

Originality and sustained development in the arts need more than a few artistic 'flagship' organisations, however generously funded. The flagships themselves, the arts as a whole and the public will be served if a wide range of artists and organisations is funded, and if funding categories are flexible and respect the unpredictability of the new. This means also that all elements of public funding, national, regional and local, have responsibility for the support of development and originality in the arts. Each has an indispensable role, alone and in partnership. A sense of adventure and a willingness to go beyond the beaten paths are as necessary for arts funders as for arts organisations and artists.

CHAPTER 6 · THE AUDIENCE AND THE ARTS

'Access' is a term much used – overused – by those in the funding system and by those they fund. All publicly funded bodies with an interest in the arts have access as a principal aim in one form or another. The first clause of the Arts Council of Great Britain's mission statement is 'to open the arts to all'; a guiding principle of the BBC is to provide broadcasting services 'as a means of disseminating education and entertainment'. Throughout the arts community there is wide agreement that the arts should be more accessible. There is generally less agreement as to what the word means.

This chapter and those which follow seek to distinguish between the word's various meanings. At one level, 'access' is about breaking down the barriers, from physical to economic, which inhibit people from enjoying the arts as audience members, viewers, readers and so on. It considers why people are able or unable, choose or choose not, to attend arts events, what might be done to encourage them to do so and how the experience can be made more pleasurable. That is the subject of this chapter. On another level it is about assisting people to celebrate and express themselves in terms of their own cultures. It requires a self-critical examination of what is funded and how far it meets the needs of the diverse communities which make up this country. That is the subject of Chapter 7.

Chapter 8 considers the arts as activities in which millions of people take part in - arts in the community and amateur arts. Chapter 9 discusses education, training and the arts. Education and training underlie almost every issue discussed in this book; but they are particularly crucial to the subjects of appreciation and participation.

Breaking down the barriers

Artificial barriers

The public attitudes survey showed that there are many millions of people actively enjoying and participating in the arts, whether supplied by commercial organisations, publicly funded organisations and activities, education (particularly adult education in the case of amateur participation), broadcasting, recording or amateur societies. This mixed economy forms the basis of arts provision. Unfortunately some arts activities (particularly those in receipt of public funding) are still regarded as pursuits which require a high level of education and a knowledge of certain codes of behaviour. This may be reinforced by the way they are marketed and reviewed.

Opera may be used as an illustration, though the point applies more generally. The marketing of arena opera and opera on television is very different from that of opera performed in conventional venues. There is no obvious reason why this should be so, not even price: opera in an arena is not on the whole cheaper than in an opera house. It is largely that there are different social codes attached to watching opera in an opera house, in an exhibition hall or in one's own living room.

In his report for the Gulbenkian Foundation, *Beggars' Opera*, Graham Devlin shows how over the years opera has swung back and forth between being a popular art form and one perceived as socially exclusive. Its current popularity has been won through the influence of many factors — star artists, television and film, exciting staging, the pure spectacle of the event. Whatever the reason, demand now outstrips the supply of suitable venues and companies. As the magazine *Opera Now* has noted: 'for people living outside London the biggest single reason for non-attendance is the lack of operas for them to attend'. This demand is to some extent being met by broadcasting, film, arena events, and small-scale productions and touring. Recordings of popular operas are doing well in the record charts. Increased availability, largely as a response to market forces, is making the social barriers that surrounded the art form seem increasingly irrelevant and artificial.

The nature of arts buildings (or other venues) and their overall programme of activities are important here. Some of the most successful of the regional producing theatres have opened themselves to work beyond their traditional remit, taking place not only on stage but throughout the building's public areas: in effect, they are theatre-led arts centres. Arts centres themselves can create a naturally welcoming atmosphere, in which people are attracted into the building for any of a variety of reasons — maybe for a specific event, maybe not — and are then encouraged to sample a range of other activity. It was noted in Chapter 3 that this sort of flexibility and variety is of considerable benefit to artists; it has an equal part to play in removing artificial barriers to the public enjoyment of the arts.

There is no reason why all art forms should become mass activities. Indeed the more opportunities that are available, the more 'minority interests' there will be. But **people should not be discouraged from attendance at arts events by either true or false expectations that they will find the atmosphere and conventions alienating and intimidating. Their attendance or otherwise should be determined by the events or activities that are on offer.**

Physical barriers

Barriers to physical access take many forms. The majority of mainstream arts facilities are located in town and city centres and may be difficult to reach for people living in suburban and particularly rural areas; but even people who live near arts venues may be wary of visiting town centres at night. Touring continues to be an important way of combating both geographical and transport problems.

There is a clear need to improve the quality and character of town centres. The higher percentage attendance in West End than in most regional theatres is possibly due in part to the West End's being an entertainment and cultural quarter. Regional theatres, on the other hand, are often isolated in town centres with little else to offer at night.

Physical access and disabled people

Physical access problems are most acute for many disabled people. They often have more intractable transport problems and rely effective and appropriate public transport or on voluntary, family or paid help. The buildings where arts activities take place frequently do not meet the needs of many types of disability, despite pressure for more sensitive planning of new buildings and a considerable amount of work undertaken by local authorities and arts venues. The need for more physically accessible buildings is discussed in more depth in Chapter 12.

The private and public sectors are failing to recognise the potential purchasing power of disabled people, apart from excluding significant numbers of people from the arts. One major exception is television, where commercial stations and the BBC produce teletext subtitling for drama programmes and films (as well as news and other features). The Broadcasting Act 1990 requires an extension of subtitling for the benefit of the deaf. Sensory barriers are perhaps the most powerful deterrent to the participation of visually-impaired people in the arts. There is little programme information and few guide books available in media accessible to them. For example, only 1% of museums provide information in braille, 4.5% in cassette and 10% in large print. Relief maps and three dimensional models are hardly in use in arts and heritage venues. In many instances, touching is prohibited, and few museums have developed tactile information displays. Audio description is available in a few theatres and has been developed for television in the United States, but there is huge scope for growth.

Placing conditions on grants is a vexed issue which has had limited success. But as long as the conditions are reasonable, enforceable and monitored, it is one means by which the funding system can help to ensure that arts buildings and facilities are genuinely accessible to disabled people. **Grant-aided organisations should undertake an audit of their provision, in consultation with disabled people. This should address physical access, employment, training, programming and marketing.** An action plan should result from this, whose terms should be incorporated into the organisation's contract with its funders (see Chapter 3). The nature and scope of these plans will vary greatly from organisation to organisation: a major building-based theatre has greater opportunities, and thus more responsibility, in this respect than a small touring company.

The best advocates for disabled people are disabled people themselves. The funding system should work in partnership with disabled people and with national and local government to resolve the issues that affect their ability to take an active

and creative role in society.

Enclosed environments
There are particular barriers experienced by people who live in homes, hospitals or prisons for all or long periods of their lives and have little access to the outside world. Patients, residents and prisoners are clearly not a homogeneous group. Even within these places there will be a diversity of people from a range of social and cultural backgrounds and with varying levels of previous contact with the arts. What they have in common is that for whatever period, this place is their home, their freedom of movement and range of choice are limited. This being so, there should be available specific, appropriate opportunities for them to engage with and participate in the arts – for art's sake, though it will also often have therapeutic benefits.

There is much research and specialist expertise in this area of work, such as the Shape network (which helps bring arts experiences to people in enclosed environments); two national agencies and approximately 200 projects on arts in hospitals; and a recent report commissioned by the Home Office on arts in prisons.

Having artists visit institutions is often as valuable as generating internal activity. It is important for the artist to be independent of the institution, and for there to be mutual forbearance and trust between the artist and the staff of the organisation. Working in such an environment presents a real challenge to artists, and also to the staff of the institutions. They should be encouraged to undertake training and to be open to discussion, so that their needs and the aspirations of the participants are understood and met. As a matter of principle, whenever possible, arts activities in such institutions should be planned jointly between administrators, providers and residents. Ideally the institution should have a member of staff with responsibility for the co-ordination of the project, to form a link between the residents, the staff and the arts project and ensure that the artist is not isolated.

Assessment of this type of work requires a detailed understanding of its limits and circumstances. **The funding system should strengthen its relationship with specialist agencies, relevant government departments, regional health authorities, local authorities and other providers to devise and fund programmes to ensure that the arts are available to those who live in enclosed environments.**

Price barriers
Until recently, price did not appear to form a crucial barrier to most people attending most arts events. The report *Pricing in the Arts*, prepared in 1990 by Millward Brown for the Arts Council, showed that 'price' was ranked tenth in a list of twenty factors that people used to make decisions about attending arts events. It was well behind factors such as 'the quality of the performance', 'that it is entertaining' and 'the subject matter'. This response was the same for all sections

of the community, including the young, the unemployed, lower income groups and infrequent arts attenders. The public attitudes survey showed that people in the higher socio-economic grades are more likely to be put off by price than those in the lower grades. This suggests that people's reactions are not necessarily determined by levels of disposable income. Perceived value for money is more significant than price as an absolute issue. In museums and galleries special exhibitions with fairly high admission charges are often extremely popular, even where there is free admission to the core collections.

It is important to note that these findings applied only within certain limits. Arguments on pricing in the arts often fix on extreme cases as if they were typical. Everyone – including the management of the Royal Opera House – would agree that top-priced seats for appearances by Pavarotti are higher than ideal; but most arts events cost only a fraction of this.

Nonetheless, pricing is significant and, as the current recession has deepened, has become far more so – affecting among other things the number of events attended and the seats chosen, and the choice for family visits between a gallery which is free and one with an admission charge. Furthermore, people are likely to be more cautious about their artistic choices. They may, for example, choose not to pay £10 to see an unfamiliar play at their local repertory theatre but be prepared to pay £30 for a ticket to a West End musical or £20 for a rock concert which they are confident that they will enjoy. Cost can ensure that arts events become 'events' in the sense of being rare and special occasions, rather than an integral part of people's lives. It is notable that the first tickets sold for most arts events tend to be the most expensive and the cheapest: those in the middle price ranges are often more difficult to shift. Price may be a particular deterrent for disabled people because, for example, in order to hear or see a production they may have to buy high-priced seats, pay for a companion and meet higher transport costs.

The recession may have more insidious effects also. A theatre's audience may be predominantly middle class and highly educated. Those who run the theatre may regret this, believing that their mission is to enable as broad a section of the population as possible to enjoy their work. But they are probably not funded adequately for this, and they have an obligation to maximise their income. It is natural for them to set prices as high as they believe can be borne, and to focus their marketing on those sections of the population which they know will be most responsive. Thus the social, economic and educational make-up of the audience remains unchanged, and barriers to wider enjoyment remain in place. Such an approach poses dilemmas not only for arts organisations but also for those who fund them. The present aims of the Arts Council, for instance, include both the growth of earned income among the organisations it funds and a broadening of the social mix of audiences. There is a potential contradiction here.

Subsidy reduces prices for events and activities. But unless this goes hand in hand with serious attempts to demystify the arts experience – to remove the

artificial barriers discussed above – it may simply provide the same audiences with a cheaper night out. **What is needed is a planned programme of offers and concessionary ticket prices, carefully targeted and backed up by programmes of education, outreach, audience development and marketing, designed to broaden the social and economic mix of audiences and visitors. This should not be confined to building-based organisations nor to any particular art form. These elements should form part of the contracts between funders and arts organisations.** The implementation of this proposal will require additional money from the funders to match enhanced performance on the part of funded organisations.

Do we need more arts?

The public attitudes survey found that around half of adults feel that there are enough art events available in their area, against one-third who believe that there should be more. There is, not surprisingly, a higher percentage of those interested in the arts who would like to see more available (42%) compared with those who are not interested (23%). Levels of satisfaction increase with age: nearly half of 16–19 year olds feel that there is not enough provision in their area compared with a third of 25–44 year olds and only a quarter of the 65 and over group. There is surprisingly little difference between the 'satisfaction level' in rural and urban areas and conurbations – around 50% in each case. Generally, the higher the attendance at each type of event, the greater the demand for more of the same. The major exception to this rule is the cinema, which has the highest attendance (45%), but only 5% of the population demanding more, perhaps indicating that increased provision over the last few years (particularly through multiplexes) has almost satisfied current demand.

Generally the arts which are in greatest demand, whether performed, screened or exhibited, require capital-intensive provision, particularly of buildings, if top quality and popular work is to be promoted. Limited funds mean that choices have to be made between more arts activities and higher quality arts activities (though Chapters 4 and 5 showed that this is not a clear trade-off). **The findings of the public attitudes survey suggest that higher quality – backed up by measures to remove the barriers discussed earlier in this chapter – should be in general a higher priority than increased quantity.**

It was noted above that opera is reaching a wider audience through a variety of means. Broadcasting may be the most important of these because it is so widely available. Clearly, for all art forms it provides a very different experience from live presentation, but one which is very valuable on its own terms. As well as the tremendous amount of material already produced for television and radio and the number of films shown, there is potential for greater investment by arts funding

bodies in more specialised productions, relays and adaptations; for encouragement of new writing and composing; and for commissioning work specially for the electronic media, particularly where it exploits and expands the artistic potential of the media. The funding system should ensure that broadcasting becomes more central to its work, and should set aside resources to enable the system to enter into partnerships with broadcasters, producers and broadcasting companies. This theme is developed in Chapter 15.

Development through marketing

It does not follow that an opportunity will be taken up simply because the barriers to enjoying it have been removed. Its benefits and attractions have to be identified and actively marketed. Marketing the arts and media is a theme that runs through this document implicitly and explicitly. It is particularly important in helping overcome the barriers highlighted in this chapter.

Effective marketing requires information about and an understanding of audiences. Up-to-date and useful market research is an expensive but essential part of audience development. The funding system should support the gathering and dissemination of generic information, by marketing agencies and consortia and the funding bodies themselves, to underpin the work of arts and media organisations. One of the clearest requirements is a close relationship between the artistic and marketing arms of arts organisations – a relationship that does not always exist at present, and whose absence may result in marketing staff feeling undervalued. Marketing is not about 'selling' a product but is an integral function of the management and planning of an organisation or project. **Effective marketing is an essential part of establishing trust and mutual respect between an arts organisation and its public.**

The undervaluing of the marketing function (proverbially the artistic director gets praised for a successful production, the marketing manager is blamed for an unsuccessful one) and the lack of appropriate expertise in many organisations continue to be problems. It is in the interests of the arts for practitioners and organisations to be aware of the benefits of understanding audiences and marketing the work effectively; to have appropriately qualified staff at a sufficiently senior level in the organisation; and to make available training to develop skills in a constantly changing field. The funding bodies should support this, particularly with advice, expertise and training grants.

One of the most important innovations in arts marketing has been the creation of marketing consortia around the country, based on the common interest of all arts and media organisations in pooling expertise and information on audiences and their needs. Parallel to, and sometimes as part of, these consortia, specialist assistance may be available – for example providing reasonably priced publicity

and distribution services. **The funding system should encourage and support the development of marketing consortia and networks, as the basis of a network of marketing support, research and information.**

The funding system has a broader role in this respect also. Tourists, from both within and outside the United Kingdom, form a substantial proportion of the audience for many arts events. The liveliness of the arts in the United Kingdom is one of the more important 'draws' for tourists. The funding system has recently undertaken a number of projects with the regional tourist boards, English Tourist Board and British Tourist Authority. This partnership should be continued: its success is to the benefit of the economy in general and the arts in particular.

Conclusion

Inevitably, much of the funding system's work is focused on artists and arts organisations. But this is a means to an end – the end being to serve the public by supporting the arts. It is part of this duty to seek to remove barriers to enjoyment of the arts – whether the barriers are what this chapter calls artificial (based on unwelcoming arts buildings, inadequate information or unnecessary conventions, for example), economic, physical or psychological. **Wherever they live, whatever their circumstances, people should have a genuine opportunity to enjoy the arts, as audience and participants.**

It is a complex and long term matter to make a reality of this ideal. This chapter has suggested a few of the necessary steps, ranging from substantial practical improvements in provision for disabled people – including issues of representation, employment and training as well as physical access – and planned and targeted programmes of offers and concessionary ticket prices, to partnerships with broadcasters. Effective and imaginative marketing, and a proper valuation of the marketing function within arts organisations, have an important part to play in encouraging people to take up available arts opportunities.

Such improvements in availability must be coupled with the maintenance, or enhancement, of quality: the strategy exercise suggested that, where a choice is necessary, quality should be in general a higher priority than quantity.

CHAPTER 7 · CULTURAL DIVERSITY

Public funding of the arts tends to reflect the pattern of what *is*, rather than what *might* be. Without a high degree of flexibility and responsiveness it may actually inhibit rather than encourage the development of cultural diversity and cultural exchange. In a fragile subsidised arts environment the strength of existing institutions may appear as a potential or, in some cases, a real obstacle to other interests. Much of this book is about the value and methods of promoting cultural diversity.

'Cultural diversity' is a term difficult to define. In this chapter it refers to art produced by or for the specific communities or cultures which make up British society. Not all art produced by women or disabled people, say, will come under this heading: cultural diversity depends in part on self definition, and artists may not choose to be so defined.

In the publicly funded sector the desire to support cultural diversity has been expressed in part through policies of equal opportunity; in the commercial sector market forces have led the way. In some cases the latter has been more successful. The contribution of Black cultures to popular music and dance, for example, is widely recognised, but it is not reflected in patterns of public funding. This does not mean that equal opportunities policies are of no value; it does mean that they require more than good intentions. **The vital requirement is for equal opportunities policies to generate genuine change within organisations, rather than to be viewed as bureaucratic hurdles and constraints – something that has to be done. This is as true for the funding system as for arts practitioners.**

Cultural priorities

The United Kingdom is made up not of a single culture, but of a multiplicity of cultures, cultural groupings and aesthetics. None of these groupings – such as women or people of Indian origin or disabled people – is itself homogeneous: there is as much diversity within as outside them. But part of individuals' sense of identity arises from the groups to which they belong. **'British culture' is neither a single concept nor a set of neat packages labelled 'youth culture', 'women's culture' and so on: it is a kaleidoscope, constantly shifting and richly diverse. The aim of the funding bodies should be to reflect, encourage and support this diversity.**

But there are real dilemmas as to the form of this support. Identifying 'disadvantaged' groups as a focus for attention risks both being patronising and ending up with the vast majority of the population in this 'disadvantaged' category (women, young people, old people . . .). Focusing on only a few such groups is exclusive. Using a quota system, although a useful way for setting targets ('2½% of the population is of South Asian origin, so 2½% of arts funding money should go on South Asian arts'), can also be mechanistic and may prevent cross-cultural work. Too often, such minimum targets are regarded as absolutes and are crudely applied. The percentage of available funding going to theatre is determined not by the number of theatre lovers, but by the development needs of the art form. Similar criteria should apply to the funding of culturally diverse art.

Consultation on these issues suggested three conclusions.

First, there are many artists and arts organisations whose work springs from and pays tribute to specific communities, whether Black, gay or disabled. If the art is of high quality, and only if it is of high quality, then it deserves support. Art has a wide range of benefits, sources and meanings, including the political, social and economic. But **for the arts funding system, artistic quality and import-ance must be the principal criteria for support.**

Second, **where an organisation is a major cultural resource for its area, town or the country as a whole, it should seek to reflect the mixed nature of the community it serves.** Arts organisations which are inherently diverse, notably arts centres, are particularly well placed in this respect. But this is no less a responsibility of buildings and organisations devoted to single art forms.

Third, **the staff, advisory systems and governing bodies within the funding system should reflect Britain's diverse cultures.** The strategy consultation process provided opportunities to meet for groups representing a wide range of interests, including people with disabilities, folk enthusiasts, lesbians and gays, amateur artists and Black artists. They were united by two perceptions: that they had been denied public funding as falling outside the 'mainstream'; and that the cultural interests they represented were not adequately assessed or given support and encouragement by the arts and media funding system – that they were doubly excluded.

The current advisory structure is largely dependent upon people who through their employment or other sources of income are able and prepared to give their time voluntarily. The Crafts Council pays its advisers at the same rate as jurors. The rest of the funding system should be prepared to pay for the advice and time of those many people (including the majority of artists) who are self-employed but could strengthen decision-making processes.

One of the themes of the consultation process was that a number of areas of artistic work and practice had not received due attention, or had even been discriminated against in terms of practical support and funding (despite, in many cases, strong advocacy and expressions of commitment from arts funders), and

were now in urgent need of such support and funding. What follows are some of the examples, selected to illustrate the issues of cultural diversity.

Disabled people and the arts

In recent years many disabled artists have been working to have disability arts recognised as a cultural practice in its own right, incorporating a number of different forms which express the relationships that disabled people – themselves a very diverse group – can have with the world around them and among themselves. The emphasis is on the identity of disabled people, their place in society and on their 'visibility' in a world which fails to understand the effects of disability and the creative contribution that disabled people can make. Disability arts practice is by, and largely for, disabled people, and disabled people should play a key role in its assessment. For example, deaf people share similar experiences of the world and in general have sign language as their first or only language. Arts using sign language are important to much of the deaf community, and largely unique to it. Funding bodies have in the past done little to support such work.

Disabled artists face problems of both practice and principle arising from society's failure to take their needs into account. One practical problem relates to the benefit system – see page 44 above. Another is that disabled artists often depend on the funding system for their additional needs. For instance, the specific touring needs of Graeae theatre company include special transport and the requirement to stay in (usually expensive) hotels with facilities for disabled people. This requires extra resources and a sensitive and flexible attitude on the part of the funders.

There is also the issue of disabled people's representation in the arts and media – an issue which crosses all art forms. One has only to examine poster images of disabled people, or how they and their disability tend to be treated as 'the problem' at the heart of a play rather than being portrayed as ordinary members of society, to see how important this is. The funding system should provide support for disabled and other artists to construct new, positive and unpatronising ways of depicting disabled people. **It should, in summary, ensure systems for assessing disability art on its own terms; support projects and organisations arising out of disability cultures, with disabled people fully involved in that assessment; encourage the development of disability art forms through participation and public performance; and in appropriate cases provide revenue support for companies of disabled artists.**

Black arts

The arts in Britain have been greatly enriched by many ethnic groups: people of

African, Caribbean, and South Asian origin; Chinese, Vietnamese, Irish, Cypriot, Polish and other Eastern European communities. Some of these groups practise their traditional arts largely to preserve links with their cultural roots, but in the main the arts have had an important function in helping communities to develop their identity within British society. This section focuses on the arts of Black cultural groups, as an important example (for this purpose, 'Black' includes people of African, Caribbean and South Asian origin). For these groups, the arts have a critical social and cultural purpose in identifying a place in and a relationship to a predominantly White society. In some areas of the arts, such as popular music, Black artists and influences predominate, though the business interests that control these sectors are largely White. Furthermore, in many parts of Britain non-Western European arts activities are a major contributor to local culture; for example through Indian festivals and the strength of Asian dance teaching in Leicester, and the creative and participatory opportunities offered by carnival in London and some regional centres.

But there are few Black people in senior positions in the arts, outside of specifically Black arts organisations. The Cave in Birmingham, Talawa Theatre Company's new theatre in London and the Nia Centre in Manchester are rare current examples of public sector support for independent Black arts venues. There is an expanding and dynamic Black arts movement which despite its contribution and its popularity tends not to receive the recognition and level of investment from funding sources which would allow it to achieve its full potential.

From the viewpoint of Black artists and administrators, it is the lack of long-term and 'structural' funding which distinguishes the treatment of Black and White institutions. They note that most of the leading funded Black arts organisations in London in the early 1970s subsequently had their funding withdrawn, while funders kept faith with their White counterparts and enabled them to become secure and respected institutions. It is vital that the funding system should be and appear to be even-handed in its approach to the support of arts organisations of all origins.

There have long been calls for a specific fund to facilitate investment in the Black arts economy, developing training, materials and new initiatives. Such calls are a sign of the funding system's failure to instil confidence about its commitment to Black arts. **There was a strong feeling among most of the Black artists and organisations participating in the consultation process that the creation of such a fund would be a crucial step in shifting the balance of power in the arts.**

It is appropriate also to repeat here the principal recommendations of the report *Towards Cultural Diversity*. Though the report was written for the Arts Council, they are relevant to the funding system as a whole, and most remain to be implemented. The funding system should:

(i) establish funds to assist Black companies, organisations and groups to obtain a building base for their work (see Chapter 12);

(ii) maintain and expand development resources to secure and encourage innovation in Black arts;

(iii) create a place for Black arts organisations and groups within each funding category or objective;

(iv) institute codes of practice for monitoring cultural diversity;

(v) expand training schemes with an emphasis on arts administration and technical skills for Black individuals and organisations;

(vi) increase advocacy of Black arts with government, local authorities and other relevant agencies; and

(vii) increase the Black representation within the system's management and advisory structures.

Women and the arts

The position of women in the arts reflects the position of women in society as a whole: although they are more than 50 per cent of the population, they are under-represented in decision-making, management, and organisational processes. Until recently, their influence has been equally under-represented in 'official' histories of art. The contribution of women to the arts has been particularly underrated as practising artists, in employment and management, in funding, and in education and training.

Women as artists. The 'rediscovery' and promotion of women writers by publishers like Virago and Women's Press have helped to change many people's view of the history of literature. This trend has not extended across the art forms: performance of work by women composers is rare, and men still dominate the visual arts and are the most produced playwrights. The same is true for interpretive artists such as directors and conductors: women are a small minority. There has also been an undervaluing of those arts and crafts – such as textile work – in which women have been pre-eminent. This is changing (witness the support given to the development of textiles by the Crafts Council and the Regional Arts Boards) but not fast. The system should review its policies for the support of women as artists and ensure that selection and assessment processes are genuinely open, fair and representative.

Employment and management. Recent research commissioned by Equity and published as *Equal Opportunities in the Mechanical Media* (cinema, television, commercials and radio) showed that women have fewer opportunities for work than men. They play fewer different roles, earn less than men throughout their working careers; and have their career at its busiest up to the age of thirty (compared with forty for men). There are many women working in the arts but far fewer at a senior level in either artistic or administrative posts, or on the (unpaid) governing bodies and boards of arts and media organisations. The very conditions of work tend to place a premium on a level of dedication and mobility that is difficult to reconcile with family commitments – which in practice bears down particularly hard on women.

It is in the interests of the arts as well as of fairness to resolve these issues. It requires a more positive attitude towards employment practice, taking into account child-care provision, career breaks for raising families, adequate parental leave, flexible working hours and improved systems of internal promotion and career development, so that able staff have the opportunity to advance their careers without having to uproot themselves.

Funding. Funding for many projects which explored women's issues through art and for support organisations for women artists was lost as a result of the abolition of the metropolitan authorities and financial pressures on others. Both forms of funding are necessary if the work of women artists is to achieve its full potential and reach a wide audience.

Education and training. Although traditionally women have been encouraged to take up arts subjects, the curricula of arts courses at all levels tend not to take account of the practical circumstances of many women's lives or particular issues arising from the relationship of women to the arts. Training programmes for women should work around the disjointed nature of many women's careers, which may be broken to raise children. The National Vocational Qualifications currently being developed are potentially advantageous, because they can be gained over a longer time and may be earned in the workplace and through short-course training as well as through more formal education. The funding system should work with the training authorities, providers of training and arts organisations to ensure that training opportunities are available to equip women with the skills and confidence to operate in areas of employment where they are currently disadvantaged.

To sum up, the needs of women in the arts are for recognition, respect, resources and the power to use those resources. In addition, the funding system should work with arts organisations not only to combat discrimination in attitudes towards women at work, but also to abolish practices which may be indirectly discriminatory under the case law and guidance which have grown up around the Sex Discrimination Act – such as unfair recruitment procedures and lack of provision for career breaks.

Children and the arts

For children, the arts are inseparable from the fantasy and play which are so important to their development, education and enjoyment of life. But outside school, arts provision is mainly intended for adults or at best for young people from twelve upwards. There are many exceptions, including traditional Christmas shows and pantomimes, the work of specialist performing companies, and events, often with a strong educational or participatory element, put on by libraries, museums, galleries, cinemas and arts centres. But the distribution of these activities is uneven and there has been relatively little attempt to integrate the arts into children's own activities as opposed to those which are provided *for* them.

The National Children's Play and Recreation Unit based at the Sports Council has attempted to raise the profile of children's play and provision for it. Its recent pilot projects have used professional artists in both training play-workers and working directly with children. Artists have also been used to construct play sculptures and spaces which encourage imaginative play, expose children to the arts in an environment which they can enjoy, and incidentally create works of art to appeal to people of all ages. The playground in Grizedale Forest, Cumbria, is a fine example. Nonetheless, participatory arts provision for children is still limited in scope. There is scope for permanent arts-based projects for children in the country's art galleries, generating the interest and educational benefit of the projects at the Natural History Museum or EUREKA in Halifax, for example. **New technologies (such as interactive video and virtual reality), combined with artistic vision and children's insatiable demand for new and creative experiences, could generate exciting activities if properly resourced. The funding system should encourage and support any move in this direction.** Furthermore, radio and television programmes can be important means of helping children to develop their imagination and creative skills. Children's broadcasting should be an area included in partnerships between the funding system and the broadcasting companies (see Chapter 15).

Parents and children. Where children are involved, parents also are affected. The public attitudes survey showed that the presence of young children causes a major reduction in attendance at arts events; less so in participation, particularly if the activity can be home-based. Other than where programmes are designed specifically for children, arts organisations tend not to take full account of the needs of people with children. In such areas as timing and opening hours, the arts sector is set in its ways, with museums and galleries generally confined to daytime opening, and performing arts events scheduled almost exclusively in the evenings. Experimentation on both sides could lead to a broadening of attendance: the funding system should encourage this.

The issue of parents and children is, in part, practical: provision for wheelchair access also helps people with prams and pushchairs. But **arts organisations**

should see the presence of children as an opportunity, not an obstacle. They should make judgement about age limits based on the suitability of the material presented, not on assumptions about the behaviour of the audience. Arts activities should be provided which parents and children can attend or participate in *together*. If the activity is not suitable for children, separate and simultaneous arts provision should be made for them — for instance, specially designed programmes in museums. A crèche on its own may be valuable, but may be unduly passive.

Young people and the arts

At the Youth Clubs UK conference *Developing Youth Arts Policy* in October 1991, Rachel Feldberg of Red Ladder theatre company said:

> You can't work with young people and ignore the significance of music, fashion, clubbing, Bhangra, home recording, dance, karaoke, soaps, TV, rap, graffiti and so on . . .

> In this country we have cut off the arts from everyday culture; they become something that happens in theatres or galleries behind closed doors. Instead of developing young people's enthusiasm, arts are part of a structure which excludes them, confirming their worst suspicions about 'culture' and convincing them of their inadequacies.

> In the face of this, conventional arts wisdom has only two options: either struggle to educate young people, so that they can appreciate the beauty of the objects locked in the institutions; or interpret their activity as a radical oppositional culture and leave them to get on with it. Most education and outreach programmes stem from the first. The second is deceptively simple. It works on the premise that all young people have the freedom, confidence and resources to get involved in whatever activity takes their fancy.

This is a neat summary of one of the themes of this book — one which applies not merely to young people. Education as an issue is discussed in Chapter 9. This section considers young people's involvement with the arts.

Excluded or involved? The public attitudes survey showed that most young people are involved in the arts, as broadly defined: people aged between 16 and 24 have the highest level of attendance (91%) and the highest level of participation (66%) of any age group. Young people form the highest audience of any age group for the cinema (81%), pop music (46%) and rock music (30%), and are major attenders of museums (32%) and plays (24%). In many forms of arts participa-

tion, from disco dancing to woodwork to drama, young people are more active than their elders.

But this does not mean that young people are well supported by the funding system or existing youth structures, or that youth arts are equally available to all. The survey also suggested that young people generally have a considerable interest in many areas of the arts, which declines as they get older; and that education, especially higher education, is a primary influence. This waning of interest may be natural in many cases. In others, it indicates that there is inadequate assistance for young people to develop their arts interests in later life.

Opportunities for young people. As was noted in Chapter 6 (page 69), the attitudes survey showed that young people are the least satisfied of any age group with the level of arts provision available to them, and the most concerned about the price of arts activities. It also showed significant demand by young people for mainstream visual arts and theatre: practical and economic barriers are preventing enjoyment, not merely a perceived 'cultural exclusivity'. This suggests strongly that **there is still a value to outreach work, and ways must be found of making mainstream arts activity more accessible;** this was an issue discussed in Chapter 6.

Engaging with young people. Young people's cultural activities most often occur outside institutional structures – playing and listening to a wide range of music, television and radio, dancing and fashion. Commercial and media interests appear to understand young people's needs well, largely perhaps because they appreciate their value as a consumer group. Conversely, young people know how to select and interpret commercial and media products in order to suit their own interests and styles.

The funding system and funded organisations must be able to relate more closely to young people's interests, and to intervene where the market fails them. For example, although the commercial market may encourage young people to look at the creative use of technology, it is largely through subsidy that facilities can be provided such as video equipment, training, rehearsal and recording facilities. **Young people should be involved more in the processes that make decisions about their needs, rather than have those needs identified and provided for by others.**

The youth service and youth clubs, whether local authority or independent, have made a significant contribution to the development of the arts among young people (albeit only a minority). The concept of 'youth arts' has developed through this sector. This phrase is a useful shorthand, but it is not a description of a discrete art form: that way lies a separate and marginalising approach. The interests of young people should be dealt with as an integral part of arts provision and support, not as a separate category.

Provision for young people has become a high priority for RABs and the Arts Council, working in partnership with youth organisations and the local authority

youth service. The conference *Developing Youth Arts Policy* concluded that every youth service should have a policy for the arts backed by a sufficient budget and a commitment to training youth workers. This conclusion should be commended to local authorities, and the funding bodies should work with them to make it a reality.

Arts organisations themselves are equally important in this area. There are many arts projects dedicated to working with young people, including theatre for young people; theatre in education; community arts projects such as Jubilee Arts in the West Midlands; combined arts projects such as Artswork (part funded by independent television companies, representing another side of the broadcasting companies' interest in young people); and youth-oriented arts centres combining a mixture of cultural influences, such as the Waterfront in Norwich, the Leadmill in Sheffield and the Roadmender in Northampton. In common with many community- based projects, work of these sorts with young people tends to be low on the list of arts funding priorities. Support of arts work with young people is critical to their developing and sustaining an interest in the arts, which may last throughout their lives. They must have the opportunity to engage with the arts outside school in ways that suit them.

Old people and the arts

Chapter 2 (page 22) highlighted the predicted increase in the number of older people over the coming years, particularly a large increase in the number of people aged over 80. The opportunity to become involved with the arts decreases with age for many reasons, such as infirmity, mobility problems, isolation (especially in rural areas), economic difficulties and fear of going out at night. Many people develop sensory disabilities as they get older. But these problems are not unique to old people, and not all old people face them. Old people have the same rights to attend and participate in the arts as anyone else. As their numbers increase, it becomes even more important that arts opportunities are available to them in forms which meet their needs.

Many of the measures which are part of providing opportunity and choice to the population generally are particularly relevant to old people: good physical access to arts buildings (Chapter 12); more daytime activities (discussed above in relation to parents and children); the retention of adult education and distance learning opportunities (Chapter 9); a broad range of arts broadcasting, including arts programmes on daytime television (Chapter 15); and greater provision within residential institutions and homes (Chapter 6). Some apply more to old people than to others, such as community-based activities involving artists and writers, particularly oral history and reminiscence projects, which may result in plays, books of poetry and prose, videos and exhibitions.

The funding system should ensure that its policies take full account of the needs of older people. As with young people, the focus should be on their involvement rather than on prescribing *for* them. Where necessary, studies should be commissioned into the particular needs of older people, to inform policy and practice.

Lesbian and gay people and the arts

No discussion document was written on the issues of lesbian and gay people and the arts; nor, originally, was a consultation seminar scheduled. But one was held in response to calls from lesbian and gay artists and administrators. The contribution of lesbian and gay artists to the arts in Britain and worldwide is indisputable, yet their position in society is precarious. Those who declare themselves in favour of freedom of speech often seem to make an exception for lesbian and gay issues - witness section 28 of the Local Government Act 1988, which seeks to limit an area of artistic expression. The demands of the lesbian and gay communities are largely similar to those of other cultural groups: recognition of their art as an expression of their culture and experience, support for their artistic practice, peer group assessment, and a rejection of apparently discriminatory policies. In other ways their position is unique because of legislation restricting their activities. In addition it is common for arts organisations' equal opportunity policies to be limited to issues of gender, race and disability and not to include sexual orientation.

Sexual orientation is an improper ground for discrimination in employment and training in the arts. This should be made explicit in the funding system's equal opportunities statements and policies, and in those of funded organisations. The system should support further opportunities for the gay and lesbian arts community to meet and develop their ideas and policies and should work with that community to assist it develop its own policies and practices.

Many lesbian and gay artists feel that the funding bodies seem unapproachable, unsympathetic and unaware of their needs. Ways must be found of overcoming these perceptions. Lesbian and gay respondents to the strategy consultation argued that each funding body should designate an officer with responsibility – and a budget – to deal with lesbian and gay arts, and that awareness training should be provided for staff, board members and clients.

Conclusion

The mixture, and yet the distinctiveness, of cultures in Britain is unique.

But funders and others who work in the arts could do far more to assist in the achievement of true cultural diversity – a 'culture of cultures'.

The cultural groups discussed in this chapter have two factors in common: they are part of the richness, variety and excitement of the arts in Britain: and many of their members feel that, as cultures in their own right, they have been marginalised, patronised and disenfranchised by the funding system. The chapter has suggested how, both by general measures and by specific initiatives, Britain's diverse cultures can be supported to achieve their full potential.

CHAPTER 8 · ENCOURAGING PARTICIPATION IN THE ARTS

Among the most significant features of the public attitudes study were its findings on the level of participation in the arts and the contribution that the arts make to community life. More than half the population participates in the arts in some form, and such participation sustains many folk and traditional arts and crafts around Britain. For many people, 'doing' is as important as 'seeing', or more so. It is sustained by enthusiasm, skill and self-motivation. It is unregulated and largely unfunded but it has its own structures and economy; its importance is undeniable.

Coincident with the development of this strategy two other important reports have been published: *Amateur Arts in the UK*, commissioned from the Policy Studies Institute on behalf of the newly created umbrella body the Voluntary Arts Network; and *Arts and Communities*, the report of the National Inquiry into Arts and the Community. Both are concerned with participation in the arts, though approaching the topic from different perspectives. Indeed, historically, the subject has been bedeviled by problems of definition, a fact recognised but not resolved by the two reports.

In the view of the National Inquiry, in its Interim Statement:

> Amateur arts is primarily the practice of the arts for its own sake.
> Community-oriented arts is arts with additional social purposes. These
> include personal development and social cohesion; expressing or reinterpreting
> cultural, religious or ethnic affiliations; articulating feelings about social
> issues or local problems; and stimulating or contributing to local action,
> democracy and change.

The PSI report argues that the amateur arts, like all human activities, are practised for a mixture of motives; that the 'additional social purposes' of community- oriented arts can be found in the amateur arts; and generally that there is a high degree of overlap. The report suggests that the primary distinction in practice is that amateur arts are self-motivated and self-organised whereas:

> community arts programmes and projects tend to be initiated, or at least
> facilitated, by those paid to take initiatives, whether community artists,
> animateurs, community workers, local government officers or others.

Part of the distinction may also lie in the amateur arts' focus on people

applying their own creative skills, against that of arts in the community on helping people to explore and develop as yet unrealised skills.

The distinctions are important not least because they have affected the attitudes of the arts funding bodies: they have traditionally taken more interest in the community development potential of the arts, largely through the funding of community arts projects employing professional workers, than in the amateur arts. But emerging from discussions of these two reports is a greater acceptance of the common ground. **Both areas of work are concerned with the provision of opportunities to practise and enjoy the arts, to exercise and develop imaginative talent and capability. The distinctions are rarely useful: it is time now to emphasise what unites rather than what divides these two streams of participatory arts.**

The amateur and the professional

> *To the many problems the theatre has to confront in the provinces there seems to be added, nowadays, the mounting strength of the amateur theatrical movement.*
> *Arts Council Annual Report 1951/52*

Forty years on there is still a residue of disdain for amateurs by the professional arts community – and in some cases, vice versa. But there is also a greater understanding of the role of the amateur and the volunteer in arts development.

The figures in Chapter 2 (page 21) demonstrated the scale of the amateur movement. The basic point to be made here is that amateur and professional arts are not two separate and distinct worlds. In the words of the PSI Report:

> **The amateur and professional arts are intertwined and interdependent; the term 'amateur' is not unambiguously separated from 'professional'; rather than a clear amateur/professional divide, there is a complex amateur/professional continuum or spectrum of ambition, accomplishment and activity.**

There are three points to be made which embellish or qualify this statement. First, this continuum is clearer in some art forms than in others. Choral music in Britain is sustained by amateur choirs, many of which perform at the highest level of expertise in concert and on record. Several are associated with the leading symphony orchestras and have professional chorus masters and conductors. Furthermore, the National Federation of Music Societies has done much to develop skilled volunteer promotion of music at local level. In drama, on the other hand, there is often a greater distinction between the amateur and the professional, with clear links existing only in particular cases, such as the community play movement

and young people's theatre. It is, perhaps, for creative artists – writers, visual artists, craftspeople – that the image of a continuum is most apt. When a writer for the first time receives payment for a radio play, has she suddenly become 'professional'?

Second, an emphasis on the distinction between amateur and professional can be irrelevant or even damaging to emerging arts organisations. This is exemplified by the following statement (made some years ago) by Jatinder Verma of the Tara Arts Group:

> Over and over again, attempts have been made to categorise us as either 'professional' or 'amateur' or 'community arts'. Tara is an Asian theatre group, drawing upon the resources and skills of the community in London and is held together by two full-time workers. Clearly it is not a 'professional' group, except in standards of presentation. Nor is it an 'amateur' group. Which amateur group has a consistent programme of touring productions throughout the year, productions which are toured around the country? And Tara is not a 'community arts' group either; only two of its twenty members are full-time workers, and the group works solely in the medium of drama.

Tara Arts has since developed substantially; but this state of 'in-betweenness' typifies many emerging arts organisations, particularly in such fields as Asian arts and disability arts.

Third, with artistic quality as the overriding criterion for funding, the amateur/professional distinction is unhelpful.

A footnote on local authorities. Local government has traditionally been the major funder of the amateur. In fact, the sole contribution of some councils to the arts has been through the funding of local amateur groups. Local education authorities have over many years provided support for activities such as youth orchestras, bands and theatre companies. But this situation is changing fast. On the positive side, local authorities with arts budgets and policies have taken on the support of amateurs and professionals as equal parts of their local responsibilities. On the negative side, the introduction of local management of schools has made it more difficult to continue support for extra-curricular arts activities, particularly those requiring co-ordination between schools. It has also, in some cases, meant the introduction of room hire fees which are restricting the use of school premises by amateur and adult education groups.

Arts in the community

Community-based activity is highly valued: in the public attitudes survey, 79% of respondents felt that the arts bring together people in local communities. But it

has tended to be regarded as a local issue, requiring no national input. Support structures for arts in the community are weak and are characterised by a diversity of institutions and policies, combined in many cases with patchy and short-term funding. The picture across the country varies from region to region and differs between local authority areas. Community-based provision has a great deal to lose from pressures on local government arts budgets; and thus a great deal to gain from the introduction of a statutory responsibility on local authorities to support the arts, attracting revenue support grant from central government (see further Chapter 10). **Arts in the community are indeed a local issue; but they need and deserve advocacy and support at all levels.**

Support structures and the role of the funding system

The earlier parts of this chapter contained important statements of principle. What should happen in practice?

(i) The funding system should ensure that it has the staff and resources to support participatory arts (whether provided by amateur groups or community-based activity) at a national and regional level, through advocacy and policy development. Support of participatory activity should be included as an important element of RAB and national funding body plans.

(ii) The system should provide practical support for amateurs in a variety of ways, through funding umbrella organisations (see (v) below), funding professional input (as is currently done with music societies and via animateurs, for instance), providing training for amateur promoters and others, involving amateurs in decision-making processes and lobbying on behalf of the amateur.

(iii) The system should encourage programmes to draw together the wide variety of interests and practices – professional, amateur and community-based – which exist within each art form. In relation to dance, the animateur movement and the national dance agencies provide an obvious focus; similar initiatives are under discussion for literature, building on the work of animateurs, writers' and readers' groups and partnerships with public libraries. The concept can be extended to other art forms.

Participatory arts activities are essentially locally based. But there is a place for a representative national voice – not as another layer of bureaucracy, but in order to assist networking at local level and to provide an overall view of and advocacy for

good practice in this area. For the arts in the community, this role was performed by the Arts Development Association (ADA); its demise in early 1992 left a major gap. For the amateur arts, the Voluntary Arts Network (VAN), which had its origins in a Carnegie UK Trust conference of 1988 and which commissioned the PSI report, has now been formally established under the chairmanship of Sir Richard Luce and is able to represent a wide range of participatory arts interests. It seems unlikely that a national body could be formed at present to speak for all aspects of participatory arts. Accordingly:

(iv) The funding system should consider providing support for VAN to act as the national voice of the amateur arts, to build bridges with other areas of the arts and to spread good practice throughout the amateur movement.

(v) The Arts Council and some RABs provide recognition and support for the National Federation of Music Societies; the BFI similarly for the British Federation of Film Societies. They should consider extending this support to representative amateur organisations in other fields and art forms.

(vi) If there were an initiative to establish a national body to act – as the ADA was doing in effect – as a national voice for arts in the community, the funding system should support it in principle.

(vii) Finally – and to preview discussion in the next chapter – adult education is important to participatory arts activity, and deserves partnership and advocacy from the funding system.

Folk and traditional arts

Folk and traditional arts are included in this chapter both as an example of a participatory art form and as an important special case. As Ros Rigby, author of the discussion document on folk arts, pointed out:

> The folk arts are amateur arts in the true sense. Done for the love of the activity, they can be pursued for enjoyment, and there are examples of many practitioners who have not chosen to make a living from their skill.

However, while they are largely practised, performed and promoted at an amateur level there is also a large body of professional folk artists working and recording at a national and international level.

The folk and traditional arts field is made up of paradoxes. Folk arts can

transcend both national and art form borders, yet are locally based and specialised. At their worst they can be inward-looking; at their best they can celebrate the diversity of cultures in the United Kingdom, both indigenous and originating throughout the world. Traditional arts activities form the basis of many community celebrations and events among diverse cultural groups, from well-dressing in Derbyshire to the Caribbean tradition of carnival; yet to some their image is exclusive.

The influence of folk traditions is felt across many art forms. For example, most nineteenth and twentieth century composers have been influenced by folk music in some respect, as have a number of pop and rock musicians; storytelling is a traditional practice that has had an important influence on some literary forms; and folk arts have nurtured many performance and practical skills. The public attitudes survey showed that the audience for folk music is comparable in size to that for, say, contemporary dance, jazz or opera, and that participation in folk music is as high as or higher than in most other forms of music requiring instrumental skills.

In common with many amateur pursuits, the organisation of folk arts through self- supporting clubs and societies, in many ways a major strength, has left it neglected by arts funders. This protects it from being 'institutionalised' but it also means that development work is difficult to sustain. There are of course exceptions to this: a number of RABs fund folk music development projects.

The significance of folk and traditional arts as performing and participatory activities, their influence on other arts activity, their diversity and scale, and the excellence to which they can aspire mean that the funding system should provide more support for them in the future than it has in the past.
The funding bodies should, for instance:

(i) commission a feasibility study into the provision of a national working archive or archives to strengthen the study of folk traditions and help their contemporary development;

(ii) consider whether the public profile and artistic awareness of folk music or other performance forms would be raised by establishing a touring network on the lines of the Contemporary Music and Early Music Networks;

(iii) lobby for folk and traditional arts to be part of the arts components of the national curriculum in England: they are already part of the Scottish and Welsh curricula;

(iv) consider with folk development workers whether the network of folk arts

development agencies, such as Folkworks and Traditional Arts Projects, might be extended to other regions, providing educational, training, promotional and marketing services to folk artists, participants, promoters and audiences; and

(v) ensure that their national and regional advisory structures contain appropriate skills to assess and help to develop folk arts policy and practice.

Conclusion

Participatory arts of all sorts are among this country's chief artistic glories. In many respects, the level and quality of participation in the amateur and community-based arts in England (indeed, the United Kingdom) is second to none. The need to beware of false distinctions in the arts is stressed repeatedly through this book. Two such distinctions arise in relation to the participatory arts: the 'external' division between amateur and professional on the one hand; and the 'internal' division between amateur and community-based arts on the other.

Differences of emphasis between these aspects of the arts should be seen as enriching rather than divisive. With quality as the key criterion for support and assessment, the concept of a continuum or spectrum of the arts is far more fruitful than one of watertight categories. This has significant implications for arts support. All parts of the funding system should be prepared and equipped to support participatory arts through advocacy, practical assistance and financial help towards, for instance, training, professional input, and the costs of representative bodies. Folk and traditional arts were discussed in this chapter as a special case of (in general) participatory arts activity, in respect of which the funding system should provide more support than in the past.

CHAPTER 9 · EDUCATION AND TRAINING

Education and training are dealt with as complementary topics in this chapter because much training in the arts is inseparable from education – becoming an artist is a vocation, an intellectual activity and a process of learning practical skills. Yet in the formal arts education sector, there is a keen debate about the relationship between the academic and the practical, exemplified by discussion in the film, video and broadcasting sector about further and higher education on the one hand and National and Scottish Vocational Qualifications (NVQs and SVQs) on the other. Concerns have been expressed on such issues as whether the introduction of vocational standards will mean a standardisation of learning, and whether an emphasis on practical skills might lead to an undervaluing of the ability to think creatively. The informal arts education sector, including adult education and community-based participation, has been less concerned with perceived distinctions between learning skills and other aspects of education; this chapter adopts a similar approach.

The importance of education

Of all the issues dealt with in this book, education is perhaps the most important. It is at the heart of developing an interest in and an understanding of the arts and media. Recognition of the importance of education in the arts and the arts in education was the major factor common to all parts of the strategy consultation process. These were some of the areas highlighted:

(i) People *learn* to understand and appreciate the arts: such skills are not innate.

(ii) Education through the arts fosters creativity in areas beyond the arts, cultivates the imagination and develops manipulative skills and critical judgement.

(iii) It is through the education systems and networks – formal and informal, for children and adults – that the arts will come to be seen as a central element in society.

(iv) A society in which learning about and participating in the arts go hand in hand will be a society in which talented young people will feel

encouraged to make their careers in the arts: a virtuous circle will be established.

(v) While some artists can exist in isolation from their audiences, most art needs audiences: an adventurous and (in the broadest sense) educated audience is vital to the long term health and development of each art form and the arts in general.

(vi) Education is central to acquiring that sense of history and of place on which so much arts development rests.

Education is a lifelong process which takes place through play, formal teaching, participation, personal enthusiasm and experience, developing practical skills, and contact with others' knowledge and enthusiasm. Formal education is a critical part of this process but it is not a sufficient basis for appreciating the arts; many people do not follow up their experience of the arts in school once they have left and indeed many reject them as a result of bad experiences at school. The author J.L. Carr, responding to the consultation process, related a story of his own sisters and brother being introduced to literature and music at school:

> I recall Schumann's *Two Grenadiers*, Conrad's *Gaspar Ruiz*, Tennyson's *The Revenge* – they used to sing or recite them about the house. They left school at sixteen and that was the end of it. All three of them. Their enthusiasm stopped. . . . Why for the rest of their lives wouldn't they go a dozen yards out of their ways to see a Rembrandt? It's mysterious . . . Why do so many graduates seemingly believe that their education stopped with their degree exam?

Education in the arts

To encourage education in the arts should be, and to an extent is, a principal function of the arts and media funding system. It has initiated and supported influential programmes and posts in arts organisations and with education providers. The BFI has been particularly active in its provision of materials and publications for media education. In early 1992 the Arts Council published a campaigning and information booklet, *Drama in Schools*. RABs and the Arts Council have championed the introduction of artists into schools, as well as encouraging arts organisations to introduce education programmes and officers.

Much of the initiative has come from arts organisations themselves. In many areas of work, including visual arts, drama, music and participatory arts, they provide many of the informal education opportunities. Their work may be

prompted by a wish to develop audiences (education as a long-term marketing strategy) or to develop individual and collective expression, or, more commonly, both. Theatre in education and young people's theatre, for example, are important means for young people to learn through, about and with drama. The growth of imaginative education projects by our leading chamber and symphony orchestras has been one of the great success stories of the past ten years. It has, moreover, demonstrated that young people can find the close exploration of contemporary music, linked to their own creation and performing of music, both challenging and absorbing. Education programmes by art galleries and museums can include interpretation, art in the community and residencies, as well as events and activities in the galleries themselves. At their best, such projects are absolutely integral to the work of arts organisations.

Despite these positive developments, however, education still too often remains – in resource and management terms – on the margins of the arts and of arts organisations, vulnerable to budget cuts and policy changes. National funding agencies do not employ education specialists in sufficient numbers or at a sufficiently senior level for them to make a major impact (although the BFI has made a big impression on the teaching of media studies in schools), and at a regional level the picture is patchy.

The central place of education in the arts should be reflected not only in the funding system's own staffing and policies, but in the support and funding which it provides for arts organisations. If it believes that education should be a key part of its work, it should fund it as such, not as an optional extra.

The arts in education

Since the 1988 Education Reform Act the pace of change in the formal education sector has been phenomenal. This document can only highlight the direction of that change and the challenges that it creates.

Schools

The role of local education authorities (LEAs) as direct education providers is diminishing rapidly. Measures such as local management of schools (LMS) and opting-out of local authority control mean that schools are becoming more responsible for their own finances and management: within the school system, they must, for instance, prioritise arts spending within the whole range of demands on their budgets.

At the local authority level, instead of specialist advisers there are increasingly general advisers, or inspectors with some specialist responsibilities; as a result there is far less strategic planning in arts education. There is a trend for discrete

services, such as instrumental teaching, to be in effect privatised, with individual schools negotiating for the service. In consequence, the onus for developing arts education is placed on the school, without the support previously available from the LEAs. This poses real threats to further progress in arts education: specialist expertise and enthusiasm are vital, and development in the past has depended not only on commitment at the level of school or teacher, but also on partnerships between LEAs, funding bodies, arts and media organisations, artists and practitioners. There is evidence from recent research in Yorkshire and Humberside that the work of artists in schools is diminishing as a result of LMS.

There are problems also with the place of the arts in the national curriculum. At the time of writing, visual arts and music are the only arts to be core subjects in their own right in the curriculum. Drama and media foundation studies are absorbed into English. Dance (which had undergone very positive developments in many schools) has become an element of PE, potentially denying its aesthetic and social significance. The passionate debates over the components of the music and visual arts curricula – the proper balance between doing and appraising, between the work of Western and non-Western traditions – demonstrate that the arguments do not stop with the acceptance of an art form into the core curriculum. There is felt to be insufficient time within the curriculum to do justice to the arts. Furthermore, all arts subjects are discretionary for the 14–16 age group (after Key Stage 3).

It must also be remembered that many children do not go through the conventional school system. Disabled children in hospitals, homes or segregated schools may be taught an arts subject only as a form of therapy or have individual tutorage, in which case their arts education is dependent upon the interests of the tutor involved.

Further and higher education
There is evidence of cuts in courses and resources in further and higher education in the arts. Those who teach in higher education have expressed fears that the financial pressures affecting education establishments are causing them to be concerned more with the number of students than with the quality of their educational experience. In addition there is no national overview of educational practice as was once available to those institutions offering Council for National Academic Awards degrees.

Student grants are mandatory for degree courses in the arts but not for many non- degree vocational courses. This affects particularly dance and drama training (though there are high quality degree courses in drama which mix very successfully the academic and the vocational). Discretionary grants mean that policy varies from one local authority to another, and thus that attendance on some courses depends as much on geography as on talent. There is no justification for such distinctions in grant policy between arts subjects; and local authorities' varying

policies on discretionary grants are by definition arbitrary in their operation and, overall, reduce the opportunities for young people to learn and train in the arts. Work carried out by the Arts Council in late 1992 suggested that some forty per cent of places offered to new dance and drama students have been turned down for lack of funding, and that one third of students taking up places are receiving no grants towards fees. This policy reduces the employment opportunities for practising artists, for whom teaching may provide a vital part of their income. In addition, the important research and development role of arts courses is put at risk. Many of the country's most innovative performance artists, for instance, graduated from performing and combined arts courses.

Adult and community education

The position in adult and community education, a route for many people wishing to learn about or practise the arts, is similar. The provision of both is severely threatened by the tightening of local authority budgets. Broadcasting also plays an important part in this area of arts education – from the general educative content of arts documentaries and review programmes, to schools and Open University broadcasts. The arguments for generous public support of adult education in the arts are the same as those for public funding of the arts in general.

In an article in *The Guardian* in March 1992 the novelist A S Byatt recalls a literature class that she taught:

> We worked our way through the European novel – that is where I discovered Kafka, Nietzsche, Dostoevsky, Flaubert, Beckett. We were not professional Eng. Lit. people – we were stockbrokers and psychoanalysts, computer people and social workers, gas board employees and actresses, teachers and retired people, and we read by ourselves and talked to each other about what we found out and how to read better. The adult education services are being run down yet there was a centre of civilisation, where imagination and thought and information met. . . .

This is, quite simply, too valuable to put at risk.

The way forward on arts education

There is a trend to undervalue aspects of education that are focused on creativity and spiritual growth – for which there is no obvious quantifiable return. Just as worrying, there is a tendency for education to be undervalued by some parts of the arts community, and to be an early victim of budget pressures. **The task of the funding system is to help ensure that education is seen as central to the arts, and the arts to education. Its role is to provide opportunities which will not**

or cannot be provided elsewhere, to lobby for and advise on good practice, to fund and encourage the educational work of arts organisations and to work in partnership with the education sector. Initiatives in all these areas are necessary: there can be no question of choosing one aspect rather than another.

More specifically, the funding bodies should:

(i) increase the resources available to education throughout the funded sector, targeting resources in particular at those arts organisations which put imaginative and high quality education programmes at the heart of their work;

(ii) contribute to relevant training, in particular through the support of joint training programmes and other forms of collaboration between artists and educators; and work with those in the education sector to ensure that the importance of the arts in education is emphasised in training courses for teachers;

(iii) expand their research and development role in arts education;

(iv) ensure a better service for collecting and distributing information between the funding system, arts organisations and providers of education;

(v) provide advocacy, advice and (as resources allow) funding for programmes of visits to schools by creative artists, in order to share with pupils the process of creation in literature, the visual and the other arts; and

(vi) develop models of good practice in the use of new technology in arts education.

The funding system and arts organisations are only one side of the equation in arts education. The strategy consultation process suggested a number of steps to be taken by those in the education sector. The Department for Education (DfE) should:

(i) review the position of the arts in the national curriculum, to take full account of their value both in their own right and in developing other skills; ensure that the content of the curriculum encourages interest in the theory, practice and criticism of the arts across a wide range of forms and influences; and provide specific recognition to such areas as dance, drama, the crafts and media studies;

(ii) make an arts subject — of the pupil's choice — a mandatory part of the national curriculum for the 14–16 age group, in order to ensure that there is an aesthetic element in the education of all pupils in this group;

(iii) ensure that the importance of the arts in education is emphasised in teacher training courses;

(iv) provide resources specifically to strengthen the arts elements of the curriculum and to enable writers, craftspeople and artists in all forms to work within educational institutions; and

(v) make mandatory the provision of grants at full cost for all arts courses in higher and further education, including non-degree courses in dance and drama, and allocate resources to maintain and strengthen arts courses at this level.

In consultation, individual schools were urged to use their freedom under LMS to put the arts in all forms, and the development of creativity, at the heart of their work, in partnership with the arts and media funding system where appropriate. For their part, local education authorities were urged to maintain and expand a broad range of affordable adult and community education courses in all aspects of the arts; and to keep in mind particularly the needs of those areas of arts education which are vital to the health of the professional arts — such as the work of the schools' instrumental music service and instrument loan schemes.

The importance of training

The need for adequate training provision and opportunities throughout the careers of the artist and arts administrator was emphasised throughout the consultation process. The idea that individuals accumulate skills at the beginning of their careers which will see them through to the end is as inappropriate to the arts as to any other industry. People working in the arts come from a wide variety of backgrounds. The nature of artists' and arts administrators' work is never static, and is now changing perhaps faster than ever. Needs, audiences, technology, styles and fashions develop and the artist and the administrator must constantly reassess their skills and learn new ones in order to become more effective and extend their creative range.

In the words of the Arts and Entertainment Training Council (AETC):

Training and education in the arts underpins the future development and continued success of the arts by helping to create skilled and

imaginative artists and administrators. It should sustain, refresh, renew and develop each individual practitioner during their career. It should ensure best practice in all aspects of their employment. It should fit each individual to make the best of the employment prospects offered by Europe. Adequately resourced, vocational education and training can play an important part in reducing, and eventually overturning, the historic disadvantages which affect entry and progression in the arts for many people in our society (particularly women, the disabled and some ethnic minorities).

Arts management training has developed considerably over recent years and, while there are few full-time courses, there are many short courses available for in-service training in management skills. These have undoubtedly helped to raise standards of management in the arts, though particular needs remain in such areas as the management of people and training for senior managers and boards. **Arguably, however, there has been an overemphasis by the funding bodies on supporting arts management training at the expense of arts skills training. Greater resources need to be allocated to the latter without losing the impetus of the former.** Training in arts skills continues to be provided largely through full-time student courses, but there is a need for mid-career arts skills training in such areas as new techniques, media and technology; these may require funding body support.

Training is one of those crucial areas which – like building maintenance – tend to be skimped when budgets are tight. Except when it is a matter of acquiring skills to meet immediate needs, it may not be given the priority it deserves. In this respect the needs of the arts are no different from those of any other industry, and people in the arts can learn many lessons from other sectors.

Ensuring that training happens

The Industry Lead Bodies (ILBs) were established so that industries could develop skills-based standards to form the basis of training programmes and NVQs. There are several ILBs relevant to the arts and media, including the AETC, the Museums Training Institute, Skillset (representing film, video and broadcasting), the Arts and Entertainment Technical Training Initiative, and others concerned with the crafts, sound, photography, design, publishing and management.

Working with these bodies the funding system should:

(i) continue to support the development and implementation of occupational standards and NVQs for the arts and related industries;

(ii) demonstrate to organisations in the arts industries that investment in training delivers clear economic and creative returns;

(iii) ensure an appropriate balance between training in arts skills and in arts management; and

(iv) ensure that training is used as a means to promote equal opportunities in arts employment for disabled people and other disadvantaged groups.

The funding bodies should themselves conform with these principles internally, and ensure that models of good practice are disseminated widely.

The development of the ILBs into Industry Training Organisations (ITOs) presents new opportunities. These represent all aspects of an industry and will be recognised by government as the body responsible nationally for training matters. In this role an ITO is responsible for identifying the training needs of its sector, developing standards and methods, providing research and information, representing sector interests to government and other bodies, and advocating training to the industry itself. As a representative body, ITOs could be a powerful new partner for employers, funding bodies, Training and Enterprise Councils (TECs) and training providers.

The emergence of industry bodies with a broad view of training will enable funding bodies to concentrate upon 'strategic interventions', including initiating and funding training projects and networks (such as the regional training centres developed by the RABs and Arts Council); developing national training programmes for skills in particular art forms or sectors; developing grant, bursary and placement programmes; working with TECs to ensure that government training resources find their way to the arts; working at regional and local levels with education and training networks, and bringing together consortia of commercial and funded organisations (as, for example, Skill Net South West does with television companies, film and video organisations, TECs, trainers, educators and local authorities).

One of the characteristics of the arts is the diversity of the workforce – paid or unpaid, freelance or salaried, working in the public, private or not-for-profit sectors, with high or no job security. In these circumstances it is a complex matter to implement a training strategy. But there are three important steps which could be taken.

First, a national target should be adopted for the allocation of resources on training. An appropriate but long-term goal would be the European Community Social Charter level of 2% of annual payroll and 5% of staff time. This would be difficult for some organisations to meet, and in the short term a target of 1% of payroll and 2% of staff time might be more appropriate and achievable. In funded organisations the target should apply to part-time and contracted employees as

well as full-time staff, and the time allocation should apply to voluntary staff and committees. Training provision should be among the contract terms agreed between funder and funded (see Chapter 3 pages 47–49). Commercial organisations should be encouraged to adopt similar standards, and self-employed people to adopt personal training targets.

Second, the government should consider making tax-deductible the direct and indirect costs (not just course fees) for self-employed people pursuing training or related activities designed to increase their skills.

Third, the funding system's own programmes of bursaries and travel grants should be flexible enough to accommodate informal training and personal development through placements, secondments, visits, sabbaticals and personal study.

Conclusion

It is a matter of both self-interest and duty for the funding system to put education at the heart of its work, and to encourage all forms of education in the arts and the arts in education. It must be prepared to invest its staff resources and money accordingly, and to press the case of the arts with all providers and policy-makers in formal and informal education. This is a time of change, concern and in some cases considerable retrenchment for the arts in education: the need for a positive, knowledgeable and enthusiastic lead from the funding system has never been greater.

This chapter has also discussed the vital importance of **training** in the arts, and has suggested some specific areas for strategic intervention and advocacy by the funding system. **National and regional training funds should be used to make it easy for individuals and organisations to benefit from training opportunities. But ultimately it is for management and staff of arts organisations to give a high priority to staff development to analyse their own training needs and to take advantage of available opportunities.**

CHAPTER 10 · LOCAL AUTHORITIES
AND THE ARTS

This is a brief chapter not because the role of local authorities in the support of the arts is small but because it is all-pervasive. It cannot be confined to a single chapter and is a central theme of Chapter 9, on education and training, and of the next three, on urban and rural issues, arts buildings and libraries and museums respectively. The purpose of the present chapter is to cover particular issues on local authorities and the arts not dealt with elsewhere, relating to the nature of local authority support, management and structures, and its relationship with the funding system.

But the chapter must begin by acknowledging the enormously important part that local authorities and local education authorities play in the arts in this country. They make, collectively, the largest contribution to the arts of any public funders. They are, however, far more than funders; they also act as development agencies, promoters, providers and managers of arts buildings and facilities, and in some cases originators and commissioners of new and innovative work. Effective public support of the arts can take place only through combining the resources and skills of local authorities with those of the arts and media funding bodies.

In recent years an increasing number of authorities have adopted a planned approach to their support of the arts. Many employ highly skilled arts development staff, who are well placed to understand and respond to local needs and aspirations, and to forge partnerships with other providers and funders, public and private. Some authorities consider the arts to be an element underpinning all their activities (see Chapter 11); others simply recognise the importance of the arts in their own right. But these philosophies and activities are threatened by the external and internal pressures on local government finance and by possibly inappropriate management measures such as compulsory competitive tendering. In addition, uncertainties about the future structure of local government are bound to jeopardise in the short term patterns of county and district support for the arts. Many local authorities have expressed concern about their ability to sustain their commitment to the arts: some serious cutbacks are already apparent.

Spending: statutory or discretionary?

Because local authority support of the arts is discretionary, it is vulnerable. More important, perhaps, it lacks the incentive of a central government contribution

through the medium of the revenue support grant (RSG).

What has been achieved on this discretionary basis has been admirable – in many towns, cities and rural areas, it amounts to one of the great arts success stories. But it is, to say the least, anomalous that provision of the library service should be a statutory responsibility of local authorities, but not provision of other arts and cultural services. There was a strong general view in consultation that the provision of arts facilities and activities should be made a statutory responsibility of local authorities. But it is only right to report two pragmatic counter-arguments that were put during the process.

The first is that, as a general rule, legal backing and targets are as likely to lead to a levelling-down as to a levelling-up of provision. The second is that a great deal of arts spending by local authorities is the responsibility of other departments - notably education and libraries. Bringing it all together might reveal a larger figure for total arts spending than either electorate or elected members expect to see; again, a reduction in spending might be the result.

These are not unpersuasive arguments, but they do not seem conclusive. As to the first, it is clear why budgetary pressures might lead to a reduction in arts spending. It is far less clear why, say, Birmingham and Sheffield should reduce their arts support merely on the ground that arts support had become a duty laid on them: a statutory duty has not prevented them from providing substantial support for their library services, for example. And if the inducement of RSG were added, it is hard to see why the net result should not be an increase in spending. It would certainly lead to such an increase by the lower-spending authorities.

As to the second argument, the claims of local accountability suggest that local communities and elected members should have the opportunity to see what arts spending adds up to. It is for all those, inside and outside local government, who care about the arts to justify these levels. A clear idea of how, and how much, public money is spent on the arts now is necessary if it is to be spent more wisely in the future. This principle should hold even if the total revealed is unexpectedly high.

A clear conclusion of the strategy process is that the Local Government Act 1988 should be amended to make arts spending by local authorities a statutory responsibility, and that the costs of such responsibilities should be designated as eligible for revenue support grant from government. This point of view is supported by the majority of the local authorities contributing to the strategy.

The effective implementation of an arts policy is dependent upon enthusiastic and committed members and staff. Making the arts a statutory responsibility will not ensure such enthusiasm, but it should help to create a receptive climate. One issue still to be resolved is the need to define clearly, but flexibly, what is meant by 'the arts', so that local authorities know what they are authorised or expected to support.

Management: compulsory competitive tendering

One of the most important issues affecting local authority arts provision at present is the prospect of introducing compulsory competitive tendering (CCT) for the operation of arts facilities. Local authorities are responsible for both the provision and the management of a large proportion of the arts buildings in Britain. A change in the management of these facilities through the process of CCT is obviously of concern.

Among the entirely admirable aims of CCT is to ensure that services are delivered at the highest quality and as cost-effectively as possible. But it is too easy, and wrong, to assume that this means as cheaply as possible. The direct provision of arts facilities is a response to social and cultural needs as well as a financial issue. Generally the management of arts and entertainment facilities, often on very tight budgets, shows local authorities in their most entrepreneurial mode, balancing commercial and cultural pressures. Of course all local authorities should be keen to adopt more effective methods of delivery, and recent work by the Audit Commission has contributed to this. But a compulsory process may not be the most effective.

Part of the problem lies in the nature of the tests by which tenders would be judged. The discussion of quality in the arts (Chapter 4) showed that it is a concept of great complexity and much subjectivity – one that must be examined from a variety of perspectives. Tests of quality and 'quality thresholds' are crucial to CCT. **It would not be right to extend CCT to local authority arts provision until appropriate quality thresholds for this field have been developed – a task in which the arts community and the funding system should also be involved.** Furthermore, in any cost-benefit analysis of CCT, it is important to include the time and expense involved in actually drawing up specifications and monitoring successful tenders.

The proposal to apply CCT to arts facilities is based on the assumption that there is a market interested in competing for their management. In fact the number of companies willing and able to take this on is likely to be limited and the concentration of management into a few hands could reduce the variety and quality of programmes on offer. The value of local authority venues at their best lies in their ability to respond to local needs and to undertake imaginative programmes of education, outreach and audience-building. A commercial company taking over venue management may provide a cheaper service, but is unlikely to demonstrate such local responsiveness. On the other hand, the process of competitive tendering without a compulsory element could be a positive one, allowing local authorities to analyse needs and seek the best methods of meeting them. This could lead to a sharpening of existing policy and practice. **There is a strong argument that authorities should be encouraged but not compelled to undertake competitive tendering.**

In any case, there may be simpler and less time-consuming ways than CCT of encouraging efficiency and effectiveness in the management of arts facilities. One way may be to establish properly constituted trusts independent of the local authority, with the authority grant-aiding rather than directly funding. Whether this approach is appropriate will depend upon local circumstances. But it is likely that many authorities faced with the need to phase out direct provision would find this option more appropriate than CCT.

Structures: local government reorganisation

At the time of writing, the Local Government Commission is beginning its work, and the future of the non-Metropolitan counties and districts is unclear. At present both these tiers of local government have a responsibility for arts support. In some areas they work in partnership, while in others one takes a central role. Restructuring may be beneficial to efficiency in general and even to arts support in particular; but uncertainty about the future, which will last for several years in some cases, could have a detrimental effect on arts organisations, particularly those funded from multiple sources, and on arts development. **It is important for the Local Government Commission to recognise the contribution to the arts made by both county and district authorities, and to recommend structures which safeguard, and preferably enhance, levels of arts spending and commitment to arts development by local authorities.**

Partnership

Partnership should be at the core of the relationship between local authorities, the arts funding system and arts organisations. At a regional level this has been put under stress by reorganisation of the funding system, in particular by the diminished influence of local authorities on RABs. This, coupled with an increase of arts expertise in local authorities, has led RABs and local authorities to reassess their relationship. This may be no bad thing. Local authorities should be able to expect funding bodies to provide specialist advice on art forms; an overview of regional, national and international developments, supported by comprehensive research and information services; a forum for discussion and joint planning; effective grant-making procedures; specialist services to assist arts organisations to achieve their potential; and a link to further national and specialist resources. **There are signs of a shift from local authorities' subscribing to RABs to a quasi-contractual arrangement (as the Audit Commission has put it) based on the provision of services, information and consultancy. This makes it ever more important that the funding system is operating effectively and**

efficiently, and providing the services required of it. The implications of the evolving relationship between local authorities and RABs should be carefully considered when the operation of the new funding system is reviewed.

One issue that can create tension between local authorities and funding bodies is the balance between their respective funding contributions. There may be an expectation that each party will match the other in any funding agreement; in practice, each party will wish to fund only to the level of its interest in the project, and interests may be different. An arts funding body may make a larger initial contribution to a project which may tour regionally or nationally; a local authority may accord more weight to one of greater local than regional significance. **Partnerships are based on negotiation not challenge. The contractual arrangements proposed in Chapter 3 (pages 47–49) should be of benefit to both funding bodies and local authorities, as well as to arts organisations, providing that the terms and conditions are jointly agreed and monitored.** There will be cases where a single contract between an arts organisation and all its public funders will not be appropriate. But, where such an arrangement would benefit all parties, they should seek to construct joint funding contracts.

Conclusion

The consultation process demonstrated the importance of partnership between local authorities and arts funders. But it also showed that there is no consistency across the country and that, for whatever reason, in some areas partnership is potential rather than actual. There is some feeling that arts funders do not understand or recognise the expertise of local authorities, and vice versa; and that unreasonable demands are made by one on the other.

There are bound to be areas of difference, but mutual confidence and respect are essential. This can be achieved only through more formal and informal professional contacts, a demystifying of processes and practices and a greater sharing of ideas and information. This is a question of both attitude and practical measures, such as joint training, joint policy meetings and joint assessment of arts organisations. Not only the funding system and local authorities, but also related organisations such as the Sports Council, the Area Museum Councils and the regional and national library organisations should work together to develop these.

CHAPTER 11 · URBAN AND RURAL ISSUES

In a small country with a mobile population and comprehensive media networks, there is relatively little variation in the cultural influences which people receive wherever they live. But there are significant differences in the outlook, backgrounds and expectations of people in rural areas, urban areas and London and other metropolitan cities. This chapter considers the role and significance of the arts in each.

The arts in rural areas

Rural areas follow no single pattern. They include both agricultural and industrial areas (for example, mining and quarrying), determined by landscape and natural resources; they may be variously prosperous or deprived. While traditional agricultural and industrial economies are contracting, the rural population is increasing due to an influx of former town-dwellers and an expanding group of people who because of modern communications can work from their own homes. These people bring new wealth and different values to rural areas. The cultural expectations of rural dwellers are extremely varied.

Clearly, one distinctive feature of rural areas is their remoteness from the facilities and services that are commonplace in towns and cities. Remoteness may be caused or compounded by poor public transport and, for many people, limited access to a car. Transport in rural areas is a particular problem for women, young and old people. Another factor is that in spite of the influence of urban values and culture, in many rural areas the pace and style of life are determined by factors such as landscape, climate, seasons, the agricultural calendar, the self-contained nature of communities and local traditions. There is a great deal of creative activity which derives from these distinctive elements of rural life but which tends not to be included in usual, narrow, definitions of the arts; and there are many opportunities to integrate the arts with the landscape of rural areas. But as in urban areas, planning and cultural development in rural areas have tended to part company. A concern with place and the environment is not solely an urban preoccupation, and practices such as 'per cent for art' (committing a proportion of capital development budgets to original art or craft) and public art are equally valid for rural areas; indeed, the potential to integrate art with the landscape is far greater in rural areas.

Supporting the arts in rural areas

Historically, arts development in rural areas has been a lower priority for the funding bodies than have urban-based projects. In recent years the arts in rural areas have moved up the funding bodies' agenda, through the influence of lobbying, reports on the subject and new partnerships between local, regional and national bodies (arts funders, local authorities, rural community councils and their umbrella body ACRE, the Rural Development Commission, the Countryside Commission). This is a developing area of work, and as is common in such cases, rural projects may receive only intermittent and short-term funding, insufficient to enable them to prove their worth.

The public attitudes survey revealed that there is little difference in the percentage of people (79%) attending the arts between those that live in rural areas, urban areas or conurbations. There is not much difference either in the types of arts events attended, except for cinema attendance (an activity whose largest audience is 16–24 year olds, one of the less mobile groups), or, importantly, in the percentage who are satisfied or dissatisfied with the arts facilities and provision available to them. Yet throughout the consultation process, a lack of arts provision and facilities was perceived as one of the biggest issues in rural areas. This could be in part because those involved in the consultation process were not typical of rural populations generally. Nonetheless, **it should be a priority for the funding system in partnership with others to ensure that its policies for arts support are relevant to the needs of the less mobile groups in rural areas. Current support involves three main elements: taking people to the arts (through transport schemes), bringing the arts to rural communities (principally via touring), and local community-based arts development. Well-balanced arts provision should include a mix of each of these factors.**

Taking people to the arts. Programmes to provide group transport for parties to arts events in nearby towns are a common feature of rural life. They are often organised by clubs and societies for their own membership or by individuals as a community service. In some parts of the country, regional funding bodies and local authorities subsidise transport provision. When operated in partnership with subsidised arts venues such as producing theatres or concert halls, this can be an effective means of audience development. Local authorities and RABs should consider undertaking local audits of the effectiveness of or potential for transport schemes and the possible need for subsidy.

Taking the arts to people. On the face of it, touring the arts to rural areas can be linked more closely to local communities than is the case with transport schemes. There is a long tradition of rural touring of performing arts, visual arts and film, supported by local authorities and regional arts funders. But the strategy consultation generated a debate about the validity of a policy which, while it can provide high quality arts experience, is often seen as an 'off the peg' solution, offering little of local relevance. The consultation revealed that many local

authorities wish to retain small-scale rural touring as part of a mixed provision in rural areas, but would welcome the opportunity and resources also to support longer term residencies and work that is developed for and in collaboration with specific audiences and communities.

The promotion of the arts in rural areas is largely dependent on volunteers, with support from local authorities (where appropriate officers exist) and RABs. Advice is available from many sources; for example ACRE has recently published *Entertainment, Events and Exhibitions: bringing arts to village halls*, and RABs and local authorities have produced promoters' packs. The key to this type of development is encouraging and enabling volunteer promoters to take the type of risks which are second nature to many professional promoters. This can require guidance and support in the form of training and professional back-up. Some local authorities, for example in Northamptonshire, have employed rural development staff with promotion skills to encourage the establishment of local arts councils. In other cases the rural community council can take on this role. The best location for advice services needs to be determined locally, but support, training and funding need to be provided by RABs and local authorities.

Local arts development. The PSI report on the amateur arts revealed a higher membership of amateur societies in rural areas and small towns than in metropolitan areas. It gave two reasons for this: that amateur organisations in small towns and many villages tend to have an important social and community function; and that outside London there are more arts- and crafts-based adult education courses in non-metropolitan than in metropolitan districts: adult education is one of the major arts providers in rural areas. The decline in local authority support for adult education is even more of a disaster in rural areas than in urban ones.

The arts are also an important part of rural traditions and festivals. Many village social activities incorporate the arts through enthusiastic residents, village hall committees and Women's Institutes, though also in many cases they are initiated and sustained by arts development staff employed by local authorities and rural community councils. As a result, community-based arts activity is a common feature of rural life. **The wide social mix of rural areas can generate a range of arts skills, interests and enthusiasms cutting across social boundaries. With initial support, these can develop a high degree of self-sufficiency. They deserve such support, and the funding system should work with rural community councils and local authorities to provide this.**

What are the arts' development needs?
As noted above, there is little evidence of major arts deprivation within rural areas as against urban areas. **The challenge is to broaden the opportunities for people in rural areas to express their cultural interests and develop skills through the arts, and to enable than to make choices – not to have the**

funders do so on their behalf. The Gulbenkian Foundation has developed funding mechanisms for rural arts initiatives designed to encourage local involvement and control. These may provide a model for adoption by the funding system.

A number of policy implications flow from the discussion above:

(i) Arts development in rural areas is labour-intensive and often works on a long timescale. Funders should accept the need for longer term local arts development programmes rather than short term project support.

(ii) In appropriate cases, the funding system should devolve arts development funding to agencies and bodies working closer to rural communities — whether local authorities or more grassroots bodies such as rural community councils, local arts agencies and parish councils.

(iii) The funding system should co-operate with the rural development agencies at national, regional and local level on arts plans which develop the relationship between the arts and other social, cultural and economic issues.

(iv) Venues for arts in rural areas tend to be multi-use buildings such as village halls and schools. They may have inadequate facilities for the arts which they present and may provide limited access for disabled people. They should be a priority area for the programmes of building improvement discussed in Chapter 12; and as multi-use buildings, there will be opportunities for joint initiatives between arts and other funders.

(v) The provision of adult education is particularly important to the arts in rural areas (see Chapter 9 page 95).

The arts in urban areas

It is appropriate to develop briefly a couple of points from Chapter 2 as background to discussion of the arts in urban areas.

First, the migration from the cities and the accompanying dispersed pattern of development (out-of-town shopping centres, retail warehouses) will have major consequences for the arts. The experience of North America, for instance, has shown how the amount of office use, and thus the number of office workers, in the city centre, can decline steeply. This can deprive the city of both demand for and provision of such amenities as restaurants, hotels and banks. It removes prosperous commercial development to beyond the limits of the city, so that it no longer provides tax revenues to support city services. A major city centre library or theatre

may be left 'marooned'; alternatively it may become one of the few remaining focuses for city life.

Second, there is the impact of transport issues. Between 1970 and 1990, the total number of miles travelled by car each year in the UK more than doubled, increasing at about three times the rate of bus and coach mileage. But average traffic speeds in central London in 1990 were only 4mph higher than was achieved by horse and carriage in 1890. Indeed, traffic speeds in towns and cities throughout Britain have been getting lower and lower over recent decades. People may need to be coaxed into the city centres in their leisure time; but possible restrictions on car use, and the deregulation of and removal of subsidy for public transport, may act as a further disincentive.

It has nonetheless been demonstrated clearly in recent years that **the arts can make a major contribution to the social well-being and cultural diversity of urban life, to the urban economy, and to the physical and aesthetic environment: they can help to keep cities alive.** People in towns and cities take pride in their theatres, concert halls, libraries and museums. The arts can, furthermore, encourage the conditions for creativity, innovation, 'buzz', in areas of life far beyond the arts themselves. If this is to happen, there needs to be a positive and visionary approach to urban design and the care of the environment, from the grandest concepts to such issues as signposting, lighting, cleaning, policing and transport. It requires also a real partnership between public and private sectors.

The arts can also play a part in ensuring that town centres are lively and friendly environments throughout the day. The architect Richard Rogers notes, in the book *A New London*, that:

> . . . city centres with a lively mix of activities, where daytime offices and shops and other places of work coexist with homes and places of night-time entertainment, are safer than those that come alive for only eight hours a day.

The use and welcoming aspect of museums, galleries and other arts buildings is crucial here. This is discussed in Chapters 12 and 13. But arts organisations and local authorities should also consider programming possibilities outside buildings, in streets and public places, and examine the concept of 'cultural cornershops' (which could include new and existing buildings, such as libraries and community centres), serving both arts and wider community uses, located in local neighbourhoods and shopping centres.

Urban planning

In the nineteenth and twentieth centuries, British urban planning and the arts parted company. The earlier view of the city as a work of art, a planned series of aesthetic experiences, was lost. The city came to be conceived as a functional unit, with the emphasis more on efficiency and economic prosperity than on the quality

of life or the cultural aspirations of its citizens. Yet the cities people enjoy most are those which offer a multiplicity of experiences, beautiful and impressive buildings, busy, lively and safe streetlife day and night, and a diversity of activities, shops, cafés and restaurants. For the British these have too often been the places that they visit on holiday, because the majority of British cities do not fulfil those aspirations.

The 1980s saw an upsurge in investment in cities, but a legacy of too little noteworthy architecture, and too little that distinguished one city centre from another. The planning process seemed to have lost a vision of the purpose and functions of a city. In the 1990s there is an opportunity to regain that vision through a more complete view of urban development. Planners, architects, the media and the public are all beginning to contribute to the debate. The arts are inseparable from this process.

The adoption of cultural policies by a number of British cities has placed the arts within a much wider social and economic context. Those which have gone furthest in this respect, such as Glasgow, Birmingham, Sheffield and Bradford, have recognised the potential of the arts as an expression of the identity of the city as a whole and of the cultural diversity of the communities within it. These are not the only cities to have built expensive arts facilities or to have supported innovative and challenging arts programmes; but their conscious integration of the arts within cultural, economic and physical planning policies singles them out. The establishment by Birmingham City Council of an Arts, Culture and Economy Sub-committee, to co-ordinate the cultural policy elements of the work of the Finance and Management, Leisure Services, Economic Development, Planning and Education Committees, is one such model. **Urban authorities should adopt approaches to planning which recognise and exploit the links between the arts and other cultural and planning issues, and which use artists as a matter of course in the planning and design process.**

As to the role of the funding system, the relationship between the London Arts Board (LAB) and the London Planning Advisory Committee (LPAC) is a possible model for the integration of the arts into the planning process. This partnership has enabled LAB to ensure that the arts are included in every Unitary Development Plan in London; to hold seminars with planners to discuss arts and cultural issues; to develop advice and model policies for local authorities; to commission with others a report on London as a world city, emphasising the contribution of cultural policy; and to make a formal input into the drafting of DoE planning policy guidance. Similar approaches might be replicated elsewhere in the country.

The arts and the urban economy: cultural industries and urban regeneration
The 1988 PSI report *The Economic Impact of the Arts* highlighted the contribution of the arts to the urban economy in terms of employment, visitor and tourist attraction, and the 'multiplier effect' of arts investment. The cultural policies of

many cities have included support for the cultural industries (film and video, the art trade, music and recording, design and publishing).

Public money already feeds directly and indirectly into the commercial cultural industries. The BFI and the BBC are both important investors in the production and distribution of film in Britain. Many artists, writers and musicians have had their early careers sustained through public funding and work successfully in both the public and the commercial sectors. Many local authorities have invested heavily alongside private sector partners in cultural industry development (such as Sheffield City Council's investment in a 'cultural industries quarter'). Such relationships should be extended, though with some caution: cultural industries development offers no quick or certain return. Nonetheless, it would be possible for the public sector to take a more active part in the establishment and development of cultural industries, for example by establishing an investment fund which in partnership with banks could offer a mixture of commercial and low interest loans to support the development of new businesses. In appropriate cases, funding bodies should be permitted to take an equity in such businesses.

The arts and media as generators of employment or training opportunities have formed part of bids for funding under various government and European development programmes, but it has rarely been possible to make explicit their intrinsic contribution. The City Challenge programme allowed the arts to be supported explicitly as part of the assets of the cities or towns making the bid. Many successful bids included a strong arts and/or media element.

There are many examples of the catalytic effect of the arts and artists on urban regeneration. The commercial development of such areas as the former Covent Garden market, parts of London dockland, Wapping and Clerkenwell was set in train in the 1960s and 1970s when attractive, low-rent warehouses were converted into cheap studios for artists. These users subsequently attracted more 'up-market' designers, architects, media and retail tenants, pushing up the rents and promoting the commercial regeneration of the area; the artists moved on. Had arts funding bodies been able to play a part in the purchase of these buildings – and had they had the prescience – the stock of studio space could have been retained and the artists would have had a stake in a major capital asset.

At present, there is in cities throughout Britain a considerable amount of vacant office space available at low rent, which could be used for many arts purposes without planning permission. The funding bodies should explore with local authorities methods of using vacant retail and office space for arts and community-based facilities, such as exhibition space. A range of mechanisms may be appropriate for this, such as a development trust to act as an intermediary between commercial banks and artists, to provide collateral and to offer soft loans, or a single fund on a revolving basis. It would be valuable also if local authorities were to review valuations of redundant properties in their ownership and consider selling them to artists.

Art and the urban environment

The development of art in public places, often as part of urban design schemes, has been among the most exciting arts developments of recent years (as noted above, public art in rural areas has been equally successful). At its best, public art in cities is planned as an integral part of urban design, not as a cosmetic improvement to undistinguished urban architecture. Authorities such as those in Nottingham-shire, Birmingham and Gateshead have used public art in innovative ways to enhance the urban landscape and to provide local landmarks. In Britain the number of such commissions continues to grow, together with an infrastructure of public art agencies, regional slide indices of artists' work, local authority specialist posts and training courses for artists and craftspeople.

Many local authorities and other public agencies have adopted 'per cent for art' schemes. This has created valuable partnerships between architects and artists and has made an important contribution to the arts economy. The current recession in both private and public building has limited its effectiveness but not its potential. **Per cent for art may require statutory backing if it is to be a permanent feature of building development. A considerable boost would be given to the quality of the built environment if the government were to require that such provisions be written in to all public sector building contracts. The funding system should ensure that guidelines on the use of per cent for art, the services available through national and regional funding agencies and their local application, are prepared and circulated to all local and public authorities.**

Major cities: a note on critical mass

Several major cities have decided that, in terms of their cultural life, they are not and do not wish to be 'second' – or second class – Londons, but international cities in their own right. **Cities such as Birmingham and Manchester should receive encouragement and practical support from central government in their quest to raise internationally their own status and that of their regions.** The action taken by the government to support significant sporting and cultural capital projects in Manchester, as part of the 'Olympics 2000' bid, is a good example of the level of response needed to the initiatives of these cities. **Each element of the funding system, national and regional, must play its part in supporting their artistic and cultural life, in promoting their success as cities of culture, and in forming partnerships with these cities on specific and general issues.**

For example, Manchester, chosen as City of Drama for 1994, is widely acknowledged as particularly rich in that art form. This richness has a variety of sources: Manchester is recognised to be the birthplace of the producing theatre, and the Greater Manchester area is uniquely well served by such theatres; the city has venues to receive touring work on the largest scale; and it is a major radio and television centre.

This has had two important benign effects. First, a 'drama economy' has built up in Manchester. Given the variety and scale of drama activity, an actor, director or technician can – if skilled and lucky enough – make a career in Manchester. This is a rare state of affairs for any city outside London. Second, audiences are there for all the drama that the city has to offer. It has not been the case that more theatres have chased diminishing audiences (apart from the general effects of recession). Rather, the more work there has been available, the more a theatre-going habit has grown up. Furthermore, the range of drama has enabled the providers to specialise more than would be possible if any one of them were 'the' rep. One can sum up both of these points by saying that a critical mass has been achieved for drama in Manchester, enriching rather than diluting what is available.

But while local authorities – and local populations – may wish to establish such a critical mass, the arts funding system has traditionally been concerned more with equity of provision ('No-one should live more than twenty miles from a producing theatre'). Which should be the higher priority for the funding system – the establishment (or growth) of a producing theatre in a city less well provided, or further investment in a city already well provided? **It is vital in such cases that all those concerned – particularly local authorities and arts funders – understand and respect the others' policies, even where their own are, inevitably, different.**

London

Any international city has at least two faces: the one it presents to the world, and the one it presents to its citizens. This is clearly true of London.

London as a world city
London is Great Britain's leading 'world' city. As the nation's capital it exerts a crucial influence over the arts in Britain. It has an international reputation for its arts provision, and the cultural life of London is a significant factor in its world status. Over 200,000 people are employed in the cultural sector, and there are over 94 million attendances at arts events each year. London is home to most of the 'national' arts institutions as well as being the centre of the commercial theatre and of the publishing, broadcasting and recording industries.

The critical mass of arts institutions and industries means that London is a major arts economy in its own right. For example its cultural sector has an annual turnover of £7,466 million; cultural activity provides 6.1% of London's employment and 5.7% of its gross domestic product; and between 1981 and 1989 employment in the cultural sector grew by 20%: it now employs as many people as health or education.

114

London's mixture of subsidised and commercial arts, and the quality and diversity of both, are unique. The aim must be to ensure that these characteristics work to the benefit of the arts, and the country, as a whole, as well as to the benefit of London.

Central or centralised? London's social, political, economic and cultural significance will remain a reality and should be a cause of pride. But London is not the only international city in Great Britain. With the increasing emphasis on regionalism, particularly by the European Community, **a relationship should be established between London and other major cities which is complementary and not competitive.** A central role will serve the nation as a whole; a centralised role would diminish the identity and contribution of other cities.

London and the media. The media have a key role in creating the images that both insiders and outsiders have of London and of other cities in Britain. Regional television companies have made a substantial contribution, but there is more to be done: **the funding system should work with the media to find ways of generating a balanced portrayal of Britain as a whole.**

Location of 'national' arts institutions. In theory, with modern communications there is little reason why national arts institutions and cultural industries must be located in London. In reality the position is more complex. The interdependence of cultural institutions makes it difficult for them to be moved. The synergy created by the concentration of arts activity in London is a positive force, producing innovation and a cross-fertilisation of ideas, benefitting the arts in the country as a whole. On the other hand can an institution based in London claim to be fulfilling national responsibilities if its audience is drawn largely from the population of one city and from international tourism? National arts organisations should be funded and encouraged to develop their regional presence by such means as touring, extended residencies, and establishing regional companies or regional centres, such as Birmingham Royal Ballet and the National Museum of Film and Photography (part of the Science Museum) in Bradford. **'National' arts and media organisations should be located wherever in the country best suits their needs.**

London as a city

London is not only a world business, tourist and entertainment centre. It is also home to millions of Londoners and is made up of a diverse collection of neighbourhoods and communities, many of them socially and economically deprived. Each of its 33 boroughs has the population of a small or medium city. But many of these boroughs have arts facilities considerably inferior to those of most cities. Since the demise of the GLC and the ILEA, London has lacked a strategic level of local government. This has impaired arts planning.

The size and complexity of the Greater London area make communications difficult. Residents of the outer suburbs have cheaper but no easier access to central London than people on the Intercity network living many miles away. Yet much of

the arts provision is concentrated in the few square miles of central London. This is valuable for the 'critical mass' effect, but the development of local arts facilities, particularly in suburban boroughs, is just as important. Serving London both as world city and as a series of neighbourhoods and communities is a challenging and difficult task. The needs of London's diverse neighbourhoods must be addressed. **Local authorities and the funding system should work with arts organisations to ensure that arts provision in central London is firmly 'grounded' – that the major arts organisations see themselves as serving London as a whole and are equipped both to assist and to benefit from local initiatives in the London boroughs.**

One of the themes of this book is to emphasise the benefits that can accrue from a partnership approach to arts support, involving the funding bodies, local authorities and others. This is exemplified by the contribution of many of London's local authorities to the development of the arts in the capital. Such partnership, involving central government agencies and the private sector as well as artists and arts organisations, will become ever more important in the future. In addressing London's planning and development needs, it is important that the government recognises the role and value of the arts and the work of the London Arts Board and the other arts funding bodies.

Conclusion

The arts derive much of their strength and significance from the places where they happen and the communities from which they emerge. Equally, the arts can provide a focus, symbol and expression for their area, whether rural, urban or metropolitan. The relationship between art and its location is intricate, and this must be reflected in patterns of arts support, in which local, regional and national elements all have a crucial part to play.

Almost all social policy has implications for the arts; and the arts can influence social policy and the quality of life in the broadest sense. **Successful policies of arts support require thought and action at the highest strategic level, as well as through practical, grass roots initiatives. The subject of this chapter poses probably greater challenges for the funding system and for all who work in the arts than any other in the book. But the prize is great: to ensure that the arts achieve their full potential in rural, urban and metropolitan areas.**

CHAPTER 12 · ARTS BUILDINGS

The issue of arts buildings is often seen as secondary to that of the work that takes place in them. It was an uneasiness with this approach that led to the commissioning of The Arts Business Ltd to undertake a combined research project and consultation exercise on the role and future of buildings which house the arts. This chapter considers briefly the significance of arts buildings in their own right; the question of basic levels of provision to serve particular populations; physical access and fire regulations; and practical issues of housing the arts, including maintaining the building stock.

The significance of arts buildings

Buildings have a cultural significance in their own right for both artists and public. The programme, atmosphere, audience and public image of arts buildings act and react on one another in a complex way. One has only to think of, say, Manchester's Royal Exchange theatre, the Hackney Empire, the Whitechapel Gallery, Birmingham's Symphony Hall, to appreciate that the building itself is not a neutral factor. Productions or exhibitions may be designed to exploit the distinctive features of the 'space'. What works wonderfully in one theatre or gallery may be entirely unsuitable in another. Often arts buildings or buildings used for the arts are of historic or architectural importance in their own right. A further relevant issue is whether the design and atmosphere of the building welcome or intimidate sections of the public. This was discussed in Chapter 6 (pages 64–65).

Ownership or control of a building is perceived in the arts as 'growing up'. Talawa theatre company's achievement in becoming the first major Black building-based theatre, housed in the Jeanetta Cochrane theatre in London, has been seen as a major development in Black arts, as was the opening of the Nia Centre in Manchester. The importance to Black communities of owning and controlling their own buildings should not be underestimated. On another scale, the purchase of the freehold of the London Coliseum for English National Opera has, as its General Director Peter Jonas put it, created a level playing field between ENO and the other National Companies. The issue of a National Dance House is perceived as central to the status of dance as an art form, even though its direct effect will inevitably be more limited.

Civic pride, artistic ambition and community consciousness all contribute to the demand for arts buildings – whether a city with a new concert hall, an amateur

drama society with its own theatre, or a building dedicated to the work of women artists. The quality of the environment, as well as of the artistic experience, is of critical importance to arts audiences and practitioners. The philosophy that 'if it hurts, it's good for you' is fortunately disappearing in the arts. Audiences demand high quality facilities whatever their social background and assumed aspirations. It is, for example, clearly misguided to provide poor facilities for community-based work on the assumption that users do not expect high quality surroundings. The design of the neighbouring pubs, clubs and entertainment facilities may show that exactly the opposite is the case. This changing philosophy has major cost implications: raising and maintaining the standards of arts buildings is an expensive business.

The issue of provision: every town should have one?

There are mixed views on setting targets for building provision. Many local authority officers, and many touring companies (in order to expand the number of outlets), favour targets related to population size. They point out that such measures cost nothing and act as an incentive for development when the opportunity arises. But the mechanical application of targets may encourage the growth of facilities with inadequate revenue budgets, product, staffing and artistic vision, and lead to a failure to respond to local need and initiative. All new or refurbished arts buildings, or multi-use buildings used for the arts, inevitably have major revenue as well as capital implications. These should be included in any capital plan. There can be few aspects of arts spending more demoralising or wasteful than to have brought a building project to fruition and then to lack the resources for an adequate artistic programme.

It will never be possible to provide arts buildings for every eventuality in every place. A town of 50,000 people may have a demand for a season of symphony concerts, large rock events and regular visits from major touring companies, but the range and size of facilities to meet this need might be largely unused for the rest of the year. Temporary arts-spaces are often an acceptable and cost-effective compromise, though they are rarely wholly satisfactory and often have physical access problems: at its worst, 'flexibility' can mean a failure to meet any artistic needs satisfactorily. On the large scale a cathedral, warehouse, sports hall or arena can be called into use; on the small scale a village hall, community centre, church, library or local school.

This does not mean that provision can or should be left to chance. In particular, **the funding system should work with other relevant authorities – the Sports Council, local authorities and others – to develop specifications for the building of new, and refurbishment of existing, multi-use buildings, to ensure, wherever appropriate, that they can be used for arts purposes**

also. Guidelines on access for disabled people should be incorporated into these specifications.

Against the general trend, consultation revealed several specific areas in which targets for national provision might be appropriate, such as:

- buildings capable of hosting middle scale touring dance and opera
- a network of visual arts and crafts exhibition spaces
- art galleries able to host large scale exhibitions requiring high security
- a network of media centres
- networks of venues to house Black arts and women's arts.

There was also an overwhelming call for the development of a National Dance House, not necessarily in London.

Capital funding – strategic or opportunist? Even with the projected benefits of a national lottery to draw upon, the level of development funding is unlikely to meet all the demands made upon it. One of the issues to be resolved, therefore, is whether central or regional funds should be used strategically, in order to fill perceived gaps in a national map, or opportunistically, responding to local will and initiative.

In fact, this is not a realistic choice: it is difficult to think of a single arts building development over recent years in which the local element – whether arts organisation, local authority or local community – was not the crucial element; whereas many 'strategic plans' have fallen by the wayside for lack of a local response. **The key for the funding system must be to support and encourage local initiative, and, where major gaps exist, to work with the local authorities concerned to resolve the issue of the demand for a particular arts building and ways of meeting the demand.**

Physical access and fire regulations

The problems of physical access for disabled people were touched upon in Chapter 6 (pages 66–67). There are probably few, if any, completely accessible arts buildings in the country and it is extremely difficult for most arts organisations to raise the money necessary to remedy this. In some cases, problems with the design of old buildings and the listing of buildings make it impossible to achieve substantial improvements. **These considerations apart, it should be a central aim of the funding system, in partnership with local authorities, arts organisations, the private sector and charitable trusts, to ensure that all arts buildings in the country are made as physically accessible as possible within the next ten years. As part of this, all publicly funded arts building projects**

should include provision for access by disabled people – as artists and technicians as well as audiences.

The ADAPT fund has been a welcome initiative in this area. It contributes towards the cost of making new facilities accessible to disabled people, and its own funds are raised from government and private sector sponsorship, administered by the Carnegie Trust. It gave around a hundred grants in its first three years, amounting to about £1.1 million. At the time of writing, it is raising funds for its next three years and is becoming an independent charity. In the past it has been able to provide funds for the private sector, including cinemas. It will not be able to do so when it has charitable status. Neither is it likely to fund local authorities, but will concentrate on the voluntary sector. The Wolfson Foundation will provide funds for 'prestige' buildings, and the Foundation for Sports and Arts will also fund alterations. ADAPT hopes to work with them on standards. There is a continuing need for more capital incentives to encourage investment in improving buildings. Initiatives like ADAPT should be reinforced by a significant sum of public money. At the same time, a programme should be established to provide matching contributions for private sector projects, with the aim of making all arts buildings accessible to disabled people.

It is easy to understand the frustration of many disabled people in this respect. Their sheer number (up to 10% of the population) makes a change in general attitude imperative – backed up if necessary by a legal right of physical access to public and publicly funded buildings. If the public sector takes a lead, then, as in the United States, the private sector will follow.

Insensitively applied building and fire regulations still identify many types of disability as 'risks', further restricting entry to what are meant to be public buildings. The latest fire regulations are designed to improve safety standards in arts buildings but pose financial and operational difficulties for arts organisations. Under the Fire Precautions (Places of Work) Regulations 1992 employers will be required to assess the risk in case of fire to all the people who work in or visit the building, and to produce a 'fire plan' designating roles for all members of staff. **The funding system must work with the fire authorities to assess the specific implications for disabled people in arts venues. The regulations should be seen as an incentive to implement rapidly measures to ensure access and means of escape for disabled people.**

Housing the arts

Needs and mechanisms. From artists and arts organisations, the main need expressed was for flexible spaces which could be adapted by the artists' vision, not that of the designers or engineers. In addition, and apart from the needs identified above, a number of specific gaps in provision were identified, such as buildings

adapted to the demands of dance, especially ballet; facilities for presenting drama 'in the round' in London; gallery spaces outside London for the largest scale exhibitions; adequate rehearsal and workshop space; and halls suitable in size, facilities and acoustic quality for symphony concerts.

This adds up to an impressive agenda for action, and one in which local authorities will inevitably be the senior in any partnership with the funding system. Nonetheless, the consultation process demonstrated that such partnership is crucial. The BFI still makes contributions to building costs, whereas the Arts Council lost its capacity to do so by ending its 'Housing the Arts' fund. This is much missed. **It is important that the funding system is provided with the money to develop capital funding programmes. These might then contribute on a challenge basis to new build and, particularly, conversion and refurbishment projects for arts buildings.**

The proportion of total costs that a funding body would be able to contribute to a building development is likely to be small, but in fund-raising terms it may be strategically vital. There are alternatives to straight cash contributions, including funds to support feasibility studies or to pump-prime fundraising efforts. An imaginative and well resourced per cent for art programme (see Chapter 11 page 113) could both encourage arts buildings projects and raise the quality and quantity of public art.

Building development is complex and daunting. It would be valuable to create sets of guidelines for the development of arts buildings which could stimulate ideas, aid costing and support political arguments. The variety of arts activities to be catered for will make this a complex task, but it could be achieved by developing and co-ordinating existing publications and knowledge across the arts and media.

Improving the condition and use of the building stock. **The condition of arts buildings in Britain has reached a critical state. This is the result not just of age causing wear and tear, but also of experimental or poor building methods necessitating major repair.** Previously there was only incomplete and anecdotal knowledge of the scale of the problem. The Arts Council is currently co-ordinating an audit of the repair and maintenance needs of arts buildings, and gaps in provision, throughout the United Kingdom. It is hoped that the results of this audit will be useful in making the case for a capital fund from the proceeds of the proposed national lottery; it should also help to highlight areas for closer study.

There is also a need to ascertain whether buildings are being used as effectively and efficiently as they might be. For example, a building economist could usefully examine such issues as the energy efficiency of different types of arts buildings and provide advice for building managers. The funding system should consider providing such a service for the arts buildings which it supports.

Conclusion

It was noted above that the acquisition of a building is often regarded as a sign of 'growing up' by the arts community. But growing up involves taking on rather tedious responsibilities as well as raising one's status. Arts organisations naturally prefer to spend money on their art rather than on (postponable) work on their building, particularly if the money available to them is not sufficient for the proper discharge of both. This is a disastrous policy in the long term: maintenance is crucial.

There are two complementary ways to deal with the issue of maintenance and repair of the arts building stock. **First, there should be a national 'catching-up' programme, pooling resources from central and local government, the funding system and charitable foundations to meet the needs identified in the audit of arts buildings, with disabled access as a high priority. The proposed national lottery will probably be a major source of such funds. Second, the funding system should encourage funded organisations to ensure that the long-term care of buildings is built into their plans and budgets, in order to avoid crisis planning.** Provision for maintenance and repair should form part of funding contracts (see Chapter 3). Where possible, local authorities also should adopt this approach in their funding of arts organisations.

In general, the role of the funding system in relation to arts buildings is likely to be as facilitator, adviser and partner, rather than as major contributor. It must support local initiative, provide expert advice, seek means to achieve effective 'leveraging' of money and work to ensure that, wherever appropriate, new or refurbished multi-use public buildings are suitable for arts uses.

The issue of access for disabled audience members, artists and technicians must be a top priority in any arts building project. The aim should be to ensure that all arts buildings in the country are made as physically accessible as possible within the next decade.

CHAPTER 13 · LIBRARIES AND MUSEUMS

Public libraries

More people, and a wider range of people, use public libraries than use any other arts buildings. There are literally thousands of local authority public library buildings and mobile libraries. They are by far the most extensive network of arts buildings – and vehicles! – in the country. They are a central community resource and gathering place; in many small towns and villages they are the only such resource. They are also the most fully used arts buildings in the country. As was noted in Chapter 2 (page 20), public libraries issue an average of ten books per year for every man, woman and child in the United Kingdom. More significantly, around half of the adult population of the United Kingdom belong to and borrow books from public libraries.

Social class and levels of education have far less influence on public library use than on the use of other arts buildings. The age, social class and educational background of library users mirror closely those of the population as a whole. The previous chapter suggested that some people feel a sense of estrangement from many arts buildings. This is not the case with libraries: they are part of people's personal landscape.

Libraries and literature

Literature has networks of production and distribution – publishers, bookshops and libraries – which other art forms can only envy. As the major publicly funded element, public libraries are the obvious basis of any national system for the support of literature. The core of this is of course the regular task of lending millions of books to millions of people; and it is this, coupled with the central place of public libraries in the communities they serve, that makes the library service the ideal medium for developing an appreciation of literature in the community. Libraries are underfunded, in the sense that an increase in resources would more than repay itself in terms of the service they provide. Nonetheless, the total annual expenditure on public libraries of about £700 million compares starkly with the £2 million spent on literature by the Arts Council and RABs. Given the disparity between these two sums, it is remarkable that the strategy seminar on libraries and literature, attended by many in the public library sector, came to this conclusion: **libraries need support from the Arts Council and Regional Arts Boards to help secure the policies, funds and staff training needed to develop their potential.**

This is support that the Arts Council and RABs must be ready to provide. In

financial terms they will be junior partners to the public library service – though their contribution may be of greater financial significance where certain special- ised, non-local authority libraries are concerned, such as the Women Artists Slide Library. But **the investment of time and money to promote literature with and through libraries promises immense returns. It should be one of the key areas for the investment of additional resources by the funding system.**

There are three main destinations for such investment. First, surprising as it may sound, there is a need to encourage libraries' commitment to literature. A Library Association research study in 1989 found that less than 20% of survey respondents believed that 'the main arts responsibility of public libraries lies in literature'; and less than 40% had a policy on the acquisition and promotion of works of literary merit. Writers' and readers' groups were mentioned infrequently, as were poetry workshops. But there are many rays of light. Many library services organise annual readers' and writers' festivals, children's book weeks, regular programmes of author visits, poetry festivals, writers in residence, and tours of sites of literary interest. Such initiatives must be built on.

Second, there is the work of 'literature fieldworkers', encouraging reading and writing throughout the community. This can sound merely modish, but in practice fieldworkers have proved a powerful force for the promotion of literature, and for building links between public libraries, booksellers, schools, adult and higher education and arts funding bodies. In most cases the public library service is an obvious home for such a service.

Third, what writers need perhaps more than anything else is an audience for their work. The public library service can assist here also. A number of libraries have experimented with displays of writing by local people, and by the use of photocopiers and desk-top publishing, people can be helped to produce as many copies of their work as there are readers for it. Such work can be made available for borrowing as part of normal library stock. In this way, writers can obtain readers' reactions, and readers may discover new local voices. Of course, the printed page is not the only form of publication. The oral tradition is thriving, particularly but not only in the Asian, African and Caribbean communities. In these cases too, public libraries have a part to play.

In each of these areas, public libraries are potentially or actually a major supplier of facilities and services. The funding system must be ready to assist by whatever means it can.

It should be noted here, finally, that proposals for the introduction of compulsory competitive tendering (see Chapter 10 pages 103–4) could have serious implications for libraries' support of literature – particularly if it were extended to book selection, which at present is a key area for librarians' exercise of professional expertise.

Libraries and the other arts

Public libraries are a valuable network of buildings, and provider of services, for other arts purposes also. Many have extensive collections of music books and scores, playscripts and works on photography and the other visual arts. Financial restrictions are putting many of these at risk. Many library departments mount important programmes of visual arts exhibitions, some in purpose-built galleries. The 1989 Library Association study suggested that nearly half of library departments have a building designed for joint library and other arts use. Residencies by dancers, potters, rock musicians and sculptors were among the arts initiatives mentioned by library departments. Public libraries can appear more friendly and welcoming (though not necessarily physically suitable) as venues for concerts and drama performances than 'formal' arts buildings. In around half of library buildings there is accommodation available for use by local groups, including arts groups. On the other hand, many libraries (and museums) are housed in old buildings which may pose severe access problems for disabled people. As was suggested in Chapter 12, a great deal of investment is needed to ensure that they are truly *public* buildings.

The 'openness' of library buildings makes them particularly suitable for multi-cultural activities. Successful examples mentioned during the consultation process include an Asian video project, a summer programme for children including Mexican music and Caribbean poetry, and sessions for Trinidadian steel bands.

The work of public libraries in promoting and housing arts activities is vital. Probably the most important assistance that the national and regional funding bodies can provide is information and advice. (It is notable, for instance, that more than 70% of respondents to the 1989 survey would have welcomed guidelines on visual arts exhibition space.) This is pre-eminently an area for the closest co- operation and partnership between library departments, local authority arts officers and the arts and media funding system: they have the potential to work together well and productively.

Chapter 2 showed how problems of definition made it hard to determine the current level of public spending on the arts. A rough guess was used to suggest the proportion of public library expenditure which might properly be said to relate to literature and to the other arts. Something better than this is needed for the future. The Director of Library Services for Birmingham City Council has suggested a formula, which is set out as Appendix C. This should be commended to local authorities.

Museums and galleries

Many of the same points apply to museums as to libraries. They are concerned with the arts, but not only with the arts. Museums offer a permanent national network

of arts buildings and art collections and they are a central part of the arts experience of millions of people (as was noted in Chapter 2, museums and galleries in the United Kingdom receive up to 100 million visits each year). Looking at paintings in an art gallery is a natural and desirable habit for increasingly large numbers of people, across all social classes, and may offer a less intimidating introduction to art than some performing arts venues.

Arts museums

All museums have, directly or indirectly, an arts role, but that role is obviously at its most central when the museum's permanent collection includes, for example, fine and decorative arts, crafts and media.

The art collections held in trust for the public by our museums are vast, beyond price, and of world cultural importance. They are also of outstanding educational importance, and a source of visual enjoyment that can be constantly renewed, replenished and developed. Museums are centrally important to any concern about developing understanding through the arts. Art in museums is not presented in a cultural vacuum. Though many visitors to art galleries prefer to make their own personal and quiet or contemplative study of a painting, the good art museum will always present a context for these viewings and provide an opportunity for a more developed or challenging understanding.

In recent years the phrase 'museum culture' has been misused to describe a nostalgic and static love affair with an imagined past. In our most exciting and imaginative museums, nothing could be further from the truth. Art in museums should be open for dialogue, debate, interpretation. Innovation is just as important in museums as in other arts contexts. The museum is a communicator. **Contemporary art and historic collections are a national resource for enquiry, learning and enjoyment. Those museums which mingle these ingredients fruitfully merit the strongest support from central and local government, the private sector and the general public.**

It is often said that visual literacy is undervalued in the United Kingdom. Museums have a key role in changing this. Museums are places for practice as well as seeing. Many programmes already exist in art museums to enhance public education and enjoyment. Many more could be developed. Artist-in-residence projects can be inspirational ways of breaking down barriers to understanding and enjoying contemporary work. Art borrowing schemes enable art from public collections, properly supervised, to be enjoyed in domestic and office settings. Publishing can bring new work to much wider audiences. Support for artists and craftspeople to use museum collections as source material can inspire an immediate and creative contact resulting in new work. A nationwide programme to place a new work of public art or craft in every art museum (from gallery furniture to a painting), assisted by a fund from central government or the funding system, would achieve at modest cost an exciting new national collection of contemporary

public work, create a market for artists' and craftspeople's work and support living artists. An enhanced policy of exhibition payment right would enable many more temporary exhibitions to be seen in galleries and museums.

A new view of the national collection of art, seen as a whole and curated by the museum and gallery profession as a whole, not as a miscellany of parts or places, is needed both to share this rich cultural inheritance wisely, and to inspire a proper nationwide strategy of collecting. This work could be started by publishing the art collecting policy of every museum in a single volume. The database for such a national archive is currently being collected as part of the Museums and Galleries Commission's Registration Scheme for museums.

Museums should achieve much more comprehensive touring of contemporary work, through existing agencies and by the museum network itself. Currently the opportunity to tour shows is hampered by inadequate training and resources and a gulf between rich and poor institutions. Imaginative tours of historic and contemporary collections would be of particular benefit.

Indeed, with the establishment of the Department of National Heritage, this is an excellent time for new and creative connections between 'heritage' institutions and those primarily involved in contemporary art. What is needed if such initiatives are to achieve their potential is not central co-ordination, but support systems which enable good ideas to be disseminated widely and lessons to be learnt. **There would be obvious benefits in a stronger and closer project-based relationship between all Regional Arts Boards and Area Museum Councils, and between the national arts and media funding bodies and the Museums and Galleries Commission.** The strategy must leave, as a clear legacy, active new partnerships of this sort.

Other museums

The collections of most museums are not concerned specifically with the arts. But in almost all cases there is the potential for valuable connections to be made. Thus, to give one example, the Imperial War Museum has a unique collection of paintings of war, many commissioned by the Museum itself. Many museums are using materials and artefacts from former ethnographical collections as the basis of more rounded exhibitions about specific cultures, their histories and artistic influence. Less direct examples can be envisaged. Why not introduce dance or mime to science museums, artists in residence to natural history museums, or involve local history museums in community plays? The use of diverse historic or scientific collections in an art context can provide new juxtapositions of material culture and natural specimens, to the benefit of artists, educators and audiences.

Whatever the nature of their collections, museums may commission public art and craft work for their galleries or gardens. Such programmes can both illuminate and be illuminated by the contents of the permanent collection. These are areas where programmes shared between the RABs and Area Museum Councils will be of great mutual benefit.

Archives

Preserving a record of the arts for present and future generations is a relatively neglected area. It is noteworthy that few of the strategy discussion papers referred to the subject explicitly. But the preservation of records is a key part of the duty owed to future generations. In most of the visual and literary arts, the work of art itself is, up to a point, its own record. But even in this basic sense, archives have suffered from lack of resources. There is for instance no up-to-date register of archives in private, public or commercial ownership, which prevents existing archives from being as useful as they could and should be. Moreover a record of the artist, not of her or his work alone, is an important element of any archive, and there are serious deficiencies in this respect: for instance at the time of writing, the National Sound Archive is unable to afford videotape recordings for its Oral History of British Photography. Once the opportunity for this is foregone it is lost for ever.

Perhaps even more pressing is the issue of performing arts archives. The need to preserve such material arises from its significance both as part of social and cultural history and as an information resource for those working now and in the future in the performing arts. These are some of the areas where time, effort and money are needed:

(i) **A survey of what is readily available at present will give those concerned a clear idea of gaps to be filled.** The Theatre Museum, which is a branch of the Victoria and Albert Museum and is the national museum of performing arts, may be an appropriate agency to carry this out, with local authority records offices performing the function locally. This should be followed by an exercise to identify priorities and to propose ways of creating and preserving archive material for the future.

(ii) This is the first century in which it has been possible to preserve live performance in sound and vision – from acting styles in Shakespeare, poets reading their work, changing performance styles of classical music, to arts reflecting cultural diversity. The present generation would not have forgiven its predecessors if they had neglected the opportunity to record Mozart playing the fortepiano or to film David Garrick acting. With all the technology now available, it is equally necessary that a record be created in sound and vision of the evolution of the performing arts. For art not based on texts, such as mime and live art, performance is the history: without a record of the performance, the history disappears. The same is true, to some extent, with dance. (One must not, however, undervalue Benesh and other forms of dance notation, which perform a vital archival as well as teaching role.) **The funding system should give**

high priority to making a reality of sound, vision and notation archives, by working with arts companies, the BBC and other broadcasters, the entertainment unions and other appropriate organisations.

(iii) Few performing arts companies can afford a professional archivist, but many have material of considerable social, cultural and historical value. The funding system should explore the possibility of setting up 'archive deposits', housed in museums, regional or national funding bodies or elsewhere, in which this material can be looked after and made available to the public.

Conclusion

This chapter has discussed why libraries, museums and galleries are crucial to the arts, and, in particular, crucial to demystifying the arts to the public. Their actual or potential artistic role goes well beyond the obvious, and partnership and support from the funding system are vital if this potential is to be fulfilled. As to archives, both measures of practical support and sustained advocacy are necessary if artists, participants and audiences, now and in the future, are to enjoy and learn from the arts of the past.

CHAPTER 14 · TOURING AND FESTIVALS

The tension between what the technocrats call 'cultural provision' and 'empowerment' – in plainer language, between providing art for people and enabling them to choose their art – runs like a thread through this book; but it appears in a particularly clear form in relation to touring. Over many years, touring in both the performing and the visual arts has largely been about 'delivering' artistic product to audiences and gallery attenders. It was not only the audiences who were treated as being in essence passive recipients of the work. It was true of venues and galleries also; there was little feeling that they might have active artistic policies of their own. This chapter is partly about how and why this view is changing. It also discusses the subject of festivals, because their purpose is allied to that of touring.

Touring the visual and performing arts has recently been surveyed in Graham Marchant's 1991 report for the Arts Council *Where do we go next?*. Graham Marchant integrated his work closely with the strategy consultation process. This chapter draws on his report, beginning with some basic questions.

First, why tour? Marchant provides the following justification for touring the performing arts (including literature); it is equally applicable to the visual arts:

> Touring exists as a way to bring about a more equitable distribution of arts activity on a geographical spread ('distribution') and to promote a wider range of artistic experience in places which already have some resident provision ('consumer choice').

Second, what is special about touring? Again, to quote from Marchant's review:

> The peculiarity of touring work in almost all its manifestations is the presence of a third party mediating the relation between those who create exhibitions, literary events, opera, drama, music, dance and the other arts activities . . . and their audiences. Whether that third party is an independent promoter arranging work in village halls, a festival director or the manager of a gallery, theatre or arts centre, the effect is comparable.

Marchant notes that the use of touring to complete a national network of provision is particularly a British phenomenon. Some European countries, notably Germany, have such extensive networks of producing venues that they rely more on exchange and collaboration than on touring companies or exhibition services. In Britain, touring is an important element of virtually all the arts, and is the major 'delivery mechanism' for dance and opera.

Third, how much is spent on touring? Marchant estimates that in 1989/90 around £25 million was spent on performing arts touring by the Arts Council and RAAs, and perhaps a further £2 million on visual arts touring – the total representing a little over 20% of what the Arts Council and RAAs spent on the arts in England. **The disparity between these two figures is considerable; the funding system should consider as a matter of urgency whether this is an appropriate balance between spending on performing arts and visual arts touring.**

Performing arts touring

The strongest single message from both the consultation process and Graham Marchant's review is that promoters and venues have been damagingly neglected by the arts funding system, with virtually all funds going to touring companies. This is not to say that the emphasis should be reversed, but that **audience development, education and outreach work, and indeed basic artistic work, are enhanced if there is a genuine** *partnership* **between company and venue.** Venue managers and companies were relatively at one in their listing of what venues should be able to offer this partnership:

 (i) decent working and performance conditions;

 (ii) close links with the local community;

 (iii) highly motivated and skilled staff;

 (iv) networks of venues, to share information, expertise and costs in such areas as marketing;

 (v) partnerships between specific venues and touring companies, to assist artistic planning, education and audience development;

 (vi) the resources to search out new and exciting work for audiences; and

 (vii) the ability – a mixture of programming and resources – to create a strong identity for themselves and to project a clear vision of what they want to achieve.

These are the areas in which the funding system should concentrate its support in terms of both advice and funding of venues. They are developed below.

Graham Marchant notes an interesting point arising from the current

emphasis of the funding system – namely, that the concentration of talent that there is said to be in companies rather than venues may be a result of the talent following the money rather than vice versa. If this is so, it is all the more remarkable that there are so many venue managers respected throughout the industry for their programming, marketing, and audience-building skills. Providing them and their colleagues with financial, networking and information support can only be to the good.

As to touring companies, one respondent to the strategy consultation process spoke for many:

> Touring for performers is not an enjoyable business, except for the occasional pleasure to be obtained from a successful production targeted to a particular section of society. To performers touring often seems endless and numbing, but accepted as an inescapable chore, like cleaning one's teeth. A number of performers accept that new work must be toured, an essential maturing process attaching to the genesis of a new production. Naturally, the burden of touring is eased when runs at a particular venue run to weeks as opposed to the horror of one-night stands and short runs.

This emphasis on venues does not mean that the funding system should start again with a new system that puts all the money into venues and allows touring companies to sink or swim. The companies are far from lavishly funded. Indeed, terms and conditions that companies are able to offer those who work for them are often among the worst in the whole profession. **But the highest priority in performing arts touring – for the benefit of audiences, companies and venues alike – is for additional funding to be focused on venues.**

There is a third party in performing arts touring that is too often neglected by the funding system: the producers of commercial tours. It was argued in Chapter 4 that the issue of quality cuts across and should override art form distinctions and the professional/amateur divide. The same should apply in relation to work produced by commercial as against publicly funded managements. It may often be possible for the funding system at a limited cost to extend a high quality commercial tour, or to make a relatively small initial investment in such a tour. This can be a cost-effective use of public money, furthering both the 'distribution' and the 'consumer choice' aims of touring. **The key requirement is for the funding system (and local authorities also) to be open-minded, and in a sense opportunistic, in its use of funds – not ruling out investment on the sole ground that the work carries a 'commercial' label.**

Visual arts touring

Marchant calculates that around 20% of shows in the independent, local authority, arts centre, university and college gallery sectors are provided by touring exhibitions. Apart from exhibitions which are shared collaboratively between galleries, the main sources of major shows are the National Touring Exhibitions Service run by the South Bank Centre, the Crafts Council, the National Museums and Galleries, and the Area Museum Councils. There is also a growing number of medium and small scale shows available throughout England, as well as shows intended for venues other than galleries.

Issues around visual arts touring are strikingly similar to those in the performing arts. The main differences are financial (visual arts touring receives far less funding than performing arts touring) and structural (with historical and contemporary visual arts funded separately from each other, and the existence of a national touring service). The main similarity – evident in Graham Marchant's review and throughout the strategy consultation process – is the widely perceived need to create a more equal relationship between the receiving galleries and those who originate touring exhibitions, which means providing funds and support services for the former.

This is not to deny the vital role of the national touring service. It provides high quality exhibitions of a kind beyond the financial resources and the curatorial expertise of most galleries. Such exhibitions can then receive maximum exposure and repeat showings in strategic venues across the country. Marchant notes that the service provides a lifeline to many galleries under severe budgetary and staffing pressures. On the other hand, the provision of a ready-made exhibition package, together with a lack of funding elsewhere in the gallery sector, may discourage the receiving galleries from developing the expertise which would enable them to originate or collaborate in exhibitions of their own. The effectiveness of a particular exhibition in a particular gallery will be increased through a partnership between local knowledge and specialist professional expertise. This will be possible only if the gallery is adequately funded and has the opportunity to contribute to the exhibition artistically and in areas such as installation and marketing. Thus **alongside the national touring service there should be more emphasis on enabling galleries to collaborate with the service and with each other in organising exhibitions and promoting tours.**

Meeting the needs – the role of the funding system

The necessary new balance between the originators of touring work and those who present it, in both the performing and the visual arts, must be reflected in funding structures. Touring is necessarily a national business (see below on Scotland and

Wales) if one focuses on the originators. It becomes in addition a regional or local matter if the focus is expanded to take in venues. If performing arts venues and receiving galleries are to be supported and funded to play a more equal part in this relationship, then RABs will inevitably play a larger part in the support of touring than has hitherto been the case. ('Galleries' should be taken as a broad term: some of the most exciting and stimulating visual arts events take place in places other than conventional galleries.)

These are some of the key areas for support of performing arts venues and galleries:

(i) **Building renovation and maintenance.** This is one of the most glaring, and certainly one of the most expensive, needs of all. It was considered in Chapter 12, on arts buildings.

(ii) **Programming support for venues.** A scheme to support venue programming should be put in place by the Arts Council and RABs, wherever possible in partnership with local authorities. Awards made under such a scheme should be specific in their purposes – for example, to develop the venue's relationship with a particular company or companies or to support programmes of marketing, education or outreach work.

(iii) **Commissioning networks: venue to venue.** Anyone running a venue who wishes to commission and produce work for it is battling against the odds. Perhaps the most valuable way in which such work can be supported is by establishing networks of similar venues able to share the cost of such work. This would not be cheap – Marchant suggests that a sum of about £500,000 per year for commissioning might initiate such a shift in practice. But potentially it offers good value for money. A pilot exercise should be introduced, with careful evaluation and self-evaluation of the participating venues. If successful, this networking approach should be extended to cover the touring of culturally diverse work, international arts activity, work for young people and disability arts.

(iv) **Networks: venues to companies.** Touring is likely to be most successful when there is a good and regular relationship between venue and company. Audience development, education work and so on are far more effective if venues and companies can work together and if the company's visits are reasonably frequent and not too short. The funding system should spread knowledge of good practice in this respect, and be prepared to make the (relatively small) financial contribution necessary to help these relationships flourish.

(v) **Programming support for galleries.** Funds are needed to support galleries which receive exhibitions as well as those which originate them. If inter-gallery collaboration is to be encouraged there must be a flexible attitude by the funding system. The RABs, with their detailed knowledge of the regional galleries and their audiences, have a vital role. It is important that they take a wide view of their regional responsibility — extending it to cover the 'export' of the best of the region's work, as well as support for the 'import' of exhibitions for the benefit of regional audiences.

(vi) **Support services: training, travel grants and information.** All the above will be effective only if those who run venues and galleries have ready access to a wide range of training and information. Travel grants are an obvious area for support. Training and information should be based on a judicious mix of directly provided services by the funding bodies, support of self-help advice networks and funds to contribute to the cost of external training courses.

Touring is also a way of reaching new audiences. This places a responsibility on the funding system, in collaboration with venues and galleries, touring companies and exhibition originators, and local authorities, to use touring as a way of introducing people to the arts. Therefore, scaled-down versions of major exhibitions — security and exhibiting conditions permitting — might be housed in public libraries or other community venues, both for their own sake and as a means of encouraging a visit to the larger show. Furthermore, touring the performing or visual arts to unconventional venues can be a way of combatting the trepidation which some people feel about entering a dedicated 'arts building'.

Great Britain

This book focuses on England: the Scottish and Welsh Arts Councils have co-ordinated parallel exercises. But there are issues which of their nature cross the national boundaries. Touring is one of these, and an obvious example is the touring of opera. Welsh National Opera, for instance, spends the majority of its touring weeks in England. Without this, many English audiences would be deprived of top class opera and Welsh National Opera could not survive as a full-time company. More generally, the need not to be bound by the national borders within Great Britain is obvious in the case of all the largest companies which tour. But the principle is the same whatever the size of company. English companies wish to appear at the Edinburgh Festival and Fringe; Scottish companies wish to be seen in London. **It is the duty of the national Arts Councils to facilitate freedom of movement, for the benefit of the arts, audiences and arts companies throughout Great Britain.**

Services to companies

There are two matters which sound mundane but are in fact important symbols of the proper supportive relationship between the funding system and touring companies, as well as being of much practical significance.

The first is to ensure that **rules and procedures are consistent among regions and between regions and the national level.** Genuine regional differences should be supported and nurtured; pointless inconsistencies should be eliminated. Consistency should cover not only such issues as standards of service but also deadlines, procedures and application forms. There can be few matters more infuriating or time-wasting for artists and arts organisations than to be faced with a plethora of application systems which do not reflect genuine regional differences but merely a lack of co-ordination between funders. If an organisation has provided comprehensive information to one funding body, it has the right to assume that it will not be required to go through the whole process again, using different forms, to satisfy the requirements of another. As far as possible, the funding system should also collaborate with local authorities to reduce unnecessary form-filling by applicants for funding.

The second is for **the funding system to use its buying and bargaining power on behalf of the arts community.** Many building-based producing theatres, for instance, have arrangements with a local hotel to provide accommodation at reduced rates for visiting artists. Touring companies rarely have the opportunity to negotiate such deals. The funding system is ideally placed to do so. It also has the potential to work out deals with airline companies, and with those who provide other means of travel, accommodation and training courses – indeed, virtually any area in which the grant-aided arts community is a significant purchaser of services. The conditions of touring, and the inadequacies of touring allowances, are major concerns for those who tour. The funding system can, and should, do much to alleviate this.

Festivals

Festivals can be among the best or the worst forms of arts provision. Some are life-enhancing; others, utterly lifeless. At their best, festivals are occasions for disruption, surprise and celebration. They bring aspects of the arts to the attention of people who might otherwise not know or care about them, and provide an opportunity for a community to come together and to promote its name and image more widely.

Festivals can stimulate exchange between art forms, and mingle amateur and professional, the well established and the innovative; they may celebrate the arts of other countries and cultures, and reflect Britain's many cultures. When they work well, they are a real 'event' – creating a sense of occasion and providing a focus for

creative activity both during the festival and afterwards. **Not all festivals are or can be such powerful instruments for the development of the arts, audiences and the community in general. But those which are or could be successful in these respects merit significantly more public funding and support than they have received in the past.**

The opportunities for partnerships between local authorities, the private sector and the arts and media funding system are clear. Each of the parties will have its own agenda and aims, which may well be very different from those of the others; but they have the potential to fit together well. These are some of the elements which the funding system should bring to this partnership:

(i) It is important to protect the essentially unpredictable quality of festivals. Funding system support should enable things to happen in the broad areas suggested below. It should not be prescriptive.

(ii) The system should prioritise the commissioning and presentation of new work at festivals.

(iii) Even festivals which are focused on individual art forms have, at their best, an open attitude to cross-disciplinary work. Funding structures should reflect and encourage this.

(iv) For smaller scale and amateur-run festivals, funding should be made available to assist with professional administration: voluntary effort is indispensable, but even a small addition of professional help can greatly assist a festival's development.

(v) A pool of money should be available to support major large scale promotions from time to time.

Conclusion

Touring the arts is vital both to ensure their wide geographical availability and to promote audience choice. It is important to all the arts, though the balance of funding between visual and performing arts touring requires examination.

Hitherto, the funding system has concentrated its support on companies which tour, and on the providers of exhibitions, rather than on the receiving venues and galleries. But the public experiences the arts where they take place: it looks to its local theatre or gallery to provide an exciting programme over the year. It is, furthermore, in the interests of all who contribute to the success of arts

touring that a company is able to build up a good relationship with the communities to which it tours, and that it can undertake education, outreach and marketing programmes within them. Thus **the highest priority in arts touring of all sorts is for additional funding and other support to focus on receiving venues and galleries - not at the expense of touring companies and the providers of exhibitions, but to enable venues and galleries to enter genuine partnerships with those who produce the work.**

The purposes of arts festivals are in some respects similar to those of arts touring. They can help to develop the arts, to encourage collaboration between art forms and to engender a sense of community. **At their best, arts festivals merit a higher level of public funding than they have received in the past.**

CHAPTER 15 · BROADCASTING

There are three aspects of broadcasting particularly relevant here.

First, **television and radio are art forms**, with unique means of expression, presentation and relationship with their audiences. They have, furthermore, developed more specific art forms: arts documentaries and drama series, for instance, are the inventions of broadcasting.

Second, **broadcasting is a major – probably the major – medium for making the arts available to the public at large**, able to transcend most of the physical and social barriers that still bedevil many of the arts. Television and radio have the potential to turn the United Kingdom truly into 'a culture of cultures'. Broadcasters commission and produce a vast quantity of new work, particularly in the fields of music and drama. A playwright or poet can reach a far larger audience through radio or television than through live performance. Television and radio provide critical debate, information and education about the arts. Nor is this merely a one-way relationship. Straight relays or (more commonly now) adaptations of arts performances can become 'events' on television. If the arts benefit from critical scrutiny by broadcasters, broadcasting benefits from an exciting arts scene to scrutinise.

Third, **broadcasting helps to support the other arts and vice versa**. Channel Four and latterly the BBC have been major contributors to the British film industry over the past ten years. Through listings programmes, television and radio help to market the arts. Broadcasting is a crucial source of work for actors, musicians, writers, composers, technicians and others working in the arts. Correspondingly, creative and interpretive artists and technicians often acquire skills and experience outside of broadcasting which are then valuable within the broadcasting industries.

In the past, those working in the other arts tended to undervalue each of these three roles, particularly the first. **Broadcasting and the other arts have a relationship of mutual dependence. Each would be crucially impoverished if this relationship did not exist. Broadcasters and the arts and media funding system should place a high priority on strengthening it.** The conference called by the Arts Council in October 1992, designed to celebrate and develop this relationship and attended by hundreds of people from broadcasting and the other arts, marked a major step forward in this respect, even though, inevitably, it uncovered as many issues as it resolved.

Timing considerations have, unfortunately, not permitted coverage in this chapter of the government Green Paper on the future of the BBC, nor of the BBC's own discussion document, both published in late November 1992.

New horizons for broadcasting

Broadcasting technologies, and thus the frontiers of home-based entertainment, are changing fast: time-shifting using video cassette recorders; high-definition television; a wider range of productions on video; more sophisticated sound recording and reproduction; specialist subscription and independent radio channels; cable television and community radio; inter-active television and three-dimensional 'virtual reality' are providing or will provide new and often creative opportunities for artists and the arts audience. Home-based media are vital, particularly for those who are not able or do not choose to visit arts venues — increasingly the case with our ageing population or many people living in rural areas: they genuinely add to people's choice as both consumers and producers of the arts.

The structures of broadcasting have developed greatly in recent years and, following the Broadcasting Act 1990, are set to expand further. But the picture is, at best, mixed. A greater emphasis on commercialism may actually limit arts programming. The new Radio Authority is licensing three independent national radio services. At the time of writing two have been decided — Classic FM (now broadcasting) and Virgin Radio (due to begin broadcasting in March 1993). The third will be speech-based; its introduction has been delayed, perhaps to 1995. At the same time the review of the BBC is raising question marks over the future of Radio 3 and considering the privatisation of Radios 1 and 2. The past twenty years have seen a considerable growth in local radio provision, both by the BBC and by independent radio stations. But this has slowed down more recently. Since 1988, for instance, only three new BBC local stations have been opened, and there may be cutbacks ahead.

The new independent local radio (ILR) services include specialist services such as Jazz FM in London and five stations for Asian and African/Caribbean interests around the country (three in London, one in Coventry and one in Bradford). Five new 'non-pop' ILR licences were scheduled to be awarded in 1992. These are potentially positive signs for arts broadcasting, though dependence on advertising revenue has already led some specialist stations either to broaden their remit or to dilute their purpose, depending on how one looks at it.

At the most local level the expansion of community radio is creating a third sector which represents a significant opportunity for particular communities to participate directly in production and programming. If properly supported, by the funding system among others, it has the potential to be a medium of innovation and experimentation, in which the amateur artist is welcome alongside the professional. Most RABs have or are developing a policy on radio, including support for community radio. The case was put strongly in the consultation process that the funding system as a whole should find a clear 'place for radio', covering both policy and funding.

The advent of satellite television has widened the choice of channels but, with the exception of films, has not had a major impact on arts broadcasting. Satellite television has not found it commercially viable to produce much of its own arts broadcasting, and has tended to rely on archive material. At the start of satellite television there was a dedicated arts channel, but this was an early victim of commercial pressures. Cable television offers new opportunities for cheap access to broadcasting at a local and community level. The current recession has slowed down the development of cable networks, and their potential has yet to be realised.

It is the duty of public service broadcasting, not the BBC alone, to further the *art* of television and radio. The arts and media funding system cannot expect to have a major financial stake in the areas listed above; yet all of them have considerable implications for the arts, and thus are within its area of interest.

Broadcasting and the arts

Broadcasting about the arts (review and documentary programmes rather than original productions or relays) is concerned with education in the broad sense. At its best it should be able to help audiences to crack the 'codes' that surround some arts, and to help people feel more at ease with them. For example, an arts documentary can bring together artworks, archive, interviews, locations, comment and analysis in ways not possible in other media.

Compared with the numbers attending individual live arts events (though the comparison may not be inapt) the audience for arts-related programmes is immense. Arts programmes are also influential: surveys have repeatedly shown that television is the most important medium for finding out about and stimulating an interest in the arts. Furthermore, the audience for such programmes is far more representative of the social composition of the general population than is the audience for live events. Nonetheless, in the view of many of the broadcasters consulted, the arts still have too low a priority on radio and television. **The funding system must renew its efforts to work with broadcasters for the promotion of the arts on radio and television. This is particularly important at the regional level:** there is considerable scope for developing relationships with regional, local and community broadcasters. The RABs have an important role in providing information and advice and identifying areas of common interest.

It is still far too often the case that artists from the 'live' arts feel patronised and abused when their work is dealt with by the media, particularly television; horror stories abound of insensitivity to the needs of artists by those putting together documentary or listings programmes. Equally, many people in the media feel that those in the other arts use broadcasting largely as a means of advertising

and self-promotion. Both attitudes are unhelpful. **For a wide variety of reasons, broadcasting and the 'live' arts have a relationship of mutual dependence: neither can truly flourish if the other is under financial or other threat; each needs the public support of the other.**

The public attitudes survey showed the importance of television and radio as arts media. Nearly half the population (47%) watches plays on television, for instance, and radio is obviously a vital medium for listening to music. The survey also explored the relationship between watching television and attending events. What is clear is that a large proportion of the television audience does not go to live events. On the other hand, the availability of the arts on television is a factor persuading a small but significant section of the population to sample the 'live' arts. **Broadcasting is not in competition with live events but complements them and provides a distinctive experience in its own right.** Broadcasters and the funding system should continue and expand their project-based relationship, including the joint commissioning of original work for broadcasting, and financial and artistic collaboration in the transformation and relay of productions originally designed for live performance. The funding system should facilitate broadcasting of the work it supports, by encouraging appropriate agreements between arts managements and unions, contributing financially to the proper equipping of buildings and other practical measures.

Conclusion

The funding bodies must continue to make interventions, and enter partnerships on specific projects, with broadcasters at local, regional and national levels. What is vital in the long term, however, is that within broadcasting as a whole – not the BBC alone – the public service commitment is sustained and enhanced. The funding bodies have an important support role here also: for instance by entering fully into the debate on the future of the BBC; by lobbying for the retention of the BBC licence fee as the Corporation's principal source of funding – the best guarantee of quality arts broadcasting; by monitoring the arts programming of the ITV licence winners and independent radio stations; by making the case for arts broadcasting to be protected in the schedules in the same way as the Broadcasting Act 1990 protects children's and religious broadcasting; and by promoting internationalism in arts broadcasting.

Broadcasting is a significant innovative group of art forms in its own right, meriting respect, support and in appropriate cases collaboration with all others who work in the arts.

Broadcasting companies are also major patrons of the arts, and there is a mutual interest between them and the funding system in strategic and

planning issues. For instance, it makes little sense for the Arts Council to discuss the future of the country's orchestral music in isolation from the BBC's consideration of the future of its orchestras. The current joint BBC/Arts Council review of orchestral provision is an important step forward in this area.

CHAPTER 16 · BEYOND THE UNITED KINGDOM

Internationalism was one of the key themes of the strategy consultation process. As with education, there was a strong view that an international perspective should inform all aspects of arts development and support. This chapter looks first at the general issue of international support and then at issues specific to the European Community. It does not deal with the issue of cultural diplomacy, which is the responsibility of the British Council.

The arts have little to do with national boundaries, but it is rare to begin any enterprise or relationship by thinking on a global scale. International collaboration generally starts with bilateral relationships: a dance company working in collaboration with a festival in France; a repertory theatre using a relationship with its city's twin city in the United States; co-operation between an English and a German art gallery. From such partnerships arise a web of genuinely international activity open to all cultural groups. The role in the international sphere of those agencies which support the arts and culture is, largely, to remove unnecessary obstacles to their free movement and to help such partnerships to flourish.

There are many parts of the arts and cultural sector for which the European market - indeed the global market – is already a working reality. For commercial theatrical producers, the major opera houses, museums and galleries, and film and television companies, co-production, selling abroad and international touring have been a way of life and an economic necessity for many years. The funding system should be ready to advise and assist such organisations where that is necessary; but **the focus of the strategy in this area is particularly on the needs of individual artists and smaller scale arts organisations, for whom information, networks and resources to enable them to participate internationally are not so readily available.**

What does the UK have to contribute?

Artists and arts organisations in the United Kingdom are highly self-critical. But it is important that they recognise and celebrate also the strengths that they bring to the arts internationally, and that they be allowed to do so more effectively. One question which is too seldom asked is: What can the cultures of the United Kingdom contribute uniquely to the patchwork of European and world cultures?

It is worth recording the answer to this question provided by Eduard Delgado, one of the most distinguished foreign commentators on the arts and cultural scene in the UK. He listed the contributions as being:

(i) a strong sensitivity to cultural diversity – even if there is far more still to be done in this area;

(ii) an imaginative approach to the cultural industries;

(iii) a unique artistic heritage;

(iv) high quality television; and (generally) good relationships between broadcasting and the arts; and

(v) innovative techniques of arts management and distribution, largely born of economic necessity.

Delgado has also noted that the most fascinating thinking in Europe about the arts – their place, practice and economic role – is found in the UK. Alongside this, however, the UK is in his view the European state with the greatest imbalance between the inherent importance and achievement of the arts and their political profile. But there are signs that this imbalance may be changing in the 1990s. The arts community is increasingly determined to assert the importance of its work; many of the cities, towns and rural areas of the UK, despite spending restraints, see cultural policies and investment as vital; and central government has demonstrated its commitment through the arts festival for the 1992 UK Presidency of the European Community and, especially, through the creation of the Department of National Heritage.

Principles and needs

Internationalism is so obviously a good thing that it may be too seldom asked why this is so. The value of internationalism and international exchange in the arts may be summarised as follows:

(i) The arts may be local, but they are also universal; by broadening perceptions international understanding is increased.

(ii) The work of the cultural sector and the quality of life of the general public in the UK are enriched as a result of exposure to and involvement in the arts, crafts and media of other countries and cultures.

(iii) The arts community and general public of other countries are similarly enriched by exposure to and involvement in the arts, crafts and media of the UK.

(iv) The export of cultural activities and artefacts to countries throughout the world plays a major role in enhancing the positive image of the UK.

(v) Many communities in the UK have historic, ethnic or other links with cultures abroad, which are mutually beneficial and deserve to be supported.

The principal objectives of an international arts policy flow naturally from this: it must encourage an international dimension to the work of artists and arts organisations based in the UK help the public in the UK to become better aware of cultural forms and activities from all over the world; broaden international contacts between creators, producers, promoters, venue managers and others through the exchange of information, co-production and other forms of co-operation; and ensure that the interests of the cultural constituency in the UK are well represented internationally.

Some of this can be done at relatively little expense – particularly those aspects based on co-operation and the provision of information and training services. Furthermore, it does not represent a radical break with the past. Networks of practitioners (such as the Informal European Theatre Meeting and the International Theatre Institute) are already in place, though more strongly within than outside Europe. Much of the necessary information is already available, some of it collected in a convenient form, such as the Arts Council's *Who Does What in Europe* and *Arts Networking in Europe*. But the approach both within individual funding bodies and in terms of co-operation between them has hitherto been unsystematic. This is an area in which clear, principled and consistent practice will pay huge dividends. It has to be said, also, that if the British public, arts and artists are to derive full benefit from an international approach, some aspects of this will cost money. It is appropriate, therefore, to begin a more detailed look at requirements with the question of funding.

Funding. It is difficult to reconcile the funding system's encouragement of artists and arts organisations to be more internationally minded with its inability to provide additional resources to help this to happen. In particular, the rule that clients of the Arts Council may not use any of their grant for overseas touring looks increasingly artificial, restrictive and difficult to enforce.

The funding situation is not getting any easier. In the past, British orchestras, for instance, have been enormously successful abroad, with very little public funding. But if they are expected at least to break even on foreign tours, the fees they have to charge may lead them to be undercut by heavily subsidised orchestras from Western Europe or severely underpaid orchestras from Eastern Europe. Furthermore, reciprocity of funding is a major issue both in terms of cash and structurally. It is too often the case that British artists travel abroad to take

advantage of more generous funding while British promoters import foreign work for the same reason. This glaring cultural imbalance is not a stable basis for growth.

Whatever initiatives are undertaken, however, it is vital that they should have an eye to the future rather than being short term and opportunistic. Preservation and enhancement of the strengths of the arts in the UK are among the legitimate aims of an international arts policy: the import of work from abroad should not be at the expense of the health of arts organisations in this country.

On the structural front, the funding of venues, common abroad, fits uncomfortably with the practice in the UK of funding producing arts organisations instead. It is now evident that foreign orchestras, opera, dance and drama companies and major exhibitions often by-pass the United Kingdom because a visit is no longer financially viable, or because of a lack of suitable venues. See Chapter 14, on touring, for further discussion of this issue.

Information. There is more that could be done to assist promoters to develop expertise and knowledge of foreign work, and UK artists, craftspeople and film and video makers to work, or export their work, abroad. In part, this is a matter of making more widely available the wealth of information already available to the funding system, the British Council, Visiting Arts, and to those working in the arts who have international experience. Where it is in the possession of public agencies, this should pose relatively few problems — it is a matter of improving co-ordination. Where it is information held by private individuals or other organisations, the issue is slightly different. Information on sympathetic host venues overseas, unexpected sources of funding and so on may have been gained with some difficulty and expense. Why should those in possession of such information choose to share it?

Training. Language training, in particular, is a key need for many British arts practitioners and promoters wishing to work abroad or bring work from abroad.

Practical issues: venues, work permits, fire regulations. There is a range of issues under this heading, ranging from the fact that much of the most exciting foreign work may not physically fit into any UK venues or meet UK fire regulations, to the sometimes restrictive attitude of UK immigration and employment authorities to the granting of work permits and visas to foreign artists. (There are, of course, countervailing issues in both cases — public safety and protecting the employment opportunities of UK artists respectively.) British artists and companies also need advice on such regulations and practices in the countries to which they wish to tour or export their work.

How to meet these needs

A policy for the support of international arts activity into and out of the

United Kingdom can be summed up in three simple concepts: money, flexibility and the support of individuals.

The following are some of the ways in which the needs set out above should be met. Not all require extra money, and where they do, the necessary amounts in some cases are quite small.

(i) Travel grants are currently available from the funding system in only a limited form. In conjunction with the British Council — which already does very valuable work through its travel bursaries — the system should develop ways to enable 'gateway' promoters, directors, curators and so on to extend their contacts and knowledge of overseas work, on condition that these are shared widely with colleagues.

(ii) Training seminars should be provided on the promotion of foreign work, sources of funding, contacts, funding structures and relevant foreign laws and regulations; and language training bursaries should be established.

(iii) More money is needed to enable British galleries and venues to bring in specific foreign exhibitions and performing arts companies. Some structures for support already exist, such as the International Initiatives Fund and the work of Visiting Arts. The funding system and the British Council should make the case to the Department of National Heritage and the Foreign and Commonwealth Office for an increase in their funding.

(iv) The establishment of new networks of information is not itself a high priority, but the injection of small sums of money to help existing networks to operate more effectively is. Networks should be seen as a service provided by, not for, artists and arts organisations. The enhanced profile of disability arts, for instance, owes much to the growth of international networks of disabled artists. Such developments should be supported.

(v) The funding system, Visiting Arts and the British Council should work closely, ensuring that artificial and bureaucratic distinctions are as far as possible eliminated. In particular, the present rules on the use by clients of any part of their annual subsidy for touring overseas should be re-examined, and clear guidelines established in conjunction with the British Council on costs and fees for overseas tours. In addition, relevant information available to each of these bodies should be pooled and made available to artists, arts organisations, producers and promoters.

(vi) The funding system should seek to persuade the domestic authorities in the UK to adopt flexible policies in such areas as immigration and work permits. British/EC artists must not be displaced; but in most cases artists are not interchangeable, and in general foreign artists add to British life and culture rather than taking work away from their British colleagues. This flexibility should be matched by authorities abroad in their treatment of British artists.

(vii) Many individual artists and makers in all forms have similar needs in such areas as advice on overseas sales and marketing which, individually, they do not have the resources to meet. The Crafts Council helps to supply such support services, and the rest of the funding system should play a fuller role.

(viii) Much of the funders' role in this area should be to identify those individuals – whether artists, producers, or promoters – with the most exciting and creative approaches to international work, and to provide them with the resources necessary for them to exercise their gifts. Funding must be administered flexibly, efficiently and speedily if it is to have the fullest effect.

The arts and Europe

Europe has at least two geographic dimensions: the European Community, and the wider Europe of the states that have signed the Council of Europe Cultural Convention. In this section, we shall consider the first of these. The second may require particular policies to be developed, but in general it is a specific instance of the international issues discussed above.

There are limits on the expansion of the European market for the cultural products of the UK. Language, tastes and cost are obvious practical constraints. Furthermore, some artists are fearful that artistic activity in the Single Market may be homogenised, leading to the production of a Euro-art if artists are patronised by European institutions for political and economic rather than cultural reasons – for instance, in an attempt to define European culture in opposition to that of North America. On the other hand, there are signs that the Single Market may strengthen individual artistic practice and help to celebrate the diversity of cultures which make up the Community, whether along regional, ethnic or national lines, rather than seek to dissolve this diversity.

There are two rather different trends emerging from the European institutions concerned with cultural affairs. On the one hand, policy towards the audio-visual cultural industries is already relatively protective, indeed protectionist, because of

a wish to defend the EC in the face of competition from, for instance, Japan and the USA. On the other hand, in the 1980s the European Community increasingly recognised the values and virtues of cultural diversity in the arts and heritage. As was suggested above, this is an area to which the UK can and should make a major contribution. But in focusing on the Single Market, it is vital not to become parochial merely on a larger scale: there is a world beyond the European Community.

Principles, needs and opportunities

The principles of a cultural policy in relation to the European Community are the same as those of an international arts policy generally, with these additions: **the aim should be to integrate cultural activity into every significant aspect of social and economic life within the Community, particularly the environment, education and economic development; and United Kingdom artists and public should be enabled to benefit fully from the funding opportunities specific to the Community and its Member States.**

The particular additional needs and opportunities that arise within the European Community are in such areas as early information on Community directives, policies and funding programmes which relate or could relate to the arts; access to Community funding; 'ways in' to the Community, including advice on lobbying, introductions and the co-ordination of visits; and similar services in relation to the regulations, practices and key individuals of Member States as opposed to the Community as such.

In relation to film and television, funding and policy have been influenced since 1988 by the European Commission's MEDIA programme, which seeks to exploit the benefit for these industries of the Single Market. Its aims are both cultural – to bind European cultures together – and economic – to use networking between Member States to strengthen their individual audio-visual economies. It is based on establishing partnership funding between the Commission and public or commercial funders in the host country. If the UK is to benefit from MEDIA and other European programmes, then the needs are projects worthy of support, full involvement in relevant community discussions and sufficient funds in the UK to attract matching funds. The first of these exists already; the second is a matter of political will on the part of the UK government and the funding system; the third requires additional resources from government.

In other cultural areas, the potential for development at the Community level may depend on the fate of the December 1991 Maastricht treaty, which included an article requiring the cultural dimension to be taken fully into account in all Community actions. Whatever happens to the Maastricht treaty it is undoubtedly true that both the need and the opportunity to influence Community cultural policy are greater than before.

Among the developments for which the funding bodies should work are these:

(i) The European Commission should be encouraged to establish funding specifically for cross-frontier touring and for artists' and producers' travel grants.

(ii) The Community should be encouraged to adopt clear, openly declared and flexible criteria for its decisions.

(iii) Community thinking on cultural issues currently pays too little attention to cultural diversity within Member States. This should be rectified.

(iv) At the time of writing, there is confusion as to how far Community regional development funds may be used for cultural projects, and whether they must be channelled through national governments or can be transferred directly from the Community to the regional level. Such funds have been successfully used for a variety of cultural developments and could be used more satisfactorily still. They are too important to fall victim to disagreements between the Commission and the UK government.

(v) Both the lobbying and the information capacity of the funding system must be developed to make it more effective in working with the European Community and with other Member States. Moves in this direction are likely to receive a boost if, as planned, the Community develops support systems for cultural networks from 1993. Such aid should be concentrated on networks which provide practical co-operation across frontiers for arts professionals, which achieve results of real substance and which have the least intrusive of bureaucracies. The system should also support new networks where gaps exist, for instance networks of Black artists.

Conclusion

The relationship on cultural matters between the United Kingdom and the rest of the European Community is a matter which requires on the one hand the greatest respect for diversity – of nation, region, ethnicity and forms of art; and on the other hand co-operation, a sharing of information and the avoidance of duplication. There is no contradiction here. The simpler and clearer the framework, and the more effective the spread of information, the more diversity can flourish. **The encouragement of both diversity and co-operation should be the keynote of United Kingdom cultural policy towards the European Community, and towards international arts activity generally.**

The funding system's international arts policy should be based on the careful analysis of two areas: the *strengths* of the arts, crafts and media in the United Kingdom and thus their potential contribution; and the *needs* of the public, artists, promoters and producers in the UK. This chapter has suggested a range of principles and practical measures to underlie and support international arts activity into and out of the UK. More money is needed, but just as important is the determination of the funding system to work with, as well as for, artists and arts organisations.

CHAPTER 17 · THE ARTS AND
THE PRIVATE SECTOR

As has been noted at several points in this book, the arts are provided and supported by a mixed economy of publicly funded and commercial sources. Partnership has been a central theme — for instance, the need for partnership between the funding system and funded sector on the one hand and the commercial arts, broadcasting and cultural industries sectors on the other; and between artists and planners, arts funders and local authorities. 'Partnership' implies equality — a relationship freely entered into because each party can benefit and learn from it.

The focus of this chapter is on some specific aspects of the actual or potential partnership between the funded arts sector and the non-arts private sector. It draws on a submission from the Association for Business Sponsorship of the Arts (ABSA).

ABSA

Private sector involvement in the subsidised arts is significant, and partnerships with this sector have an important role to play in arts development. The principal agent for the development of private sector partnerships in the arts has been ABSA. It has achieved this through acting as a link between the arts, the private sector, the funding bodies and the government. Since 1984 it has administered the government-funded Business Sponsorship Incentive Scheme (BSIS), which matches new sponsorship funds with government grant. By the end of 1991, the scheme had drawn over £32 million into the arts, matched by £15.5 million of BSIS funding.

ABSA has also established 'Business in the Arts', which encourages the business community to share management skills and experience with arts organisations. It is based on the premise that the relationship between the business and the arts communities should be not merely financial, but based on the mutual benefits to arts managers and business people of working with each other. Business in the Arts has also created training opportunities by establishing a bursary scheme to enable arts managers to attend courses at business management centres, and by opening companies' in-house training courses to arts managers.

Sponsorship and donations

Plural funding is clearly vital to a healthy arts economy. Sponsorship is a valuable component of this. But, as ABSA argues, sponsorship can only work as a supplement to and not a substitute for public funding. Levels of sponsorship in the arts have continued to increase in recent years. ABSA's survey of business support for 1990/91 showed sponsorship at £44.7 million and corporate membership of arts organisations to the value of £12.5 million. For comparison, this was nearly one-third of the government grant to the Arts Council for the same year; thus, collectively, business sponsors are major players in arts funding.

BSIS has been of great benefit to both business and the arts, attracting over 1600 businesses into sponsorship for the first time and encouraging over 90% of them to continue to sponsor. BSIS exemplifies the public/private partnership in operation. It is valuable not only for the money it has generated but also for its contribution to developing the relationship between the arts, the public and the private sectors. **The consultation process demonstrated a clear wish and need for BSIS to remain and to be developed.** It would also be of benefit if the government were to introduce fiscal reform to make giving to the arts a more attractive and tax-efficient proposition. At present, corporate sponsorship is fully tax-deductible as a legitimate business expense, but the position on charitable giving is somewhat confused. There is still much potential for developing private sector donations to the arts. The funding system should work with ABSA to develop policy in this area, and to encourage government to make appropriate reforms.

Levels of business support are impressive and encouraging. But over-dependence on sponsorship and corporate giving will not be to the long-term benefit of the arts. Business sponsorship represents a commercial partnership between the sponsor and the arts organisation. It is not a reliable source of core funding. Whether a particular arts organisation (or artist) has a product or image that is 'sponsorable' is an entirely separate question from whether it merits public funding. Sponsorship, inevitably, will not be evenly distributed. Some organisations are potentially over-dependent on it while others are unable to achieve it at any significant level; studies have shown that many Black organisations, for instance, fall into the latter category.

Mutual benefits

The introduction to the (voluntary and unpaid) boards of arts organisations of members from the private sector, who are able to combine personal enthusiasm for the arts with management and business skills, has increased the experience and effectiveness of many of these boards. For example, the new Regional Arts Boards

contain a number of business people as key board members.

The involvement of senior private-sector representatives on boards is nothing new. But with the current insolvency laws, involving as they do a high level of financial accountability by board members, the status of these members has changed. There is less tendency to recruit the 'great and good' and more to invite onto boards people willing and able to play an active part in the organisation. This is of particular value as arts organisations move beyond their traditional areas of work into, for example, commercial trading activities.

Whatever their backgrounds, board members need training in the dynamics of their organisation and their own legal and practical responsibilities. The funding bodies and arts organisations have made substantial advances in board training. This should be further developed, and private sector expertise and experience have an important part to play in this.

Another initiative established by Business in the Arts has been the placement of business people in arts organisations in order to exchange skills and experience. The benefits are two-way: the business adviser is able to pass on business practice, and in return can learn how the non-profit sector operates and generally how to work alongside people with a different perspective in their professional lives. Such exchanges are valuable provided that they are seen as a genuine partnership. There are many other programmes which involve the private sector in the arts, such as 'friends' schemes, sponsors' clubs and corporate membership. There is a temptation to let such relationships proliferate on the grounds that they must, inevitably, be a good thing. In fact, they need careful structuring and analysis if they are to prove fruitful: at worst, the cost of securing and 'servicing' private sector support can exceed the value of the support. Each party to such relationships needs to educate itself as to the aims and practices of the other. The role of ABSA, as a broker between the two, is particularly important in this respect.

Conclusion

The funding system and ABSA should continue to encourage new relationships between the arts and the private sector; but it should be recognised that these require imagination, empathy and a genuine wish to learn and benefit by *all* parties.

As to the financial side of this relationship, it is vital that sponsorship and donations continue to be seen as a supplement to, not a substitute for, public funding. It is in time of recession, when all areas of earned income – such as box office – are at risk, that private sector sponsorship and donations are likely to be reduced also: it is at just such a time that the need is at its greatest for high levels of public funding. Furthermore, as ABSA argues, an increase in public spending on the arts would encourage a still greater involvement by the private sector. The BSIS programme remains a vital element of this partnership.

CHAPTER 18 · FUNDING ISSUES

The issue of the most appropriate *forms* of support for the arts is complex and important. This chapter sketches in a few of the arguments and possibilities.

Beyond the grant

The term 'funding bodies' is revealing. The Introduction noted that it is inappropriate to the BFI and Crafts Council, which in terms of expenditure are far more direct providers of services than they are funders. Much of their activity already embodies the sorts of ideas considered in this chapter. A considerable majority of Arts Council and RAB spending, by contrast, is in the form of grants to arts organisations and artists. But a majority of the staff time of even these organisations is spent in the provision of advice, services and advocacy. 'Funding bodies' remains no more than a convenient shorthand.

It may be a paradox that, as the funding bodies are pressing arts organisations to be more creative and entrepreneurial in their approach to income growth, most arts funding money is still allocated in the form of grant aid. Many funders are exploring the use of such methods as loans, equity stakes and the funding of commercial ventures. In order to assess possible developments 'beyond the grant', the Comedia consultancy was commissioned to undertake an analysis of existing funding practice.

Comedia suggested five main reasons why methods of funding other than the grant may not be popular with much of the funding system:

(i) The funding system has traditionally favoured the arm's length principle – involving freedom from artistic interference – not only between government and itself but between it and the organisations which it funds. Loans, equity arrangements and so on imply a different sort of relationship, which might compromise artistic independence.

(ii) The funding bodies may be unclear about the legal position of some innovative financial schemes.

(iii) Arts funding bodies are 'public good' organisations. The grant expresses this more clearly than a more entrepreneurial arrangement would.

(iv) The skills and experience of the majority of the people working in the

funding system may not be well suited to developing innovative approaches to money.

(v) Alternative methods of funding might not be appropriate: most of the subsidised sector needs subsidy, not loans, to survive.

On the other hand it would be wrong to suggest that there is a standard approach to this issue among the funding bodies. The **Arts Council** operates largely, but not entirely, as a traditional patron of the arts, through grant aid. Exceptions include its Film, Video and Broadcasting and Touring Departments which operate in a much more commercial environment. Comedia suggests that the culture of the **BFI**, on the other hand, is one where an entrepreneurial approach is already widely adopted; the **Crafts Council** similarly. Practice within the **RABs** is diverse and contains elements of the practice of all the national bodies. Several operate such programmes as interest-free loans for the purchase of works of art and craft, investment in television production, purchase of commercial studio time for the use of aspiring musicians, assistance with the development of markets for regional cultural products and acting as guarantors for loans. **Innovative funding and investment programmes exist already in many parts of the funding system, particularly within the BFI and Crafts Council, but hitherto they have developed largely in isolation. It is important that the funding bodies work more closely together in this area, and learn from each other's experiences.**

Serving the arts

Do potential and existing clients want financial support from the funding bodies only in the form of a grant, or might other options be attractive and effective? From the economic point of view, it is worth noting that in the grant relationship money circulates only once, while other mechanisms might allow more financial 'leverage' and multiply its effect. Possible examples include:

- making direct loans
- guaranteeing loans from third parties
- paying the interest on a loan from a third party
- taking an equity stake in a project
- providing venture capital
- providing an endowment
- setting up a revolving fund
- acting as a bulk purchaser of goods and services at a discount on behalf of clients

- voucher systems and other methods of targeted support.

Some of these mechanisms would involve the funding bodies in no direct outlay of cash, some involve risk – and/or profit-sharing, and some would facilitate the recycling of money within the system. Few have been widely used or discussed as alternatives, or as parallel avenues of development, alongside simple grant aid. **The funding bodies should recognise that while they operate largely within certain norms, governed by tradition or legal constraints, many of their arts organisation clients operate within a more commercial environment.**

Many funded arts organisations want or need grant aid in its current form: no other mechanism will enable them to break even at year end. Others would benefit from a wider range of options. Certainly, there are many that would benefit from certain elements of their funding being provided in some form other than grant. Building-based organisations and those generating income from audiences and by selling products have complex needs. Grant aid may be necessary for the achievement of artistic objectives, while activities requiring a more entrepreneurial approach – publishing and distributing books or catalogues, running a bar or café, West End transfers – could benefit from new types of finance offered on different terms.

Through adopting more diverse funding criteria, the funding bodies can work in the middle ground between subsidised and commercial arts provision; for example, sharing the risk with publishers or booksellers for certain types of literature or helping to negotiate terms for the transfer of subsidised productions to the commercial theatre. They should also consider a broader intervention in the development of markets for the arts. For example, funding the visual arts has concentrated on the development of networks of galleries to exhibit artists' work. This may not improve artists' ability to earn a living from their work. In addition to supporting exhibition spaces, the funding bodies might help to create the conditions for the sale of work. A national loan or sales scheme, on the basis of existing regional models, might stimulate the market for purchasing work by institutions and individuals. (Chapter 3 considers other examples of support for individual artists.)

Conclusion

The funding system must consider the business development needs as well as the artistic objectives of the artists and organisations which it funds, and review its own practice, skills and advisory services so that it can respond to these needs.

In many, probably most, cases the grant will remain the basic means of support to arts organisations and artists; but it cannot be the only one. The

funding bodies should explore alternatives with each other and with those they fund; learn lessons from the commercial arts and cultural industries sectors; clarify the legal position on alternative support methods; examine the work of economic development agencies; and develop innovative funding and investment programmes to supplement grant aid in appropriate cases.

APPENDIX A · NATIONAL ARTS AND MEDIA STRATEGY MONITORING GROUP

Membership as at May 1992

Arts Council of Great Britain:	Beverly Anderson (Chairman) Anthony Everitt
British Film Institute:	Marion Doyen Michael Prescott
Crafts Council:	Barclay Price
Regional Arts Boards:	Michael Elliott Christopher Gordon
Association of County Councils:	Jayne Knight Dugald McInnes Sarah Maxfield
Association of District Councils:	Dennis Artess Ian Reekie
Association of Metropolitan Authorities:	Chris Heinitz David Patmore Robert Perkins
Committee of Area Museums Councils:	Simon Olding
Museums and Galleries Commission:	Chris Newbery
Strategy Unit:	Howard Webber (Manager) Tim Challans (Co-ordinator) Katie Williams (Administrator)

Observers

Scottish Charter for the Arts:	Gail Boardman
Welsh Arts Council:	Tom Owen

APPENDIX B · RESPONDENTS TO *TOWARDS A NATIONAL ARTS AND MEDIA STRATEGY*

The following list of respondents does not include the funding bodies or the other organisations represented on the Strategy Monitoring Group (see Appendix A).

Local authorities

Alnwick District Council
Avon County Council
Barnet Borough Council
Bedfordshire County Council
Royal County of Berkshire
Birmingham City Council
Bolton Metro Council
Bournemouth Borough Council
Braintree District Council
Bridgnorth District Council
Bristol City Council
Broadland District Council
Buckinghamshire County Council
Cambridge City Council
Carrick District Council
Cheltenham Borough Council
Cheshire County Council
Chester City Council
Coventry City Council
Cornwall County Council
Cumbria County Council
Doncaster Metropolitan Borough Council
Dorset County Council
Dudley Metropolitan Borough Council
Durham County Council
East Hampshire District Council
East Sussex County Council
Ellesmere Port & Neston Borough Council
Elmbridge Borough Council
Epsom and Ewell Borough Council
Fenland District Council
Gateshead Metropolitan Borough Council
Great Yarmouth Borough Council

London Borough of Hammersmith and Fulham
Hampshire County Council
Harrogate Borough Council
High Peak Borough Council
Ipswich Borough Council
Kennet District Council
Kent County Council
Leicester City Council
Leicestershire County Council
Lincolnshire County Council
Corporation of London
Mansfield District Council
Metropolitan Borough of Calderdale
Mid Suffolk District Council
Milton Keynes Borough Council
Monmouth Borough Council
Newcastle under Lyme Council
New Forest District Council
London Borough of Newham
Norfolk County Council Library
Northampton Borough Council
North Kesteven District Council
North Tyneside Council
Northumberland County Council
North Warwickshire Borough Council
North Yorkshire County Council
Norwich City Council
Nottingham City Council
Oldham Metropolitan Borough Council
Oxford City Council
Penwith District Council
Reading Borough Council
Restormel Borough Council
London Borough of Richmond upon Thames
Rother District Council
Rushmoor Borough Council

St Edmundsbury Borough Council
Salford City Council
Sandwell Metropolitan Borough Council
Sheffield City Council
Solihull Metropolitan Borough Council
South Holland District Council
South Lakeland District Council
South Kesteven District Council
South Somerset District Council
Stoke on Trent City Council
Suffolk County Council
Swansea City Council
Tamworth Borough Council
Tewkesbury Borough Council
Thamesdown Borough Council
Wakefield Metropolitan District Council
Wansbeck District Council
Westminster City Council
West Somerset District Council
Winchester City Council
Wokingham District Council
Worcester City Council
Wrexham Borough Council
York City Council

Other organisations

Arvon Foundation
Asian Art Society for the South West
Association of Advisers and Inspectors in Art
 and Design
Association for Business Sponsorship of the Arts
ACRE – The Rural Communities Charity
ADiTi
Age Concern
A Hall for Cornwall
AICA – International Association of Art Critics
Aldeburgh Foundation
ARLIS UK & Eire Art Libraries Society
Artlink West Yorkshire
Artreach Limited
Arts 33 – London Boroughs Arts Officers
Arts about Manchester
Arts and Entertainment Training Council
Arts for Health
Artsreach (Dorchester Arts Centre)
Association of Art Historians

Avon Pride
Association of British Orchestras
AXIS – Visual Arts Exchange and Information
 Service
Barnet Borough Arts Council
Belgrade Theatre in Education Company
Benesh Institute
Bexley and District Crafts Guild
Birmingham Hippodrome
Blackburn Contemporary Artists
The Blackie
Book Trust
Bournemouth Orchestras
Bradford Playhouse/Filmtheatre
Brewery Arts, Cirencester
Bristol Community Dance Centre
British Copyright Council
The British Council
The British Health Care Arts Centre
The British Library
British Resorts Association
Buxton Opera House
Cafe Gallery, Bermondsey
CDMF – Community Dance & Mime
 Foundation
Central Council for Amateur Theatre
Central School of Ballet
The Central School of Speech and Drama
Cheshire Dance Workshop
The Childrens Theatre Association
City of Plymouth Museums and Art Gallery
City University
Community Radio Association
CONCEPTS – The Consortium for the
 Coordination of European Performance
 Theatre Studies
CONSORT – The Association of UK Arts
 Marketing Consortia
Council for Dance Education and Training
The Crick Crack Club
Dance UK
Dartington College of Arts
Design and Artists Copyright Society
Design History Society
Derby Playhouse
Devon Community Council
Devon Puppeteers
Directors Guild of Great Britain
The Drake Research Project

Eastern Orchestral Board
Empty Space Theatre Company
English Heritage
English Tourist Board
Equity
Expansion
The Federation of British Bonsai Societies
Federation of Local Authority Chief Librarians
Folklore Society
Folkworks
Forest Artworks
Freeshooter Productions Limited
GLASS – J.S.& B.C Blanthorn
GLINT – Gays and Lesbians in Theatre
Guild of Sussex Craftsmen
The Hannah Peschar Gallery
Harrogate and Nidderdale Art Club
Highlands and Islands Enterprise
The Hungate Bookshop
Home Office – Miss V Jenson
Interfolk – The Society for International Folk Dancing
International Theatre Institute
Incorporated Society of Musicians
Independent Theatre Council
Jacy Wall Textiles
Jazz Services
Kings Jazz Review
Kneehigh Theatre
Language Alive
The Lawrence Batley Centre for The National Arts Education Archive (Trust) Bretton Hall
Leicester Arts Trust
Levitt Bernstein Associates
The Library Association
London Bubble
London Boroughs Association
London Borough Grants Committee
Londons Information and Advice Service for Disabled People on Arts and Entertainment
LPAC – London Planning Advisory Committee
London Union of Youth Clubs
Lowender Peran
MAC – The Centre for Birmingham
MAN ACT
Music Advisers National Association
Mailout
Manchester Craft Centre
The Manton and East Dartmoor Theatre

Mecklenburgh Opera
MidNag – Mid Northumberland Arts Group
The Morris Federation
Museums of Exeter
Museum Training Institute
Musicians Union
Musicworks
National Association of Teachers in Further and Higher Education
National Alliance of Women's Organisations
National Artists Association
National Campaign for the Arts
National Association of Youth Theatres
The National Disability Arts Forum
National Federation of Young Farmers Clubs
National Federation of Music Societies
The Newcastle Upon Tyne Free Festival Limited
New Playwrights Trust
New Victoria Theatre, Newcastle under Lyme
Northampton Arts Development
Nottingham Polytechnic, Faculty of Art and Design
Online
Opera North
Orange Tree Theatre
Oxford Stage Company
Peterloo Poets
Pit Prop Theatre
The Philharmonia
Proper Job Theatre Projects
Public Arts Consultancy and Management
Public Art Forum
Puffin Viking Fantail Childrens Books
Pullit Art International Organisation
Puppet Centre
P W Productions Limited
Rambert Dance Company
Red Herring Studios
Red Ladder Theatre Company
Reigate College
The Ridge College
Royal Academy of Arts
Royal Armouries
The Royal Exchange Theatre Company
Royal Institute of British Architects
Royal National Institute for the Blind
Royal Shakespeare Company
The Scout Association
Scottish Poetry Library

SEEDS – A Christian Creative Resource Centre
Sheffield City Polytechnic, School of Leisure and
 Food Management
Society of Archivists
The Society of Art Publicists
Somerset Arts Development Project
The South Bank Centre
South West Artshare
South West Textiles Group
Spare Tyre Theatre Company
Suffolk Acre
Suffolk College, Faculty of Creative Studies
Somerset Community Council
Swaledale Festival
Take Art
Theatre in the Mill
Theatre Museum
Theatre Royal Stratford East
Thomas Bennet Community College
Theatrical Management Association
Todmorden Amateur Operatic & Dramatic
 Society
HM Treasury – J B Jones
Trestle Theatre Company Limited
Tyr Gwyr Gweryn
UK Artists' Books
UK Council for Music Education and Training
University of Essex, Department of Art History
 and Theory – Professor Dawn Ades
University of Manchester, Department of Drama
University of Plymouth, Faculty of Art and
 Design
University of Sheffield, Centre for English
 Cultural Tradition and Language
Visiting Arts
Voluntary Arts Network
Warwickshire Rural Community Council
Welfare State International
Women in Music
Writers and Theatres Strategy Group
Yorkshire and Humberside Museums Council
Yorkshire Dance Centre
Youth Libraries Group

Individuals

Bernard Adams
Professor Brian Allison

Pamela Anderson
Tom Andrews
Nancy Balfour
David Ball
Peter Barker Mill
Michael Barry
Julie de Bastins
Isobel Baylis
Alan Berry
William Bishop
Roy Blackman
Fred Beake
Catherine Beedell
Alan Berry
Colin Broadley
Francis Broomfield
Sheila Broun
Sylvia Bruce
Rick Christian
Elaine Clarke
Sue Clive
T.N. Corkill
Brian Cramp
Rodolph Cribb
A J Croft
Liz Crow
Mary Curran
Trevor Dannatt
Ivor Davies
Pamela Dellar
Anthony Edkins
Mark Fisher MP
Louis K Fleming
John Gray
G J Greene
Mark Griffin
Malcolm Griffiths
Nigel Halon
Professor Jonathan Harvey
Dr June Hayes-Light
C J A Houlding
Vi Hughes
Marjorie J Hughes
Viv Jakeman
Peter Jonas
Alan Jones
Malcolm Jones
Pip Keenan
Xenophon Kelsey

Simon Kendale
Ross Lambert
Joyce E Lilburn
K Loynes
D McKenna
Mya McKeoni
Dr Jim McGuigan
Jim McMillan
Paul Miskin
Pauline Moran
J M Nye
Mike Nye
William Oxley
Joy Parry
Maurice Plaskow
Harris Pellapaisiotis
Beverley Powell
Simon Purins
E B Ranby
W H Rennison
John Rich

Simon Richardson
Sheila Rowley
Patrick Ryan
Gillian Rye
Robert Saunders
Derek Schofield
Joy Simpson
Christopher Sinclair-Stevenson
Roger Smith
Barbara Spring
David Ian Stanton
John H Taylor
Jan Truman
Michael Twistleton
Jennie Walker
Harry Ward
Michael C Ward
Andy Whitfield
John Whitney
Claire M Wise
Gordon Yates

APPENDIX C · PUBLIC LIBRARIES – EXPENDITURE ON LITERATURE AND THE ARTS

A formula could be based on the following:

Literature

- All fiction purchases (including children's)

- Poetry, plays, foreign literature (in English and translation)

- Travel writing (excluding guides)

- Biography and autobiography

- Costs of subject-specialist staff and literature development workers (but not of staff engaged in general lending library activities)

- Expenditure on literature promotion including printing and graphic design

- All expenditure on special events and activities, eg. festivals, readers/writers in residence.

Arts

To build a more general picture and to include art forms other than literature, expenditure within the following specific areas could be included:

- Photography – specialist staff, purchases of books and periodicals, maintenance and development of special collections of photographs

- Music – subject-specialist staff (but not those involved in day-to-day operational work), costs of stock to include recorded sound formats, scores and sheet music (individual copies and sets) and historic manuscripts

- Drama – subject-specialist staff, stock purchasing including maintenance and development of special collections and play-set collections

- Crafts – subject-specialist staff, purchase of stock

- Fine arts – subject-specialist staff, purchase of stock, maintenance and development of special collections, eg. fine printing

- Film and video – subject-specialist staff, stock including books, journals, films, film-strips, videos

- Arts development – specialist staff, promotional activities and publicity.

In no case should costs of buildings and storage or other overheads be included.

Printed in the UK for HMSO.
Dd. 0294230, 1/93, C47, GP 3396/6, CCN 16268.